NewTalentDesignAnnual2004 *Graphis* is committed to presenting exceptional work in international design, advertising, illustration and photography. Since 1944, we have presented individuals and companies in the visual communications industry who have consistently demonstrated excellence and determination in overcoming economic, cultural and creative hurdles to produce true brilliance.

NewTalentDesignAnnual2004 *Graphis* is committed to presenting exceptional work in international design, advertising, illustration and photography. Since 1944, we have presented individuals and companies in the visual communications industry who have consistently demonstrated excellence and determination in overcoming economic, cultural and creative hurdles to produce true brilliance.

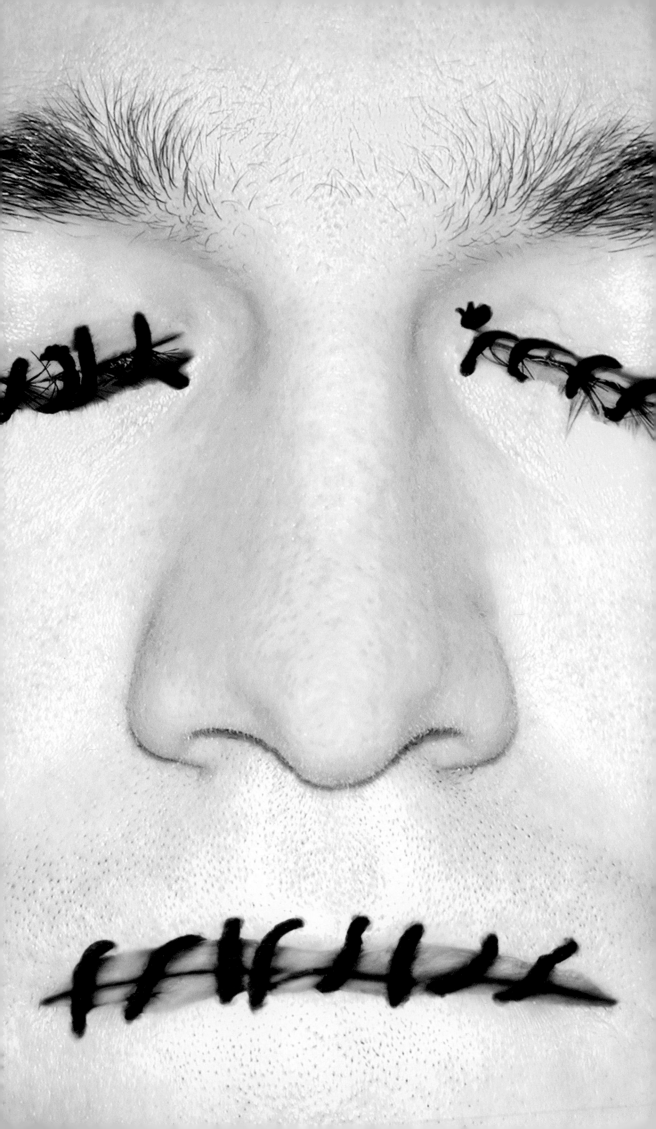

New Talent Design Annual 2004

CEO & Creative Director: B. Martin Pedersen

Editors: B. Martin Pedersen,
Laetitia Wolff and Vanessa Fogel
Art Director: B. Martin Pedersen
Designer: Andrea Vélez and Jennifer Kinon
Production Manager: Luis Diaz
Design Assistants: Dorothée Dupuis, Sarah Munt, and Esteban Salgado

Published by Graphis Inc.

This book is dedicated to
Philip B. Meggs
(1942-2002)

(opposite) Art Director: Timur Yevtuhov School: School of Visual Arts Department: Advertising and Graphic Design Department Chair: Richarde Wilde Instructor: A. Leban

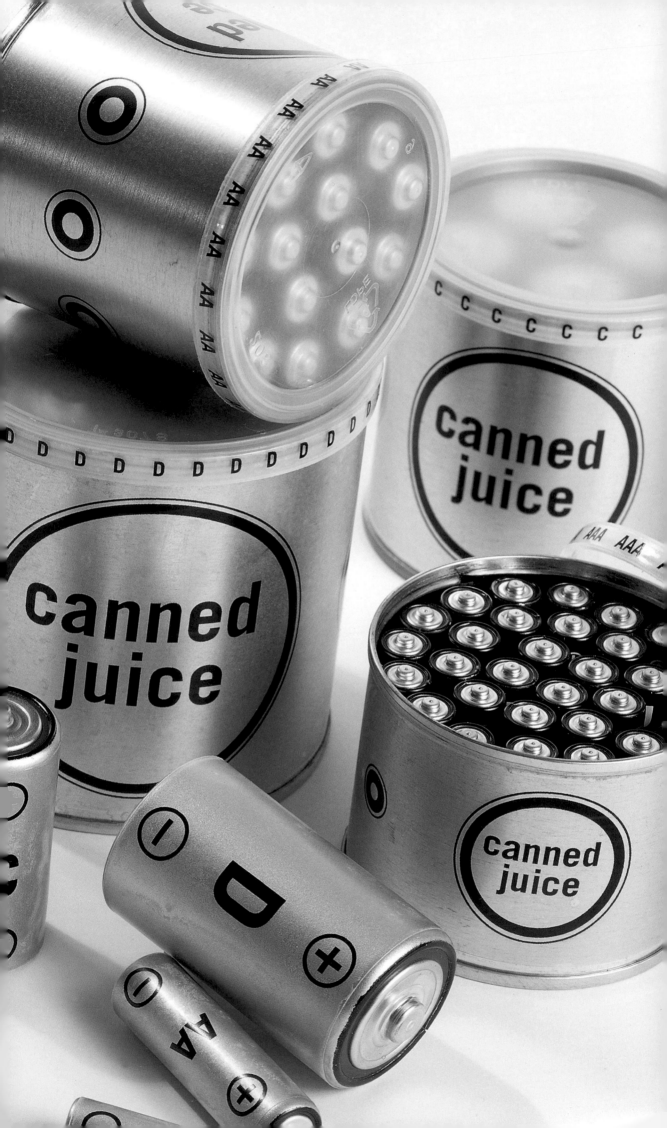

Contents Inhalt Sommaire

Remarks: We extend our heartfelt thanks to contributors throughout the world who have made it possible to publish a wide and international spectrum of the best work in this field. Entry instructions for all Graphis Books may be requested from: **Graphis Inc.**, 307 Fifth Avenue, Tenth Floor, New York, New York 10016, or visit our Web site at www.graphis.com.

Anmerkungen: Unser Dank gilt den Einsendern aus aller Welt, die es uns ermöglicht haben, ein breites, internationales Spektrum der besten Arbeiten zu veröffentlichen. Teilnahmebedingungen für die Graphis-Bücher sind erhältlich bei: **Graphis Inc.**, 307 Fifth Avenue, Tenth Floor, New York, New York 10016. Besuchen Sie uns im W.W.W. www.graphis.com.

Remerciements: Nous remercions les participants du monde entier qui ont rendu possible la publication de cet ouvrage offrant un panorama complet des meilleurs travaux. Les modalités d'inscription peuvent être obtenues auprès de: **Graphis Inc.**, 307 Fifth Avenue, Tenth Floor, New York, New York 10016. Rendez-nous visite sur notre site web: www.graphis.com.

(opposite) "Canned Juice" Art Director: Jessica Annunziata School: School of Visual Arts Department: Advertising and Graphic Design Department Chair: Richarde Wilde Instructor: Carin Goldberg

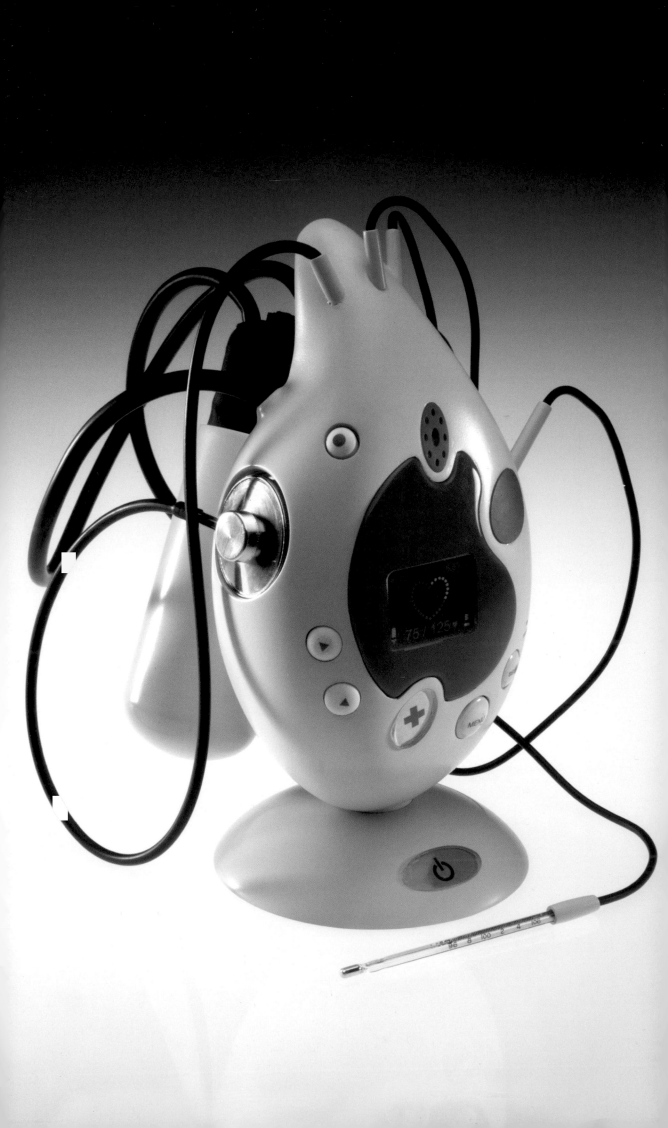

Changing the World through Design, By Richard Koshalek, President of Art Center

Richard Koshalek was appointed president of Art Center College of Design in Pasadena, California in 1999. From 1982 to 1999 he served as director of the Museum of Contemporary Art in Los Angeles, during which time he also chaired the Architectural Subcommittee for Walt Disney Concert Hall. Mr. Koshalek earned a Bachelor of Arts degree in Architecture from the University of Wisconsin, Madison, and a Master of Arts degree in Architecture and Art History from the University of Minnesota, Minneapolis.

Designers—among the most sensitive and the most observant of all professionals—are willing to challenge the status quo every day. Their creative solutions have the potential to inspire others and promote greater self-awareness and understanding of the world.

Today, as the world faces challenges of a scale and complexity unprecedented in history, the role of the designer and the creative individual is more critical than ever. To respond to the multiple challenges of escalating globalization, geopolitical conflicts, urban congestion, dwindling natural resources, and rapid technological and socio-economic changes, among others, will require original problem-solving and fresh ways of thinking—qualities that are intrinsic to designers and creative individuals. In response to this change, it seems increasingly clear that leaders in business, economics, science, medicine, international relations, and government must work together with the creative disciplines. To provide a new forum for these efforts, Art Center College of Design has launched a series of international initiatives, projects, and partnerships, including the designmatters program, to expand the range of responsibilities for the creative individual. This year, the United Nations designated Art Center as a sanctioned, non-governmental organization (NGO), a non-profit institution that performs humanitarian functions and provides support on such issues as human rights, the environment, health and education. This prestigious designation will enhance the ability of the College's faculty, staff, students and alumni to engage in world issues and demonstrate how designers can affect society, as well as increase creative opportunities to serve the design needs of other NGOs around the world. Currently, the College is developing two major projects: a website for the U.N. Department of Public Information; and a project to build a community in Kenya for orphans and elders who have lost their families to AIDS. In March 2004, Art Center will present the international design conference "Stories from the Source," which will showcase unique contributions by foremost designers and thinkers, emphasizing the role that creative individuals play in the evolution of design thinking and practice.

In addition, Art Center's new educational agenda encourages respect for the creative individual and seeks to elevate the professional "playing field"–making the creative individual equal in importance to government and corporate leaders in the decision-making process. The College aims to produce creative leaders who will build on the strengths of the past, but are not afraid to face the future. Experiences in programs such as designmatters will provide our students with the opportunity to make more meaningful contributions to the greater society by working on problems that may seem intractable, but critically need the input of creative thinking.

Encouraging designers to become involved in international and humanitarian projects is not to diminish creative individuals who chose to concentrate on developing their respective disciplines outside the public arena; this focus is valuable as well. However, by building a greater awareness of the larger world, we hope to instill designers with a greater capacity to have the broad perspective necessary to face the future–with optimism and originality.

Q&A with Sheila Levrant de Bretteville, Designer and Educator at Yale University

 Sheila Levrant de Bretteville, received a B.A. in art history from Columbia University, Barnard College, an M.F.A. from Yale University, School of Art, and a honorary doctorates degree from California College of Arts and Crafts and Moore College of Art. She is a fully tenured Professor at Yale University's School of Art where she is the director of Graphic Design Studies. De Bretteville's posters and fine press editions are in special collections in the Museum of Modern Art, New York, and the Victoria and Albert Museum in London. Her permanent public installations in Los Angeles, Boston, Connecticut, Rhode Island, and New York have been the subject of domestic and international publications and exhibitions such as: Architecture of the Everyday, Berke Harris editors, Princeton Architectural Press; Lure of the Local, Lucy Lippard, The New Press; Design Culture Now, Catalog for the National Design Museum's Triennial. Her work was featured in Print, IDEA, Spazio e Societa, Communication Arts, Eye, DesignNET, krk, and FiD.

What direction and advice do you give to students about portfolios?

We encourage our graduates to show the kind of design work they want to continue doing. We believe this is the best way for them to be hired. Many designers come to graduate school to change the direction they had been going in and to enlarge their skill set and the way they think about design and designing. Their graduate portfolios include a catalogue raisonné of all their work done at Yale. Each portfolio demonstrates the visual method they have developed while they were here as students, and includes texts and images that position their work in relation to other work in film, art, architecture, thinking, and writing. Hopefully they have become aware of the historical and contemporary contexts for their work.

What is your proudest achievement in teaching so far?

Staying enthusiastic and engaged. I am amazed that I still find it extraordinarily exciting to witness a student who suddenly understands what s/he is doing. Then, it becomes a matter of my colleagues and I nudging their process along, helping them build their work and their voice through it. The setting here is similar to a design studio in that all the students work in a large space together. But unlike a studio, each student is author and client of their own work, while building their technical, conceptual, and formal skills. Most worked as designers before enrolling, and will work in studios upon graduation. Coming to Yale is not all about getting a job. Our students demonstrate that they can generate content and form in a cumulative process and in a multiplicity of media—computational form, digital media, music, print graphics, motion graphics, video, multi-media, any and all of it. And it works in the best and more difficult of times. For instance, those who graduated during the dotcom era found jobs easily, but just as quickly firms and positions dissolved. Because they had mastered a wide variety of skills, our graduates were able to find other positions in other studios, create their own, become consultants, and reinvent themselves by using parts of the design skill set formed at Yale.

What is your fondest experience as a teacher?

Seeing our students do exactly the work they want to be doing: that is, beginning to enjoy the process of initiating projects, each project generating the next. The same applies to my colleagues and myself. Getting excited or seeing someone get excited about what they are doing, especially when it is something new for them and for the profession. More than teaching a class, I enjoy working with my colleagues to frame and morph this program to respond to the times and to our students. Also, as the first woman tenured at Yale University's School of Art (1990) I hired a number of women, younger than myself, most of whom have had children since then. Each has had to pull back a bit to rebalance the equilibrium between designing, parenting and teaching. In a way, I am glad we model lives in design for our students: showing them what it's like to be a practicing professional committed to teaching while building a family.

What part of your work do you find most demanding?

It is sometimes difficult to balance my own community-based design work with the demands of teaching and running this program. Students are designing night and day. As the director of this program and as one of their teachers, I have to be available all the time. And there is so much going on at Yale that we want to do! There are always conferences and lectures that can broaden students' perspective and ability to think and create. Last week there was a conference on architecture and psychoanalysis, this weekend it was on Taiwanese cinema; the week before last, the Turkish novelist, Ophan Pamuk gave a talk on the notion of communal melancholy that comes from the loss of a city, like Istanbul's glorious lost past. Yale University provides access to extraordinarily rich resources that directly affect the work of design students.

Name the 3-5 colleagues you most admire.

My colleagues: Michael Rock, Susan Sellers, Paul Elliman, Irma Boom, and Karel Martens.

What do you tell your students about the professional world?

I tell them to engage in it and to change it through working in it. This program is definitely not conceived to generate teachers, but to encourage practionners who are proactive, to be designers authoring their lives in design. The degree we give doesn't function like a pass to teaching even though many graduates do teach. My colleagues and I are part of those designers who have initiated their own work and created new kinds of connections with companies, communities and other disciplines in ways graphic designers had not worked before. I always encourage students to be the initiators of the work they want to do, so that along the way they'll be asked to do what they really want to do.

What are some of your frustrations with today's students?

Undergraduate education is very uneven: lots of undergraduate programs struggle to create a program that can accommodate the ever-enlarging field that graphic design has become. One of the coping strategies used is to split digital media off from the print medium, offering classes in which the students learn one or the other but not both. But today's world is more complex, uncertain, and ambiguous

This page: Portrait of Sheila Levrant de Bretteville by Bradford Fowler.

than that. One of the reasons why they go to graduate school is to make up for what they did not learn in college or on the job, and to be able to learn transversally about designs. They all want to be able to adjust to changes in the profession including those unimagined, still to come.

How do you inspire your students?
By believing in their own ability to make their way in the world. No matter what!

Do you think design can be
taught or is it something innate?
The current Dean of the Yale school of art does not have a degree and some of our most valued faculty do not either. So, no, I do not think school and degrees are necessary for everyone. Designers can be autodidacts but at the same time we believe our university setting offers an extraordinary educational environment that helps students think, write, and make visual work in which they are thoroughly engaged while receiving the support and encouragement of others around.

What is your philosophy on grades, grading?
Grades are not what motivates our students. They either are or are not working and pushing their work forward according to agreed upon standards. The vast majority succeed in doing what they came here to do. Every now and again we write warning notices that tell a student that either they are not working enough or well enough. But over the 13 years I have been at Yale, we have only had to ask three people to leave because they were not doing well here, and might have done better elsewhere.

What is the most important element in good design?
Design that encourages a thinking audience.

How do you encourage your students' growth?
I emphasize the importance of looking, seeing, reading, thinking, talking, writing, and maintaining a passion for what they do—to that last one my son would say "Oh! Mom, you are so '60s!"

Is a master's degree in your
field relevant, or even necessary?
It is relevant and necessary to those who need it to move themselves and their work to new levels of understanding and accomplishment.

What's your biggest fear about sending
your students out into the profession?
That they will find it inordinately difficult to create or find the best conditions for themselves to do the work they most want to do. Most find the kind of place they want to work in relatively quickly. Most want to balance their own design work with work for others, a studio job or part-time teaching job in combination with their own design work. Many end up creating their own firm within five years.

What philosophy on design do you
communicate to a student audience?
I do not believe that any ideas I have about design constitute a 'philosophy.' All notions about design are open to questioning by myself, my colleagues, and my students on a fairly regular basis. It may sound strange but I check whether what I say I am doing is actually what I am doing, and whether it still makes sense to me. Our faculty does it too, as a group, constantly reviewing the relevance, intelligence and vitality of our program. We readjust our understanding of design and of the educational program we are involved in together accordingly.

This page and following page: Fluctuating Fields by Albert Lee,
City Spread 1-Japan Man Diagram/Image #1249; City Spread 2-Fluid City Entry 3; City Spread 3-Fluid City Entry 21; City Spread 4-Test Strip.

New Talent Design Annual 2004

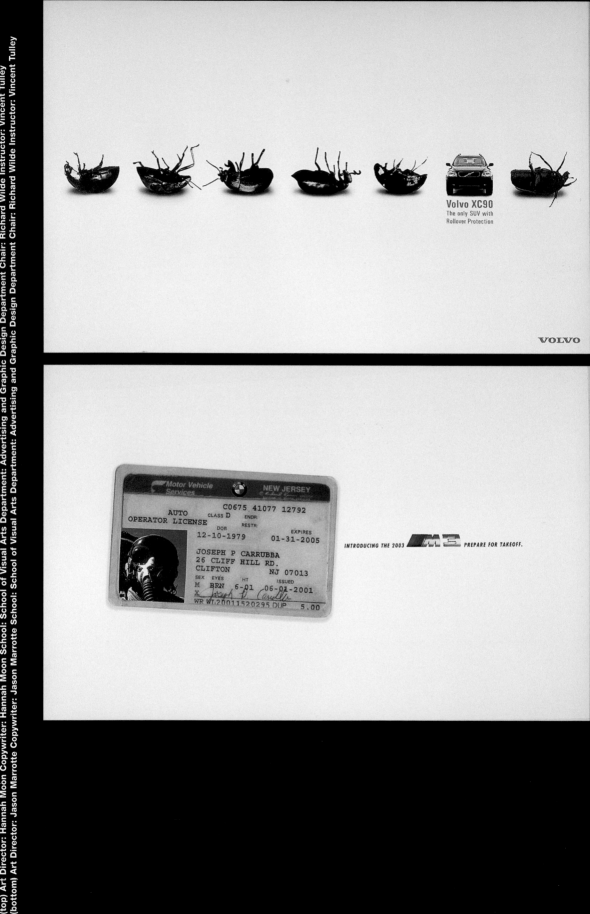

Volvo XC90
The only SUV with
Rollover Protection

VOLVO

INTRODUCING THE 2003 **M3** PREPARE FOR TAKEOFF.

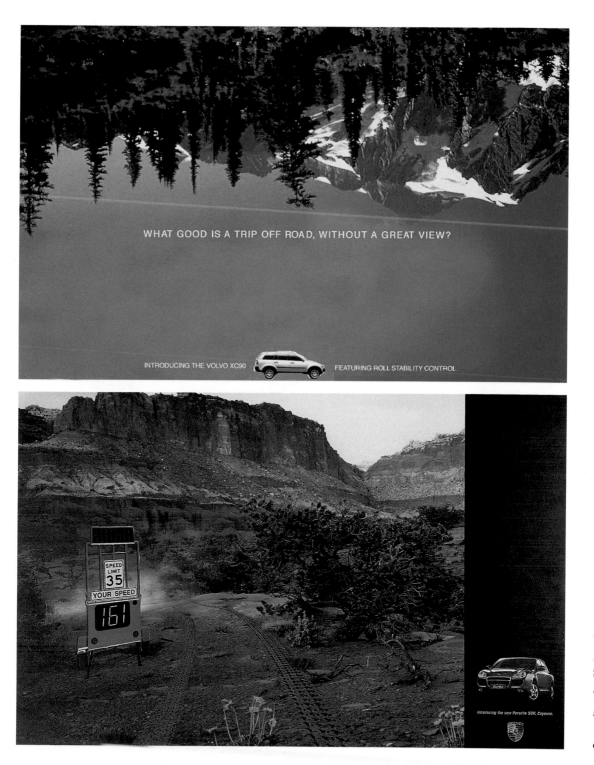

WHAT GOOD IS A TRIP OFF ROAD, WITHOUT A GREAT VIEW?

INTRODUCING THE VOLVO XC90 FEATURING ROLL STABILITY CONTROL.

Introducing the new Porsche SUV. Cayenne.

(top) "Great View" Art Director: Joe Madsen School: School of Visual Arts Department: Advertising and Graphic Design Department Chair: Richard Wilde Instructor: Jack Mariucci
(bottom) Art Director: Rob Schnabel School: School of Visual Arts Department: Advertising and Graphic Design Department Chair: Richard Wilde Instructor: Jack Mariucci

This is how I made one million _____ in the stock market.
PLURAL NOUN

It's simple. At the present time, any _____ investor with a little
ADJECTIVE

capital should be able to double his _____ in a few months.
SAME PLURAL NOUN

All the experts agree that we are nearing the end of the _____
ANIMAL

market. Just recently, for instance, the JP Morgan _____ and
NOUN

Chase Manhattan Bank has shown a/an _____ trend. Conditions
ADJECTIVE

indicate a/an _____ market for their principle product,
ADJECTIVE

automatic _____ . Chase Services International and _____
PLURAL NOUN NOUN

JP Morgan also looks _____ . At the end of the last fiscal
ADJECTIVE

_____ , they were earning $10 a/an _____ . Another
NOUN NOUN

_____ tip is Consolidated _____ . This outfit
ADJECTIVE NOUN

manufactures and sells electronic _____ of a very _____
PLURAL NOUN ADJECTIVE

quality. But whatever you do, act now. Remember, prosperity is just

around the _____ .
NOUN

MAKE THE BEST OF YOUR FINANCES.
CHASE BANK.

"Mad Libs" Art Director: Rob Schnabel Copywriter: Rob Schnabel School: School of Visual Arts Department: Advertising and Graphic Design Department Chair: Richard Wilde Instructor: Jeffrey Metzner Advertising 16, 17

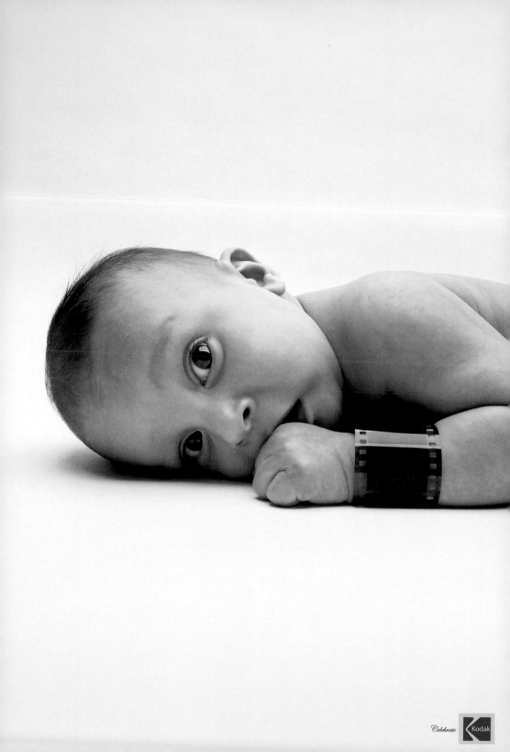

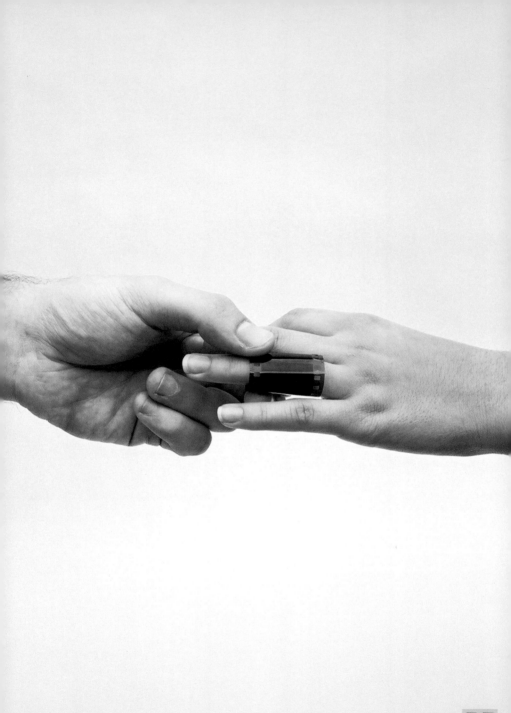

Celebrate

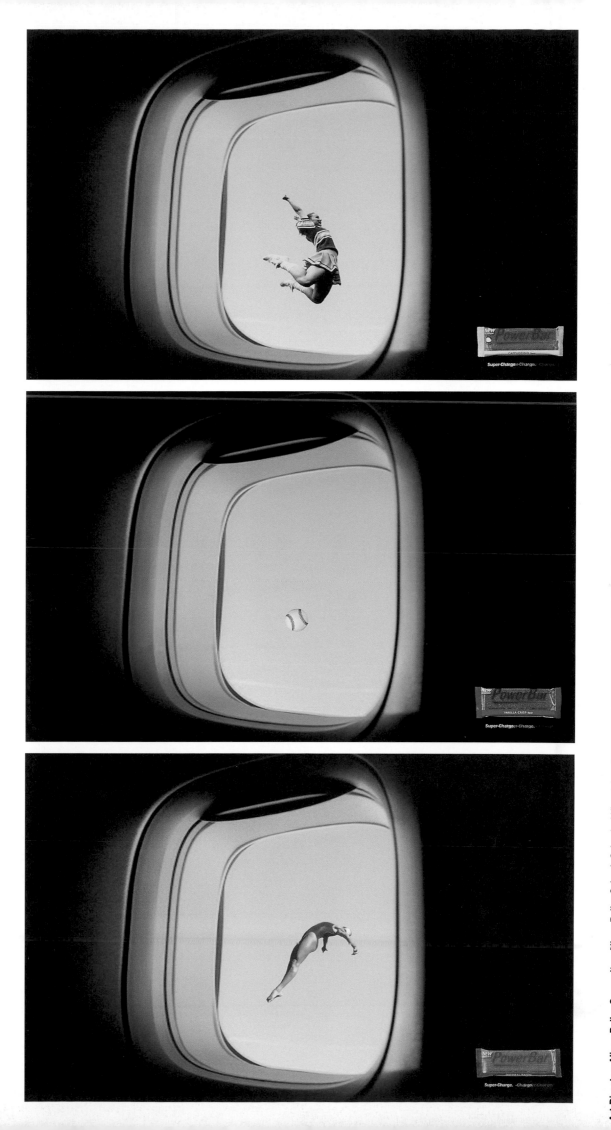

Art Director: Alison Beller Copywriter: Alison Beller School: School of Visual Arts Department: Advertising and Graphic Design Department Chair: Richard Wilde Instructor: Jeffrey Metzner Advertising 22, 23

The common cure for generations.

Not Easy.

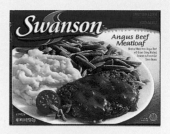

Easy.

Swanson. The 4 minute meal.

$$\vec{F}(\vec{U}) = \begin{pmatrix} \rho u_x \\ \rho u_x^2 + p + \frac{\vec{B}^2}{8\pi} - \frac{B_x^2}{4\pi} \\ \rho u_x u_y - \frac{B_x B_y}{4\pi} \\ \rho u_x u_z - \frac{B_x B_z}{4\pi} \\ 0 \\ u_x B_y - u_y B_x \\ u_x B_z - u_z B_x \\ \left(\rho e + p + \frac{\vec{B}^2}{8\pi}\right) u_x - \frac{B_x}{4\pi} \vec{B} \cdot \vec{u} \end{pmatrix}$$

Not Easy.

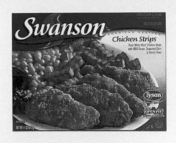

Easy.

Swanson. The 4 minute meal.

Not Easy.

Easy.

Swanson. The 4 minute meal.

Art Director: Carter Storozynski Copywriter: Carter Storozynski School: School of Visual Arts Department: Advertising and Graphic Design Department Chair: Richard Wilde Instructor: Jeffrey Metzner

Advertising 26, 27

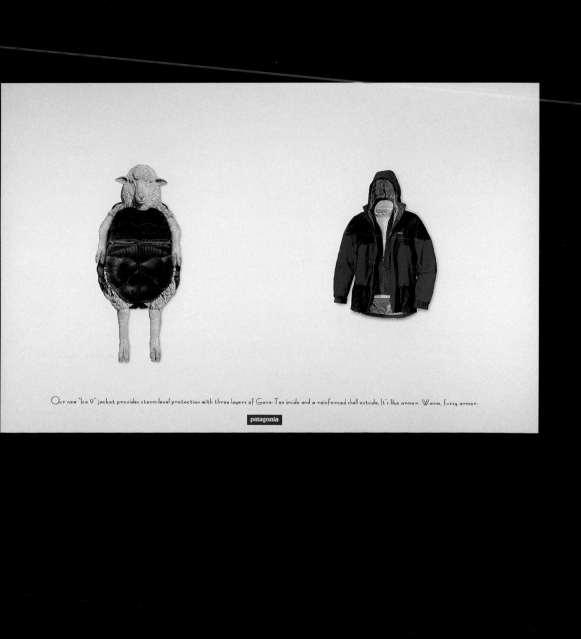

Our new "Ice 9" jacket provides storm-level protection with three layers of Gore-Tex inside and a reinforced shell outside. It's like armor. Warm, fuzzy armor.

patagonia

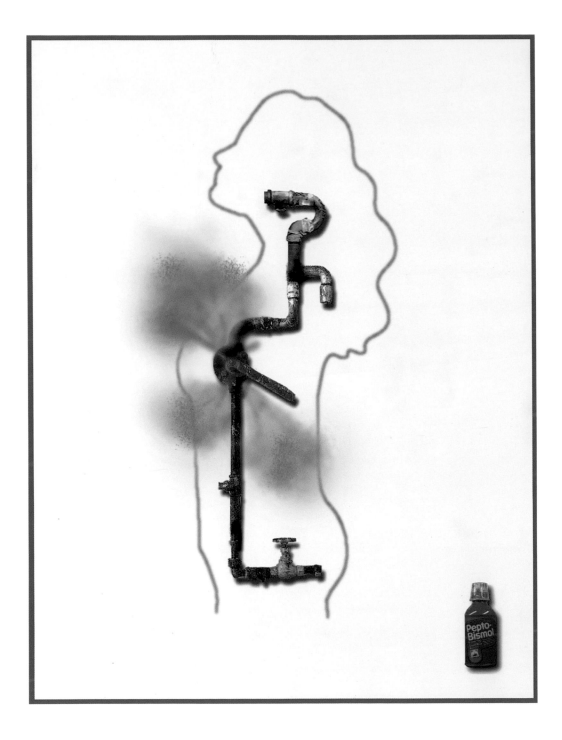

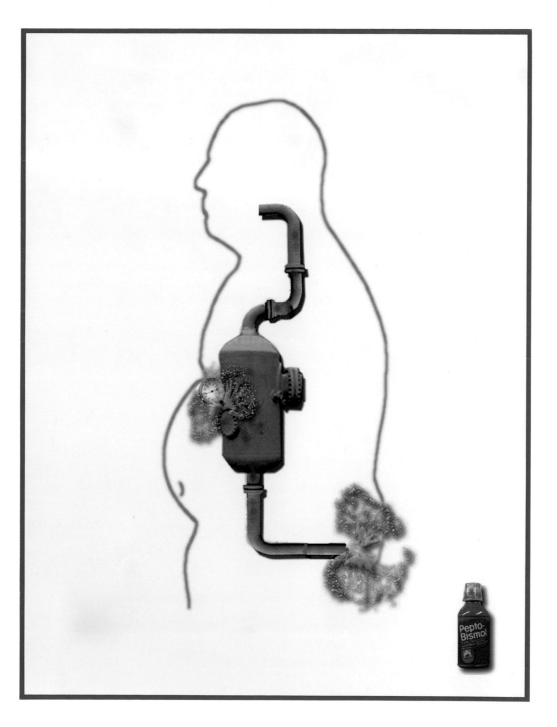

Visine®
Get Rid of the Red.

ENZYTE
NATURAL MALE ENHANCEMENT

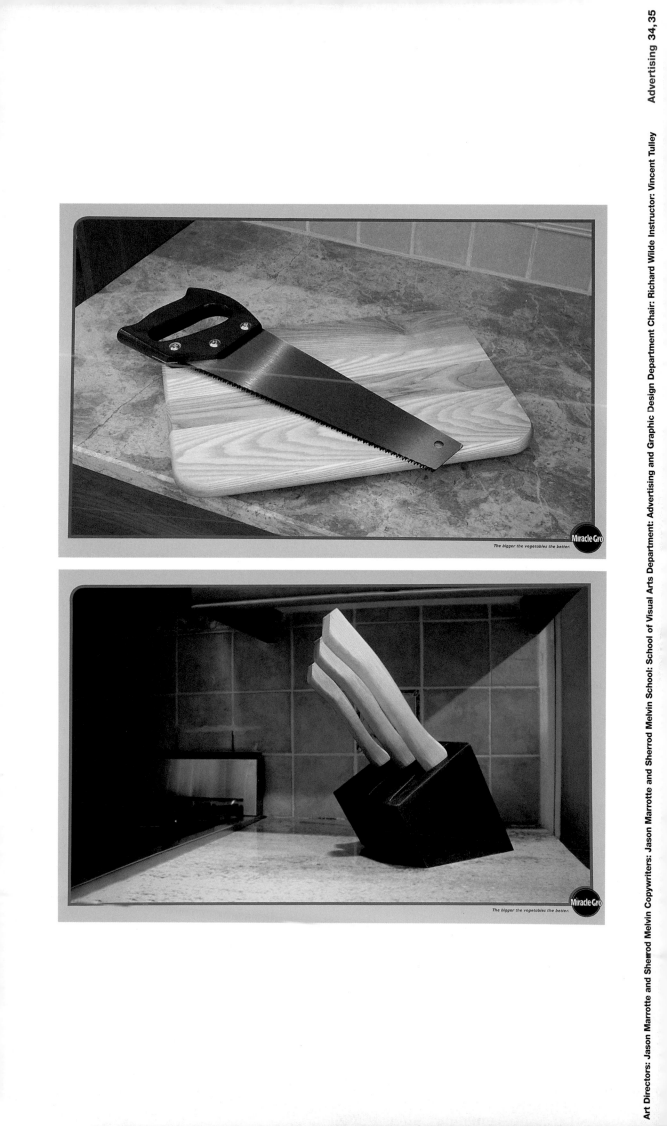

Art Directors: Jason Marrotte and Sherrod Melvin Copywriters: Jason Marrotte and Sherrod Melvin School: School of Visual Arts Department: Advertising and Graphic Design Department Chair: Richard Wilde Instructor: Vincent Tulley Advertising 34,35

You don't.

You can't.

You didn't.

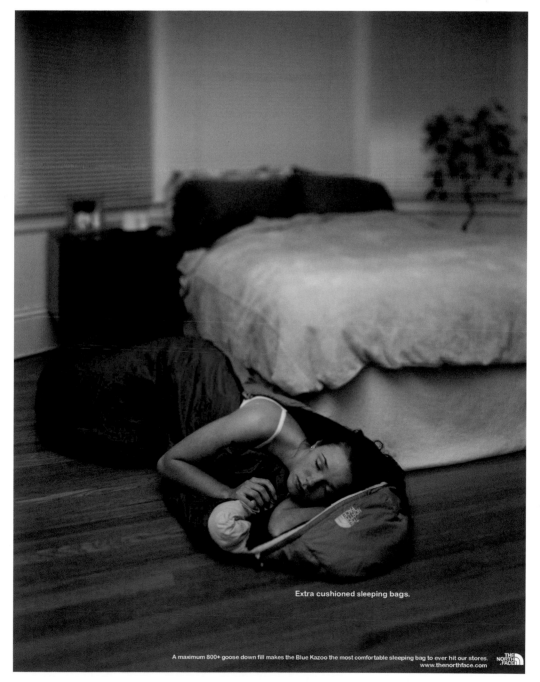

Extra cushioned sleeping bags.

A maximum 800+ goose down fill makes the Blue Kazoo the most comfortable sleeping bag to ever hit our stores.
www.thenorthface.com

give boldly

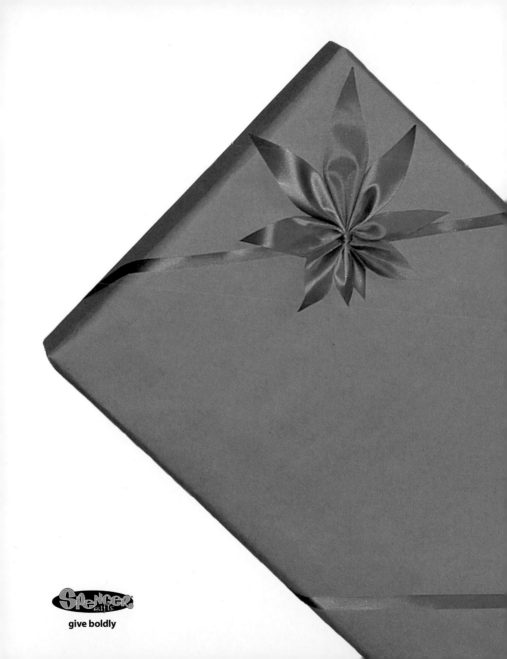

give boldly

(this spread) Art Director: Jason Marrotte Copywriter:Jason Marrotte School: School of Visual Arts Department: Advertising and Graphic Design Department Chair: Richard Wilde Instructor: Vincent Tulley

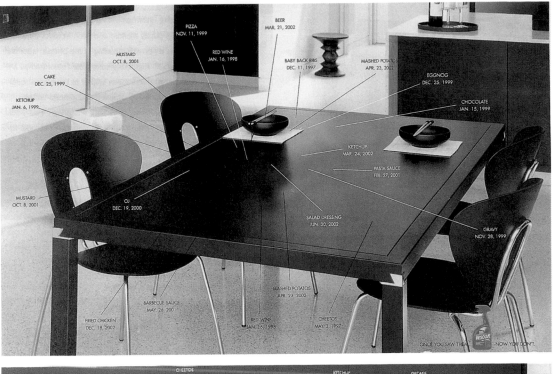

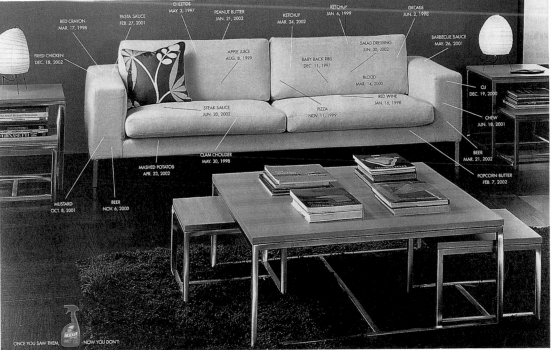

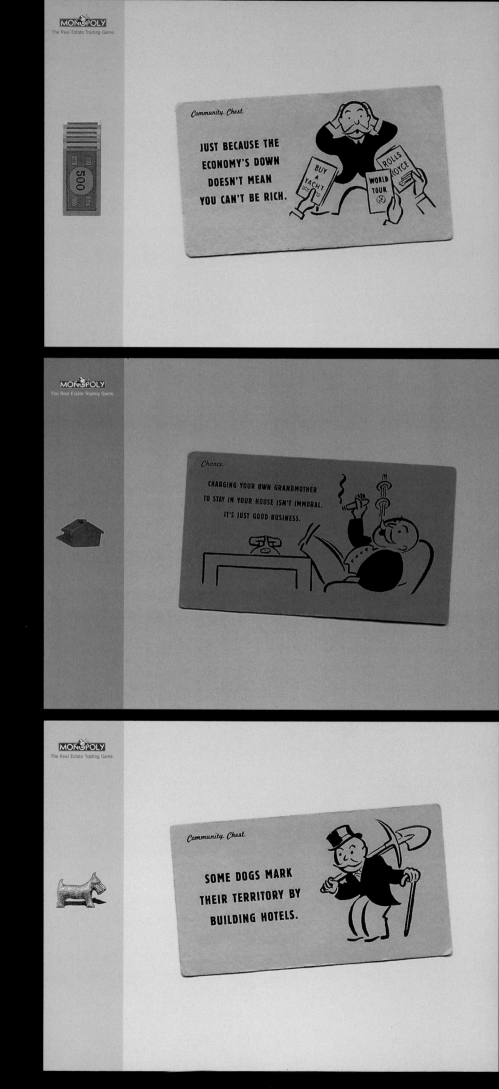

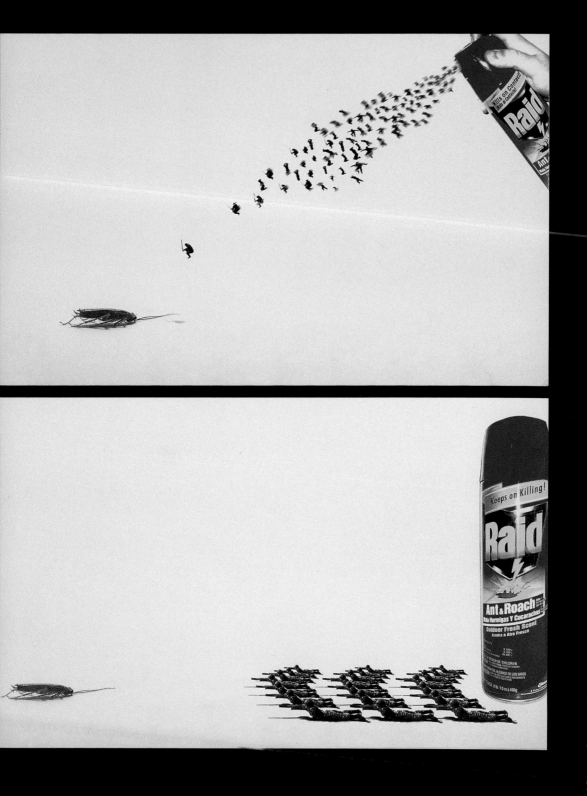

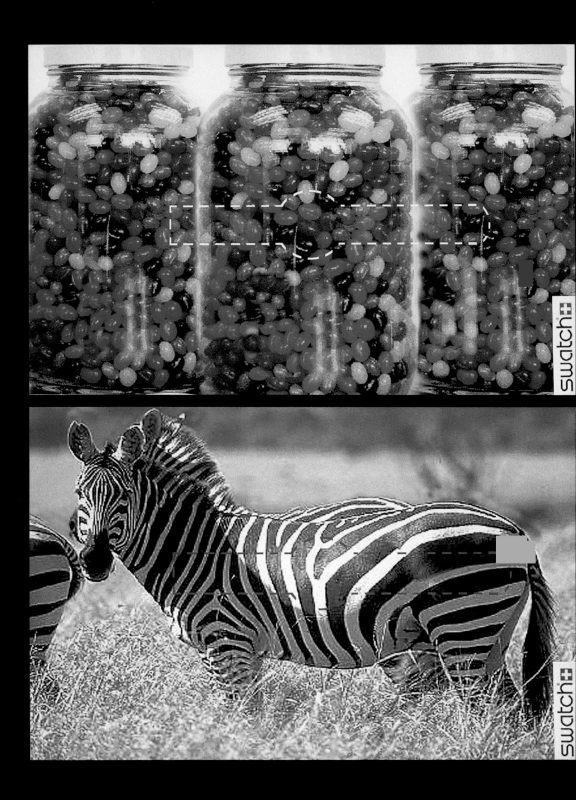

Art Director: Marie Zito Copywriters: Marie Zito School: School of Visual Arts Department: Advertising and Graphic Design Department Chair: Richard Wilde Instructor: Jeffrey Metzner Advertising 44, 45

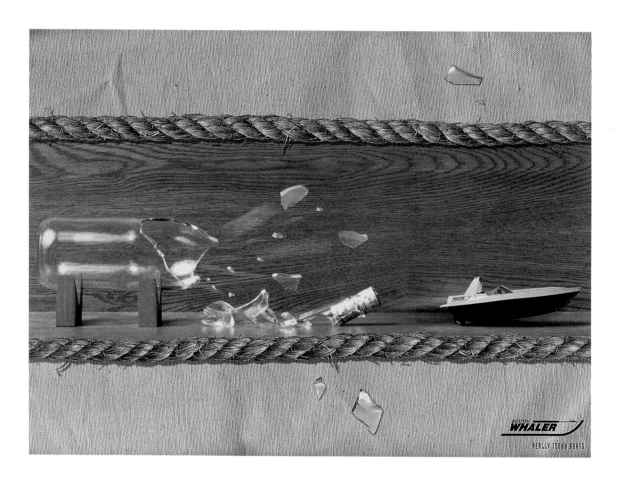

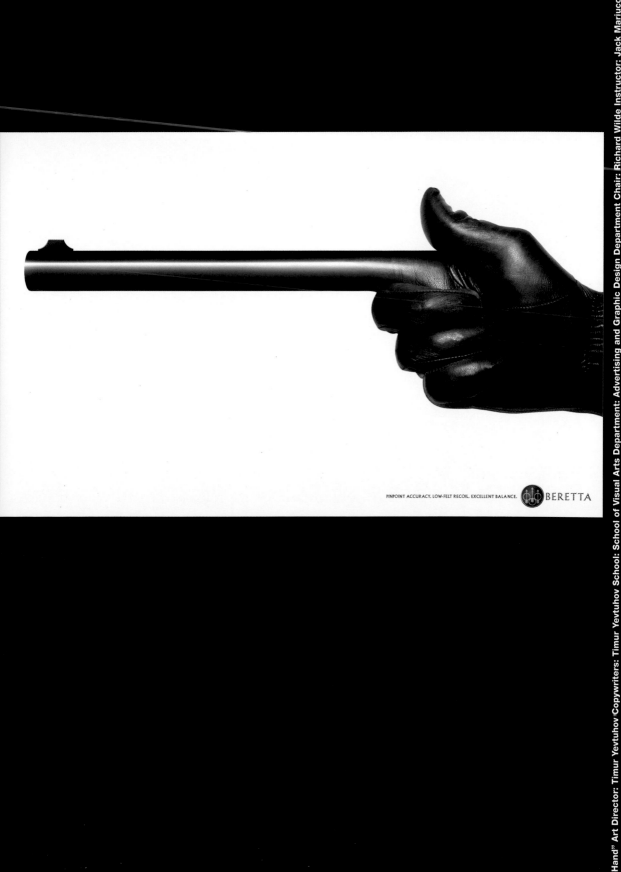

PINPOINT ACCURACY, LOW-FELT RECOIL, EXCELLENT BALANCE. BERETTA

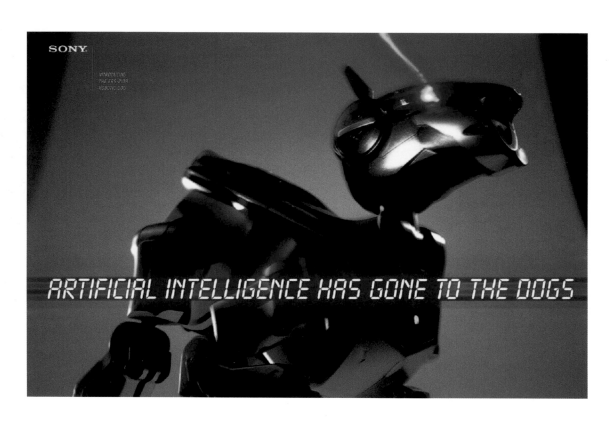

SONY

INTRODUCING
THE ERS-210A
ROBOTIC DOG

ARTIFICIAL INTELLIGENCE HAS GONE TO THE DOGS

2+miles of writing power.

BIC

LIFE DEATH

PRO-TECH
PLUG-IN CARBON MONOXIDE DETECTORS

THE HISTORY OF MICHAEL JACKSON
BROUGHT TO YOU BY PANTONE PROCESS COLOR MATCHING

| 1971 | 1976 | 1982 | 1986 | 1991 | 1995 | 2001 |

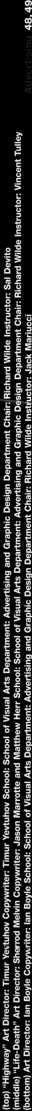

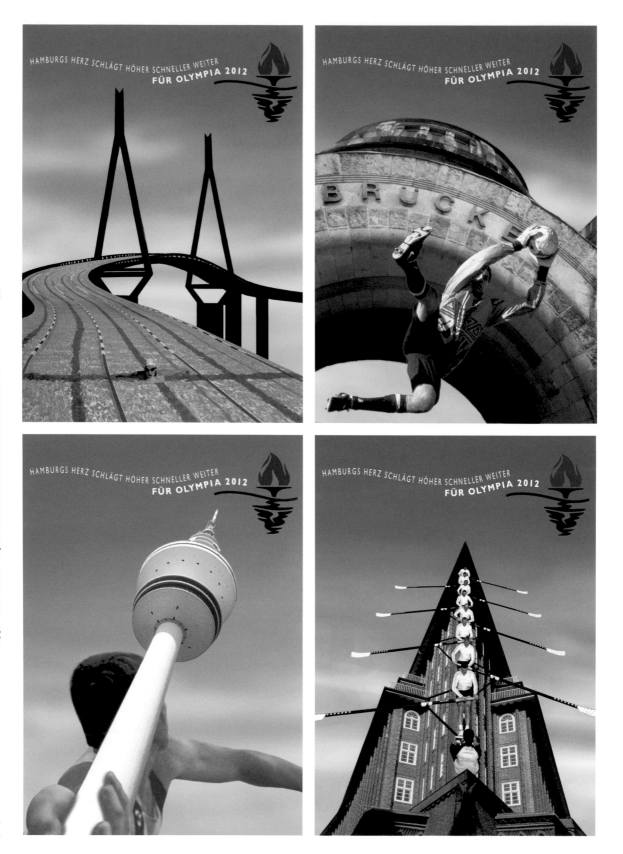

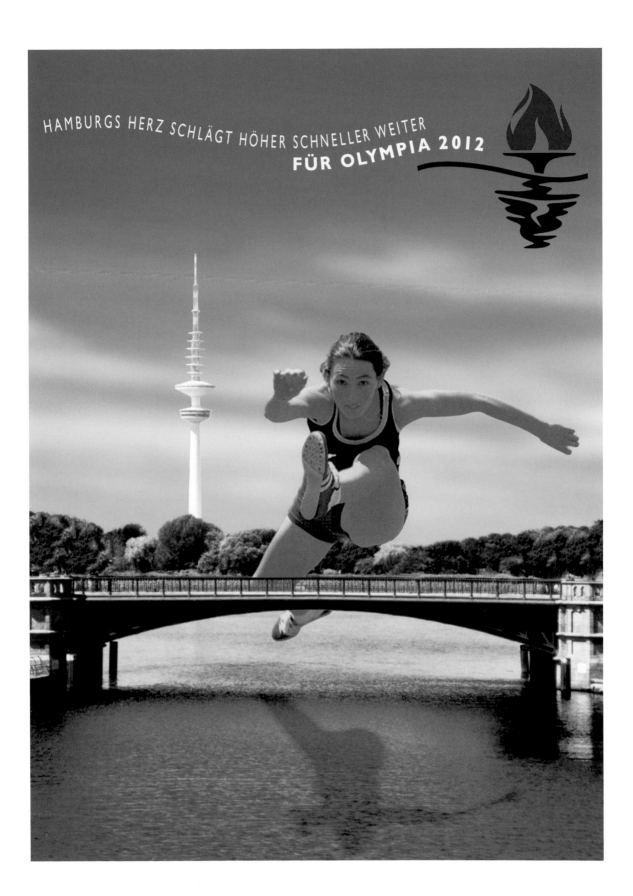

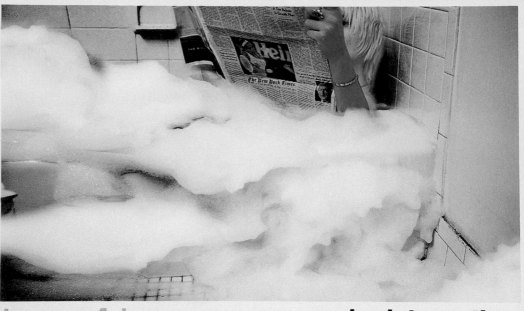

be careful. **newspapers can be interesting**

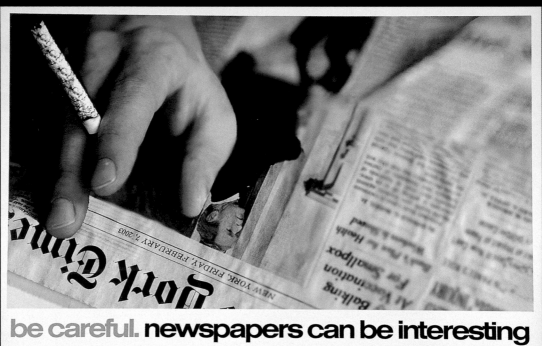

be careful. **newspapers can be interesting**

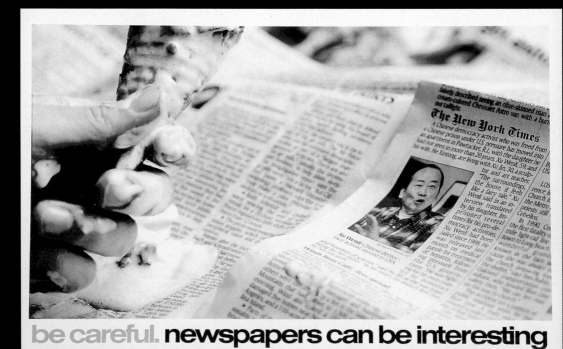

be careful. **newspapers can be interesting**

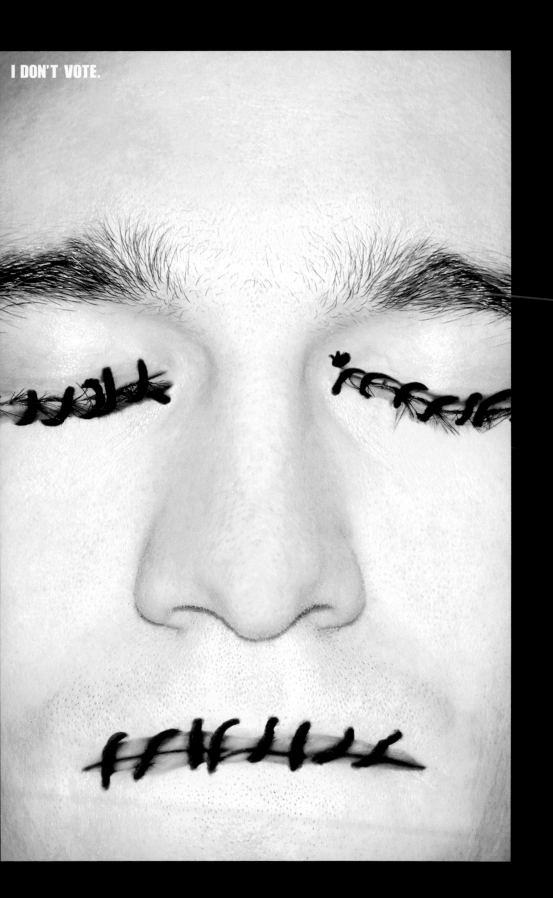

I DON'T VOTE.

Director: Timur Yevtuhov Photographer: Timur Yevtuhov Copywriter: Timur Yevtuhov School: School of Visual Arts Department: Advertising and Graphic Design Department Chair: Richard Wilde Instructor: A. Leban

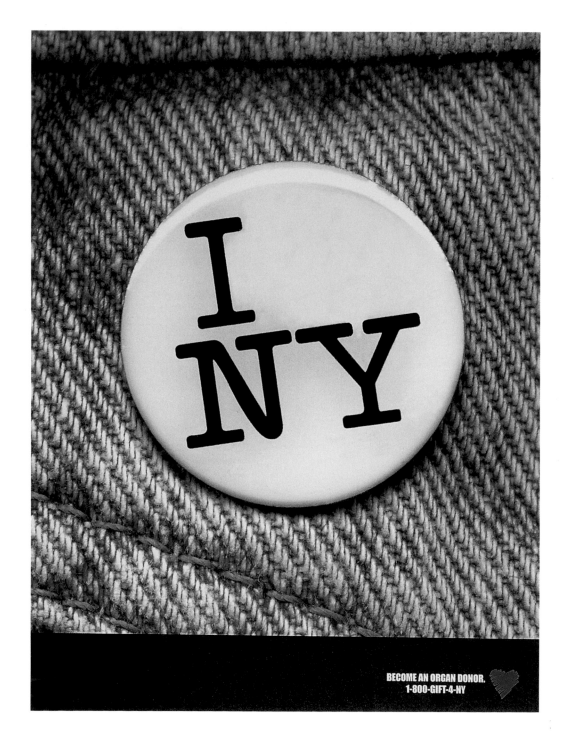

BECOME AN ORGAN DONOR.
1-800-GIFT-4-NY

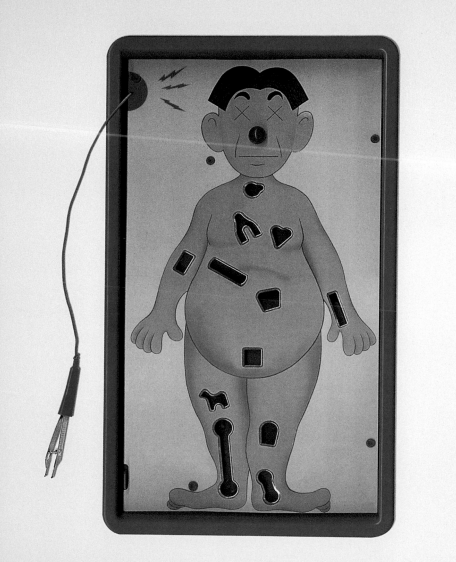

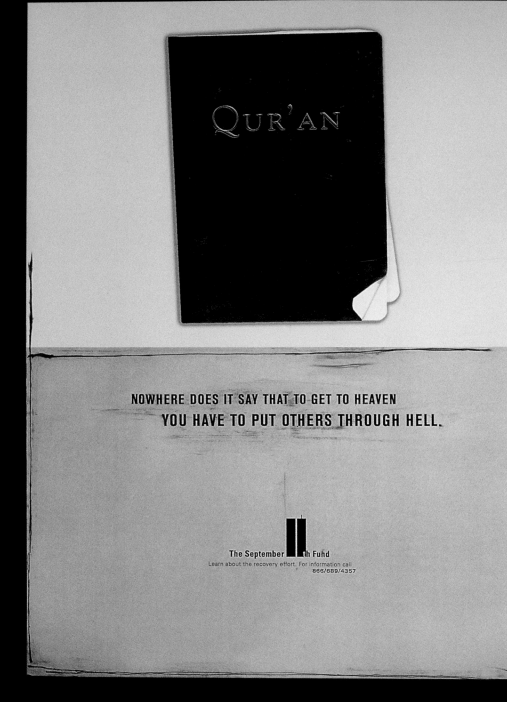

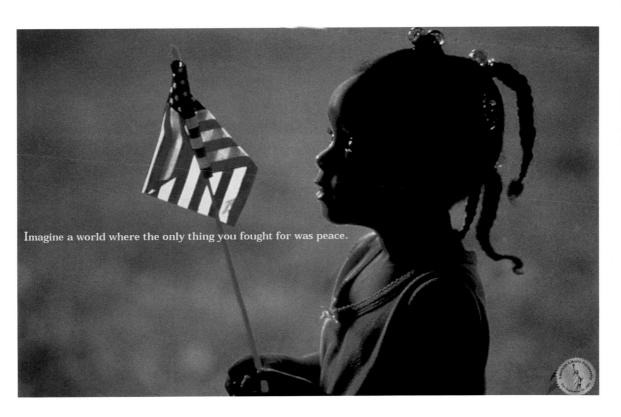

Imagine a world where the only thing you fought for was peace.

Art Director: Marie Zito Copywriter: Marie Zito School: School of Visual Arts Department: Advertising and Graphic Design Department Chair: Richard Wilde Instructor: Jack Mariucci Advertising 56,57

Toy Department. Coming Soon.

SAKS
FIFTH
AVENUE

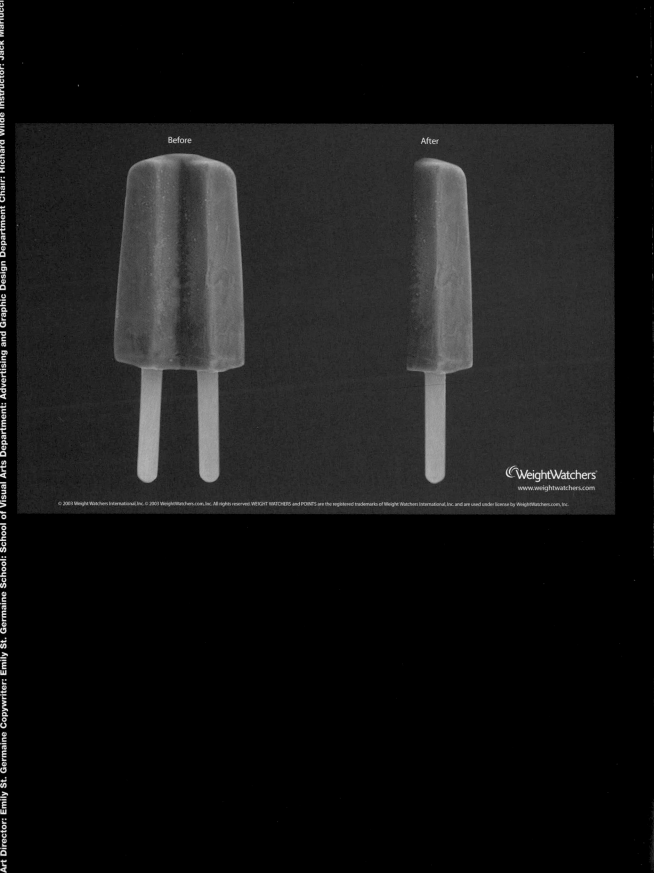

Before

After

WeightWatchers®
www.weightwatchers.com

Art Director: Emily St. Germaine Copywriter: Emily St. Germaine School: School of Visual Arts Department: Advertising and Graphic Design Department Chair: Richard Wilde Instructor: Jack Mariucci

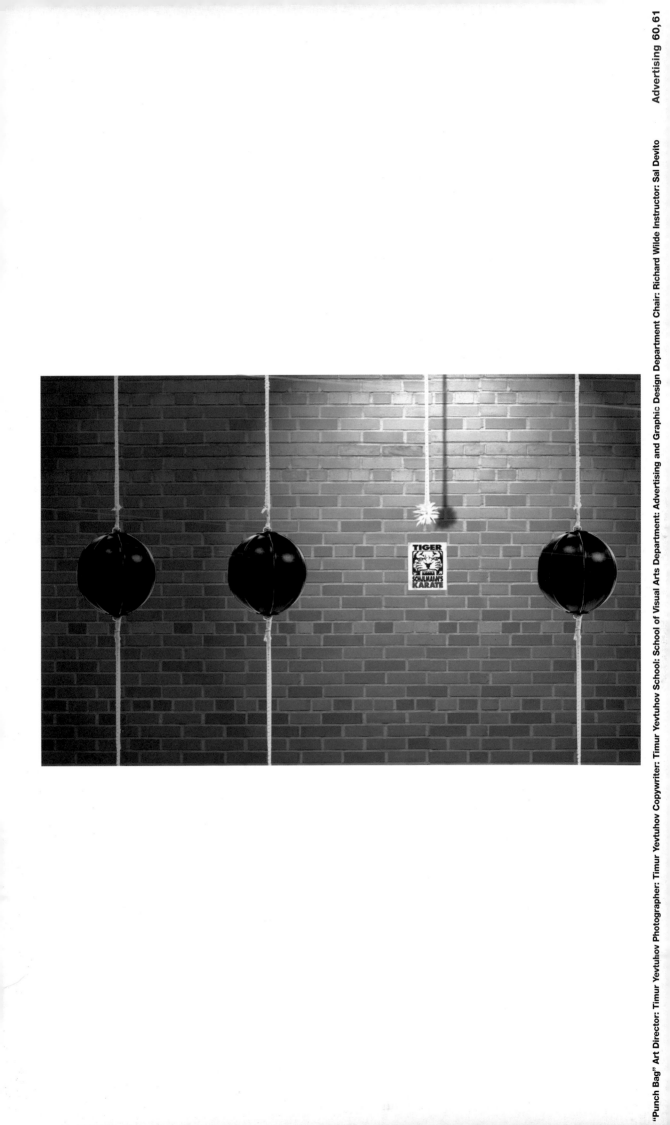

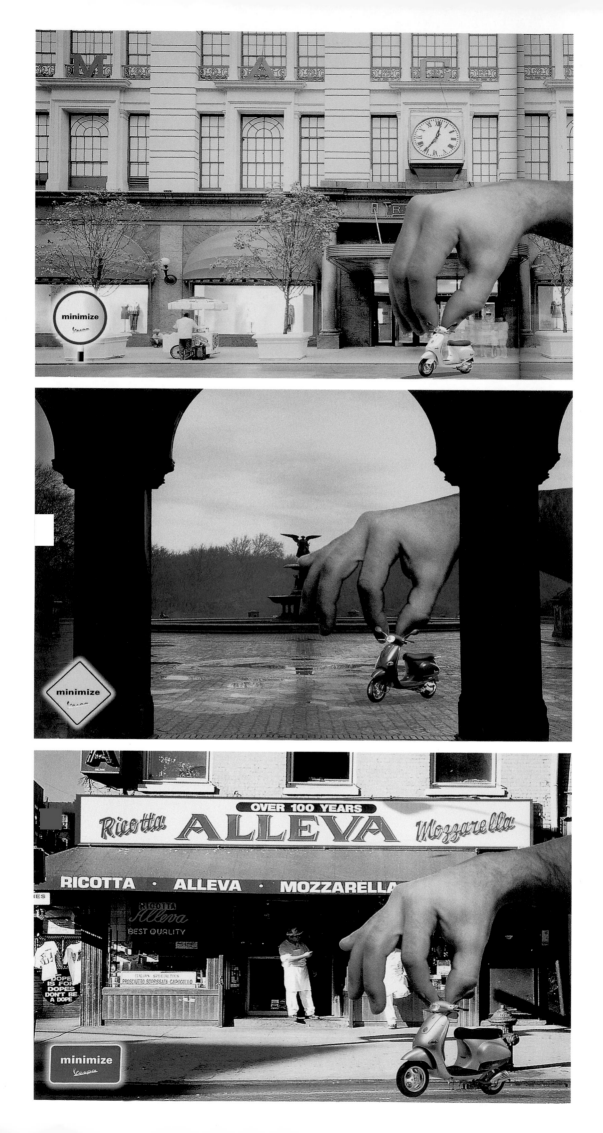

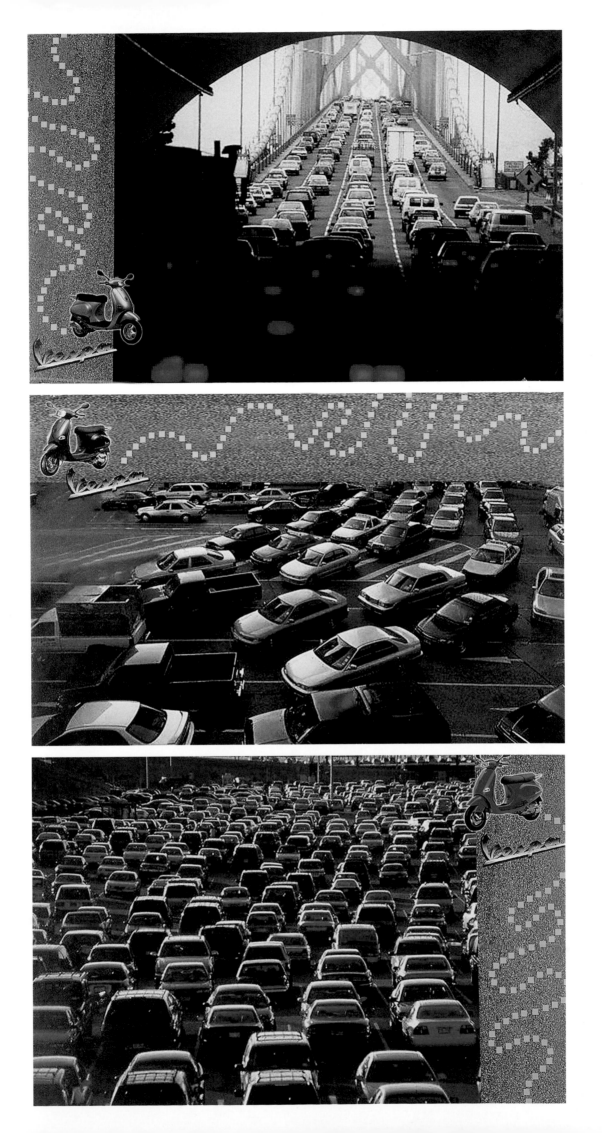

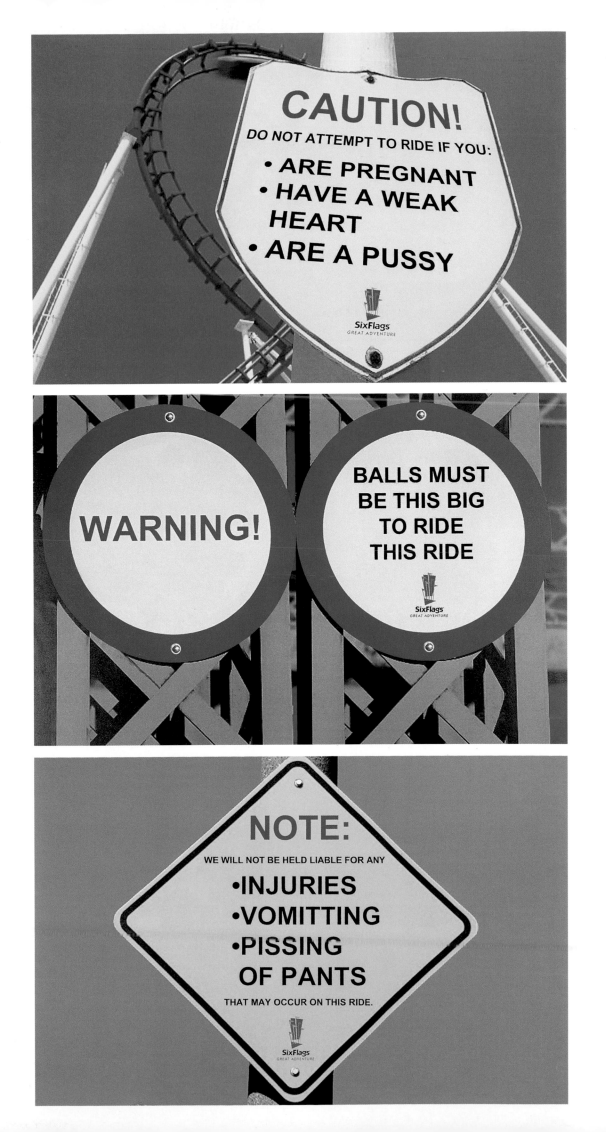

Art Director: Emily Inn Copywriter: Emily Inn School: School of Visual Arts Department: Advertising and Graphic Design Department Chair: Richard Wilde Instructor: Jeffrey Metzner Advertising 64, 65

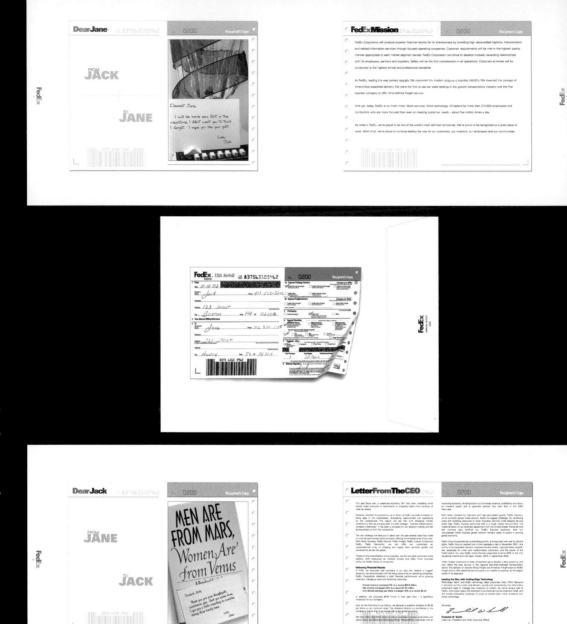

FROM **JACK**

TO **JANE**

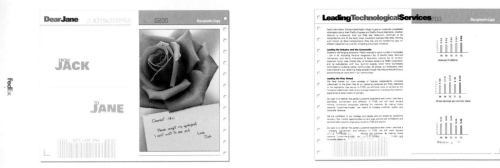

Leading the Industry and the Community

Leading the Way Ahead

FROM **JANE**

TO **JACK**

Board of Directors

Stock Listing

Stockholders

Market Information

Dividend

Corporate Headquarters

Annual Meeting

General and Media Inquiries

Shareholder Account Inquiries

Direct Stock Purchase and Dividend Reinvestment Inquiries

Financial Information, Including Form 10-K

Investment Community Inquiries

Auditors

Equal Employment Opportunity

Service Marks

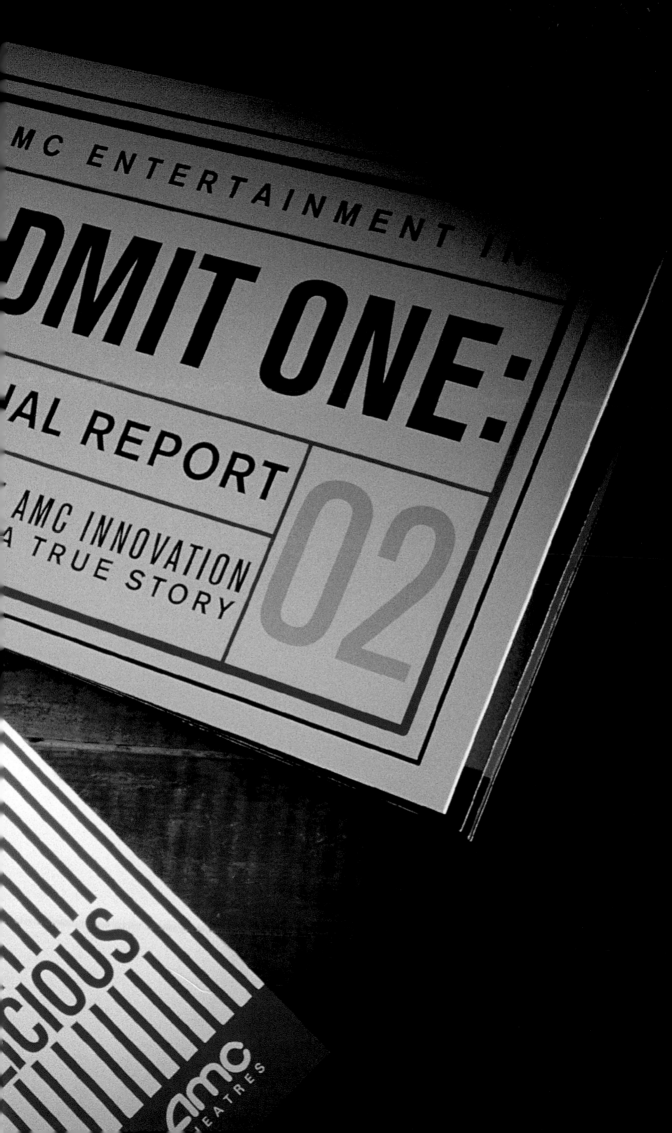

MC ENTERTAINMENT IN

DMIT ONE:

AL REPORT

AMC INNOVATION
A TRUE STORY

02

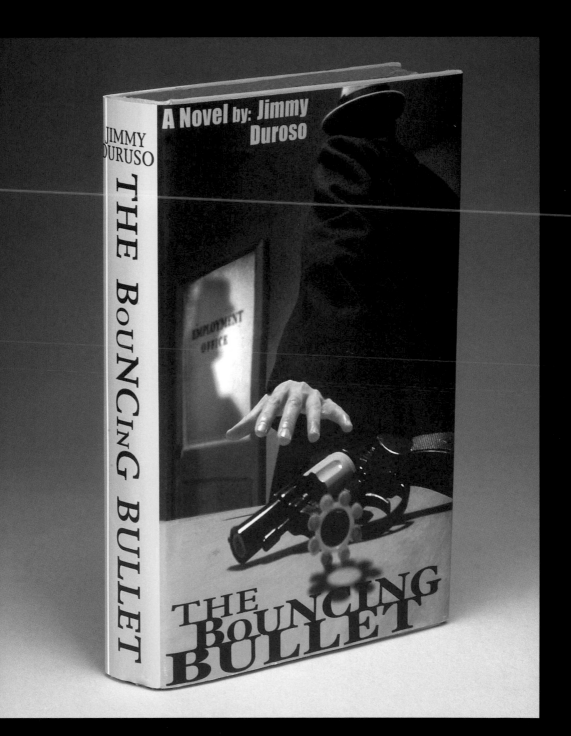

(this spread) Art Director: Leslie W. Myers

· AVERAGE BODY STATISTICS ·

· AVERAGE DAY ·

03.22

· THE AVERAGE PERSON ·

| CATEGORY: *Diet* | SUBJECT: *Meat Consumption* |

FACT: THE AVERAGE AMERICAN WILL EAT IN A LIFETIME:
21 COWS, 14 SHEEP, AND 12 PIGS.

21 cows

14 sheep

12 pigs

· THE AVERAGE PERSON ·

The
AVERAGE FIELD GUIDE
For easy identification of the average American

CARS PURCHASED

RELIGION

WAKES

BATHROOM

FLYING

COFFEE

WEIGHT

PRESCRIPTIONS

POULTRY

BEER

SHORT LIFE EXPECTANCE

BRAIN

POLITICS

VISION

SALT

MUSIC

SMOKING

PETS

TELEPHONE

READS

FEARS

SEX

HOME VALUE

WEDDING

CHEESE

DOMINANT HAND

CHILDREN

GARBAGE

TOILET PAPER

PORK

TEETH

LUGGAGE

Printed in U.S.A.

© 2004 Leslie W. Myer

THE BATTLE OF HAMBURG

On the 24th of July 1943 Air Chief Marshal Sir
Arthur Harris ordered that the maximum strength
of bombers in RAF Bomber Command should
attack the German city of Hamburg. There began
a series of raids by both RAf and the USAAF
that was in reality a battle - a bloody contest
between the bomber forces and a German City

What happened in Hamburg was an extreme
example of Allied success against the Germans,
the result they hoped for every time they
attacked a German city. Hamburg was destroyed
in the most terrible firestorms.

As with his other books, Martin Middlebrook
brings to life what happened during the Battle of
Hamburg through the perdsal reminiscences of
the ordinary people involved: survivors from the
bomber crews, the Luftwaffe's fighter pilots, the
ground defences, the city authorities and above
all the civilians of Hamburg who underwent
such a terrible ordeal

The result is a meticulous and compelling
account of one of the most devastating battles of
the Second World War, which continues to fuel
the fires of controversy and debate.

GOOD MORNING MR. ZIP ZIP ZIP

Movies,
Memory and WWII

Richard Schickel

Richard Schickel

GOOD MORNING MR. ZIP ZIP ZIP

movies, memory and world war II

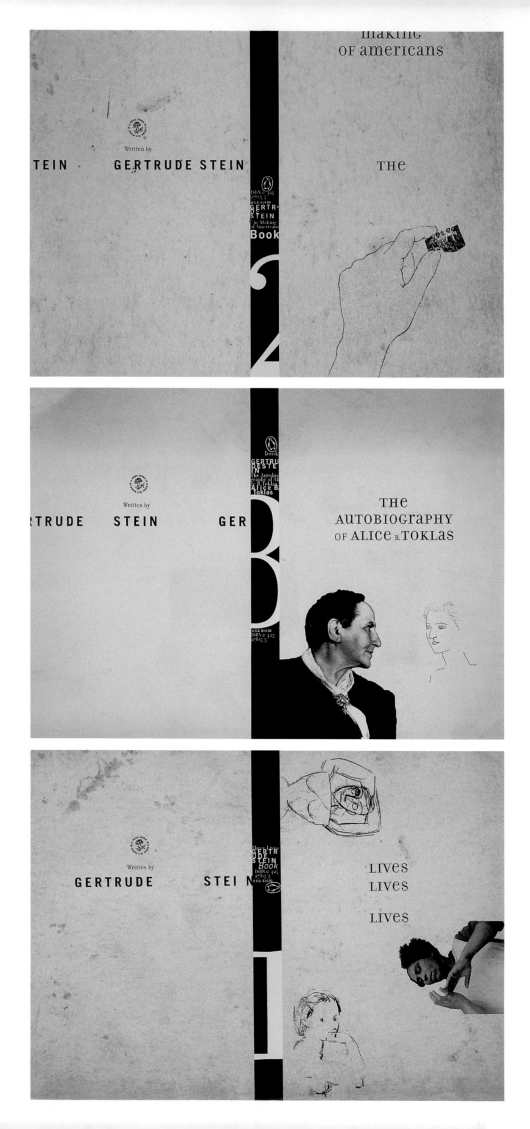

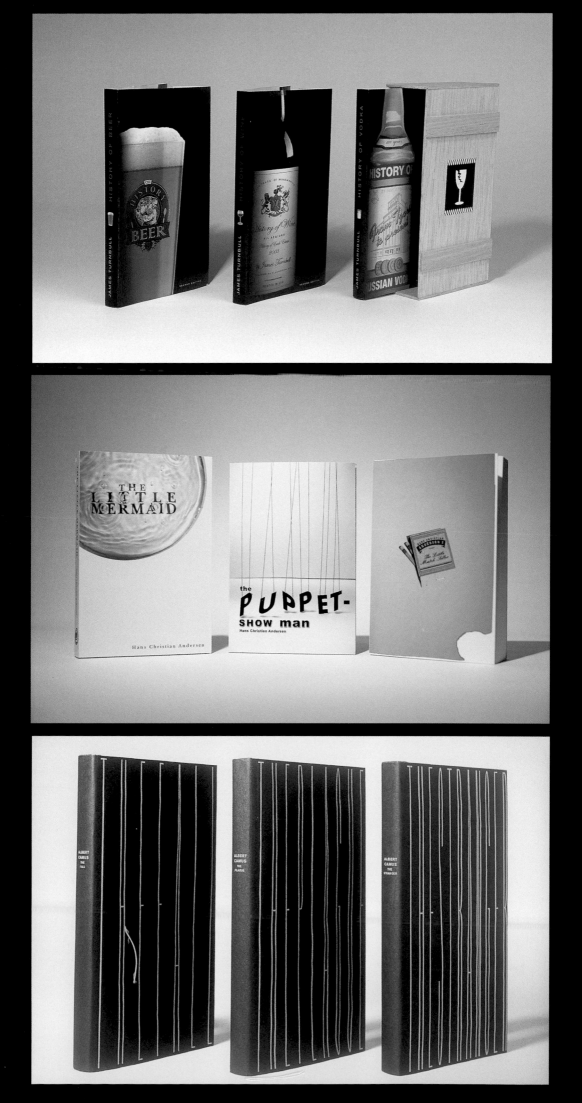

Billy was five years old. He could do most things all by himself without mom's help, even match his socks. But most of all, he always had wacky ideas.

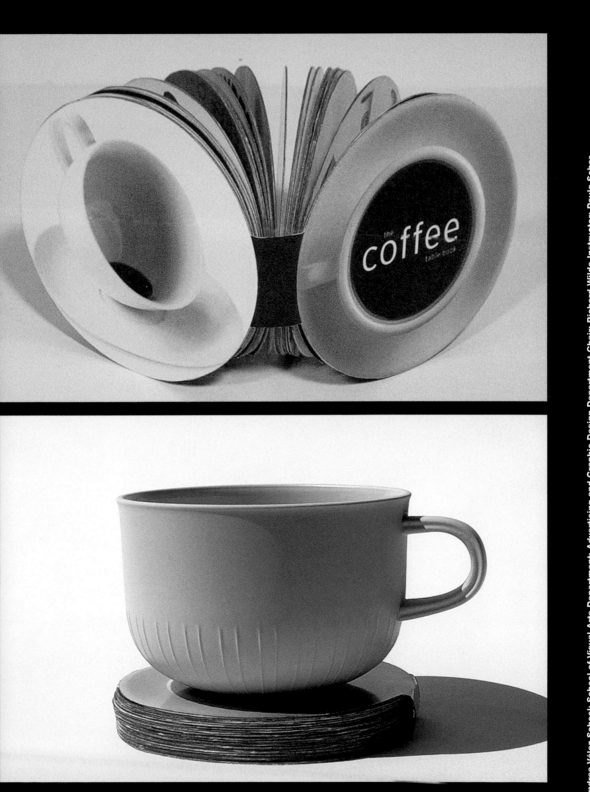

"Coffee Tablebook" Art Director: Andrea Vélez School: School of Visual Arts Department: Advertising and Graphic Design Department Chair: Richard Wilde Instructor: Paula Scher

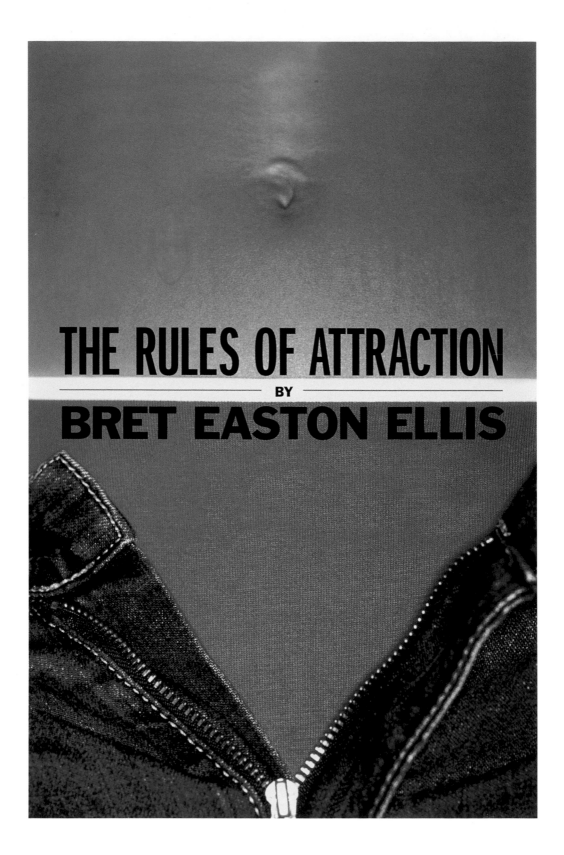

THE RULES OF ATTRACTION
BY
BRET EASTON ELLIS

(this spread) Art Director: Patrick Cahalan School: School of Visual Arts Department: Advertising and Graphic Design Department Chair: Richard Wilde Instructor: Chris Austopchuk

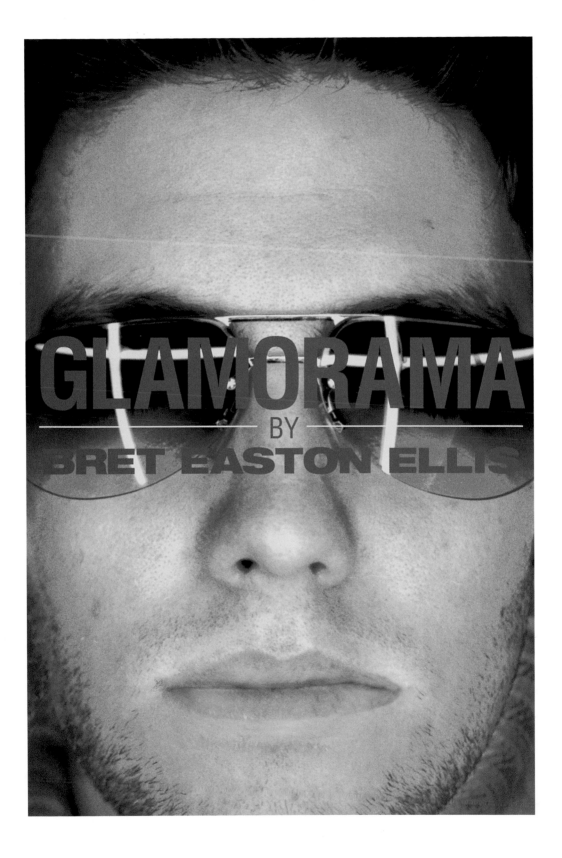

GLAMORAMA

BY

BRET EASTON ELLIS

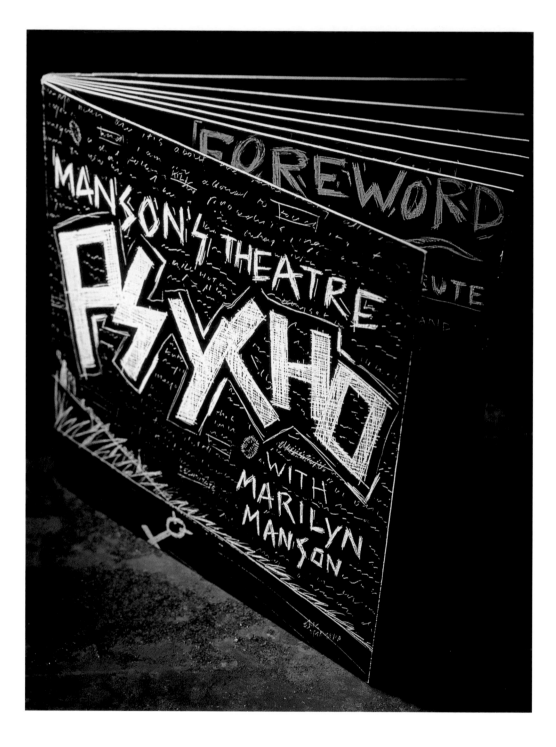

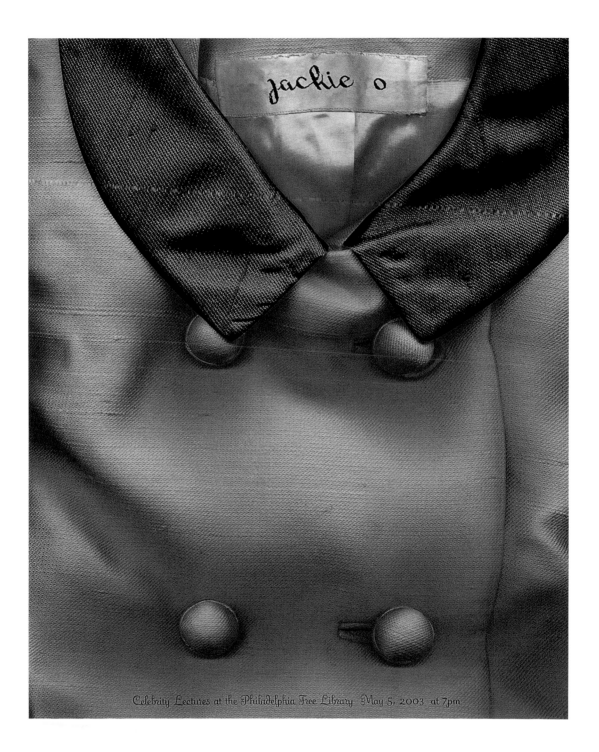

jackie o

Celebrity Lectures at the Philadelphia Free Library · May 5, 2003 · at 7pm

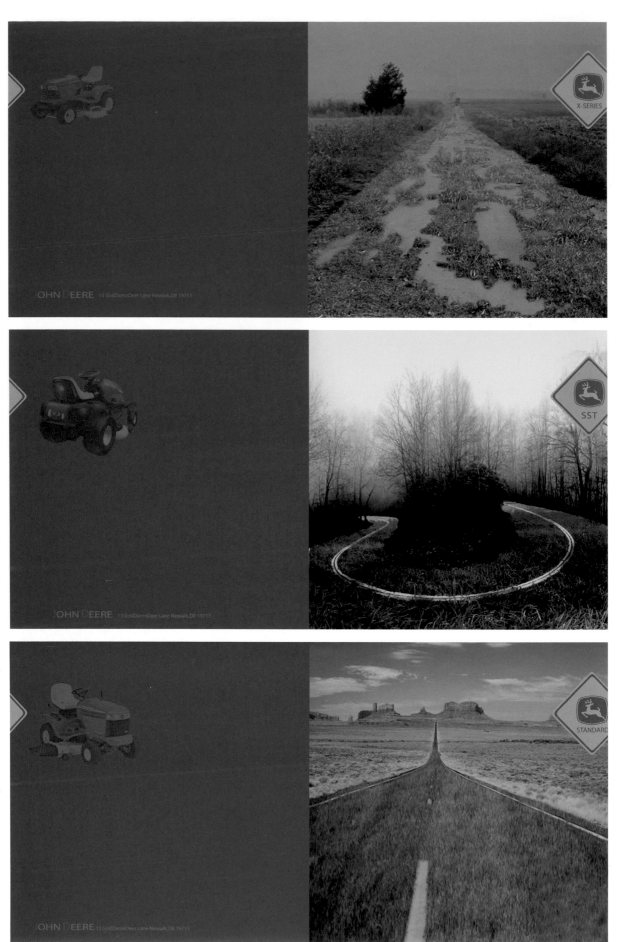

(this spread) "Grassy Roads of Wonder" Art Director: Bryan Louie School: University of Delaware Instructor: Kelly Holohan Instructor: Hendrik-Jon Francke

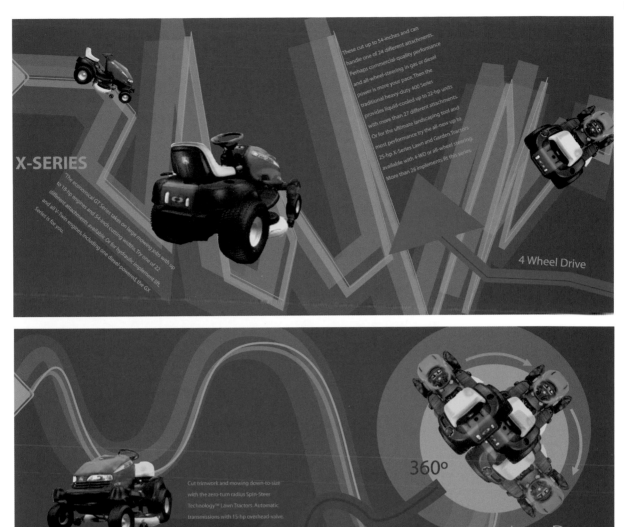

X-SERIES

The economical GT Series takes on large mowing jobs with up to 18-hp engines and 54-inch cutting widths. Try one of 22 different attachments available. Or for hydraulic implement lift and all V-Twin engines, including one diesel-powered the GX Series is for you.

These cut up to 54-inches and can handle one of 24 different attachments. Perhaps commercial-quality performance and all-wheel-steering in gas or diesel power is more your pace. Then the traditional heavy-duty 400 Series provides liquid-cooled up to 22-hp units with more than 27 different attachments. Or for the ultimate landscaping tool and most performance try the all-new up to 25-hp X-Series Lawn and Garden Tractors available with 4-WD or all-wheel steering. More than 28 implements fit this series.

4 Wheel Drive

Cut trimwork and mowing down-to-size with the zero-turn radius Spin-Steer Technology™ Lawn Tractors. Automatic transmissions with 15-hp overhead-valve.

360°

SST The moment the operator's foot touches the reverse pedal, a vacuum-actuated system senses the direction and switches the motion of the steering rods.

JOHN DEERE
spin steer technology

"The solution was a differential steering transmission that incorporates a propel transmission and a steering transmission in the same case."

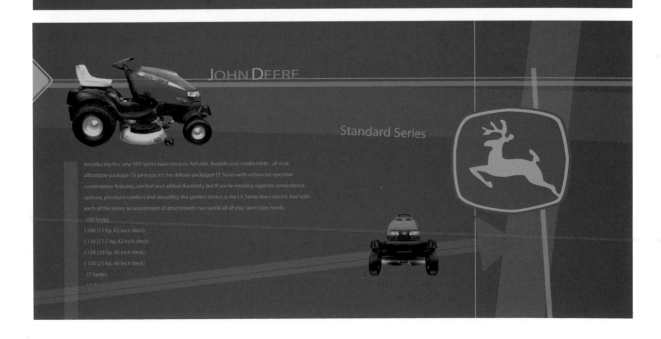

JOHN DEERE

Standard Series

Introducing the new 100 Series lawn tractors: Reliable, durable and comfortable - all in an affordable package. Or perhaps it's the deluxe-packaged LT Series with enhanced operator convenience features, comfort and added durability. But if you're needing superior convenience options, premium comfort and versatility, the perfect choice is the LX Series lawn tractor. And with each of the series, an assortment of attachments can tackle all of your lawn care needs.

100 Series

L100 (17-hp, 42-inch deck)

L110 (17.5 hp, 42-inch deck)

L120 (20 hp, 48-inch deck)

L130 (23 hp, 48-inch deck)

LT Series

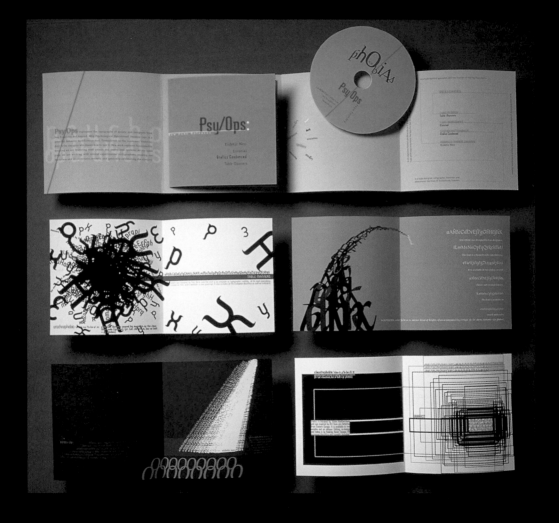

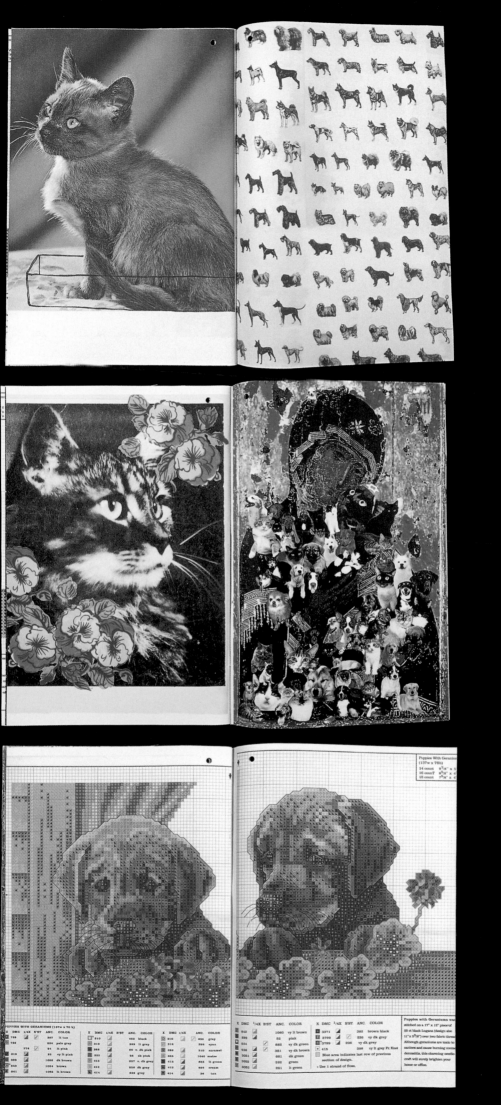

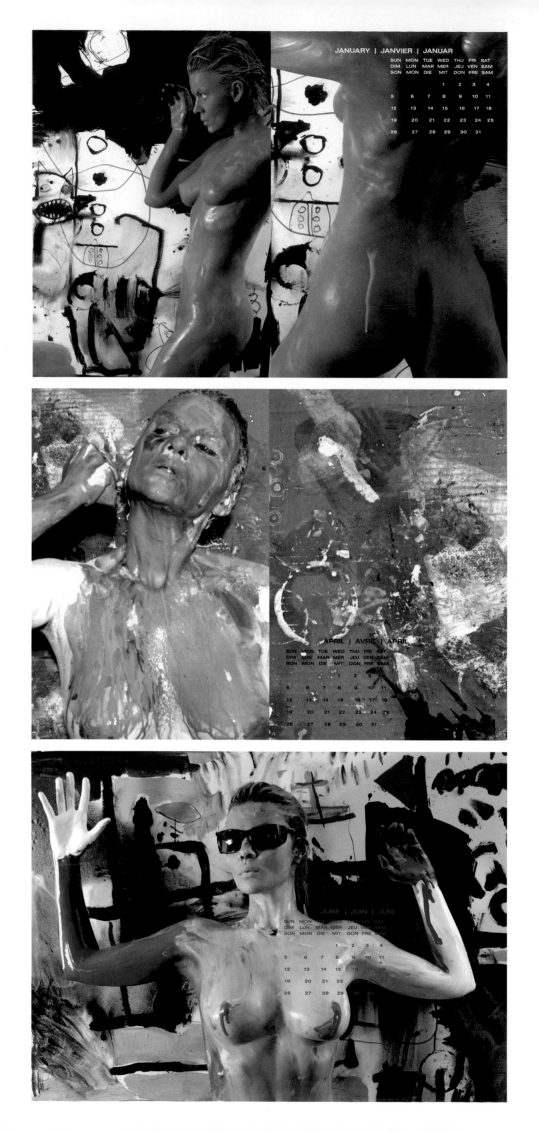

(this spread) Art Director: Nina Vesela Photographer: Nina Vesela Illustrator: Nina Vesela School: School of Visual Arts Instructor: A. Leban

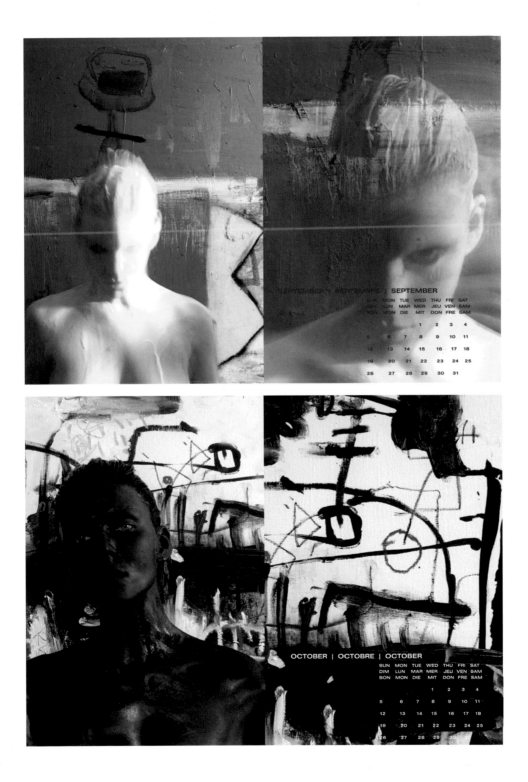

Chrysler Deutschland GmbH
Potsdamer Straße 7, HPC V790
10785 Berlin

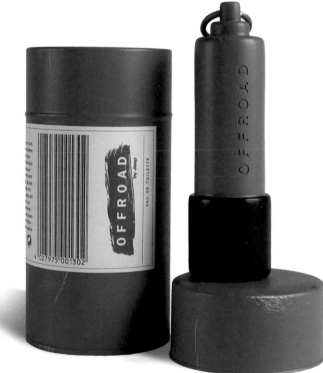
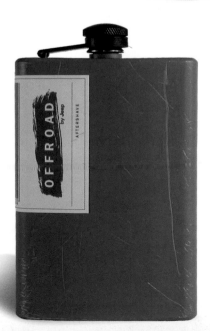

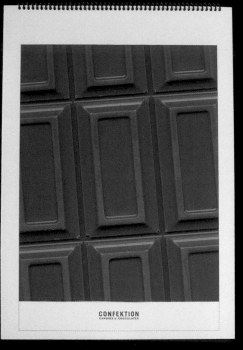

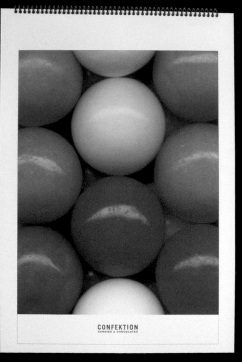

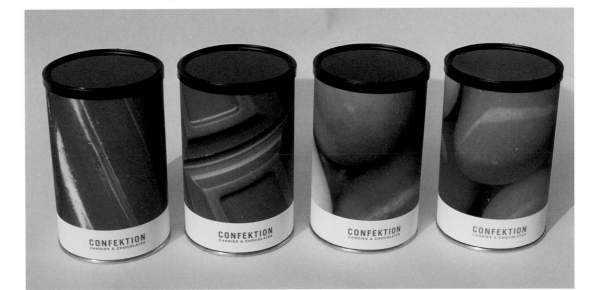

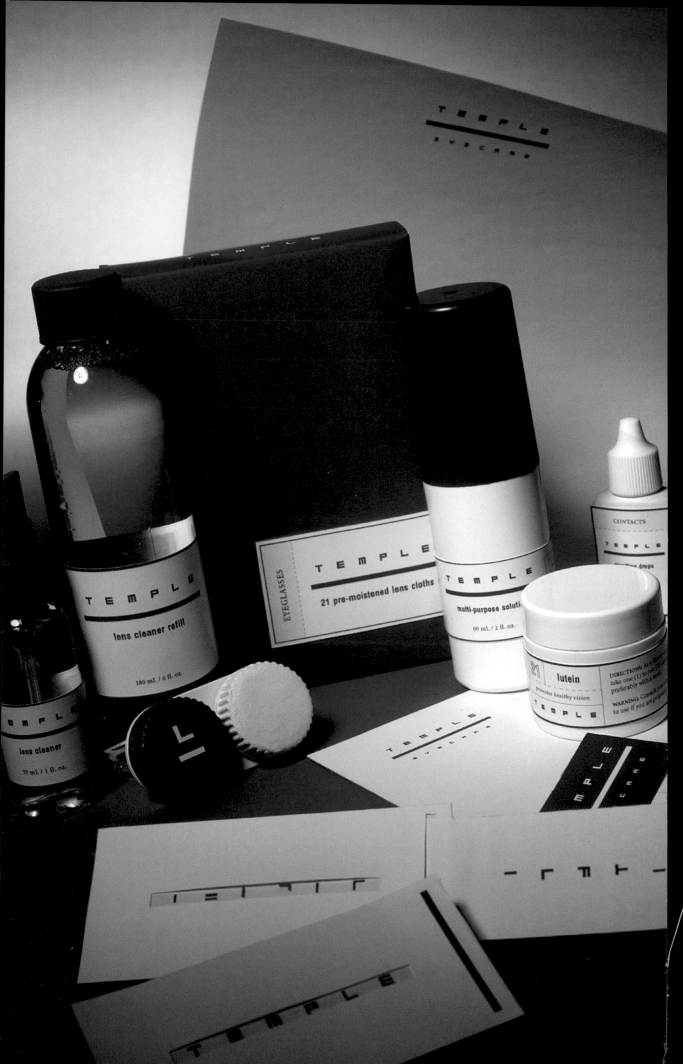

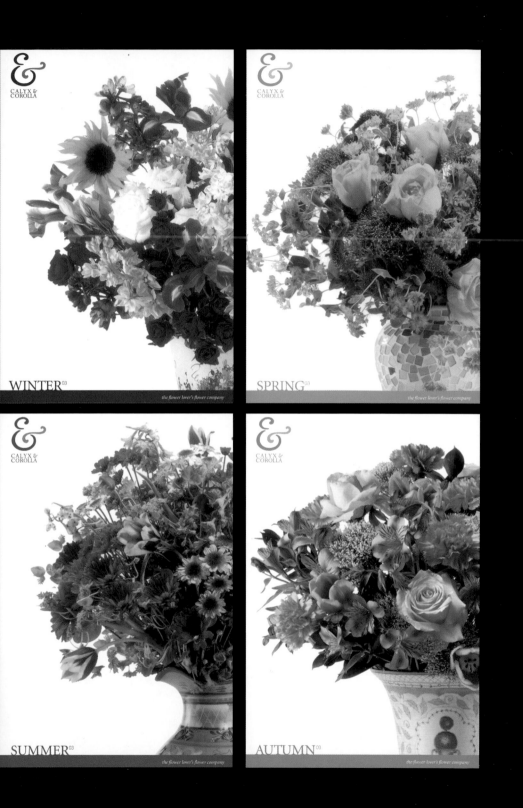

WINTER 03

the flower lover's flower company

SPRING 03

the flower lover's flower company

SUMMER 03

the flower lover's flower company

AUTUMN 03

the flower lover's flower company

(left page) "Temple" Art Director: Michael Moreau School: Portfolio Center Department Chair: Hank Richardson (this page) "The Essence of Calyx and Corolla" Art Director: Dorothy Lin School: Pratt Institute Instructor: Graham Hanson (next spread) "Baboo the Circle Store" Art Director: Karin Folman Photographer: Karin Folman Copywriter: Karin Folman School: School of Visual Arts Department: Advertising and Graphic Design Department Chair: Richard Wilde Instructor: Paula Scher

Corporate Identity 94.95

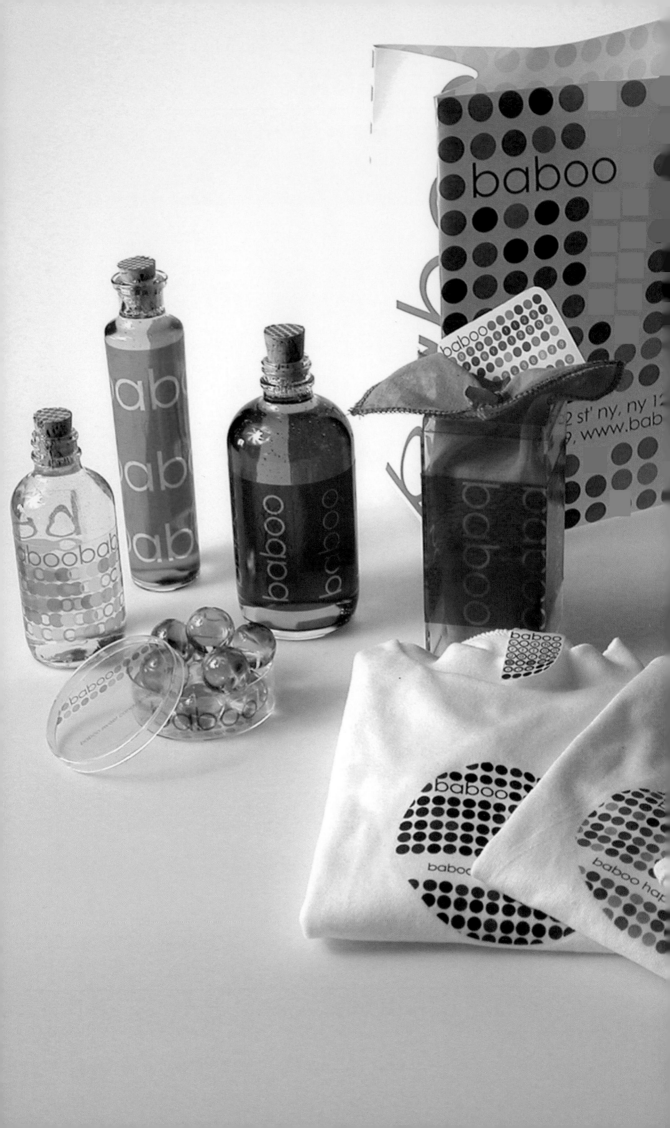

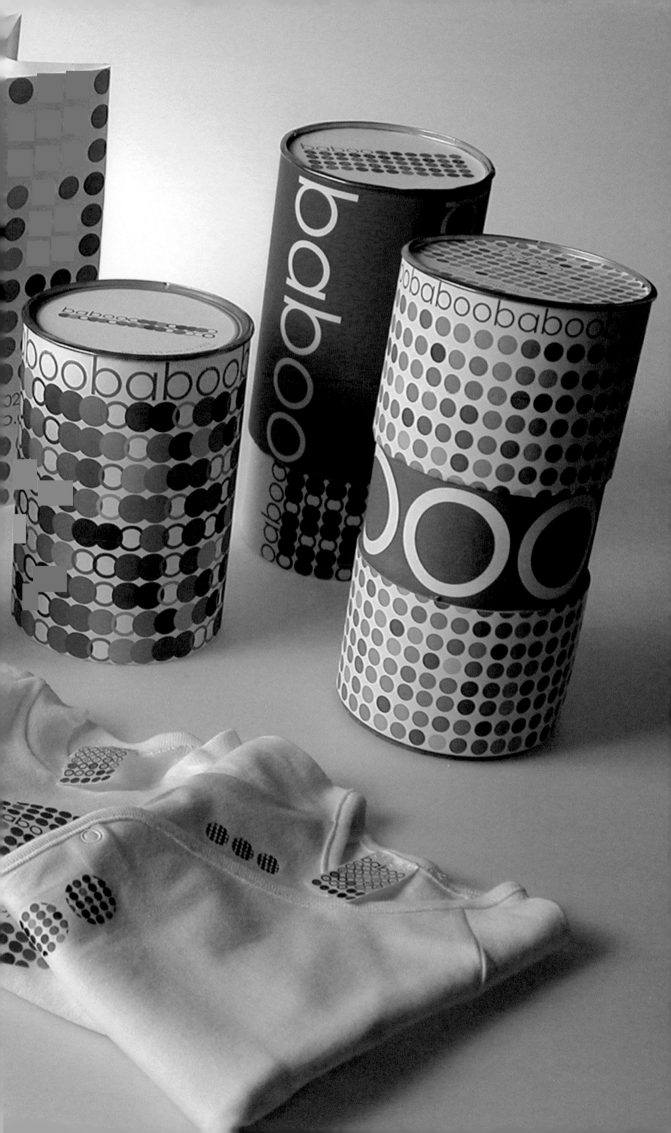

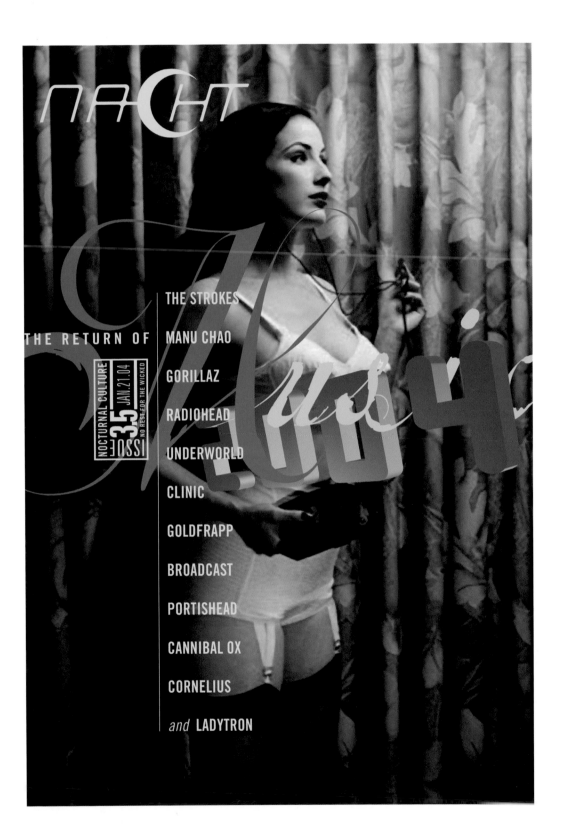

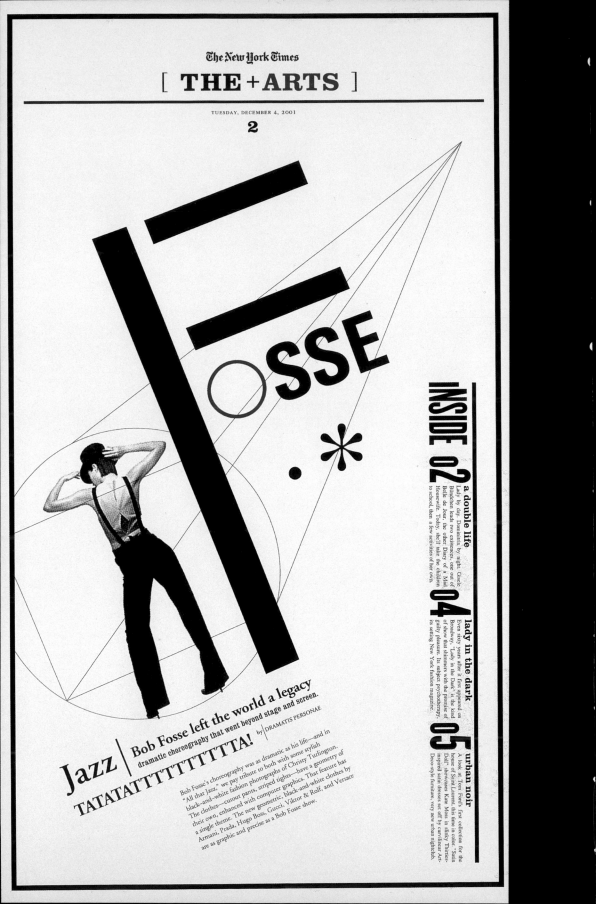

F OSSE

. *

Jazz | Bob Fosse left the world a legacy
dramatic choreography that went beyond stage and screen.

TATATATTTTTTTTTA! by | DRAMATIS PERSONAE

Bob Fosse's choreography was as dramatic as his life—and in "All that Jazz," we pay tribute to both with some stylish black-and-white fashion photographs of Christy Tudington. The clothes—cutout pants, striped tights—have a geometry of their own, enhanced with computer graphics. That feature has a single theme: The new geometric, black-and-white clothes by Armani, Prada, Hugo Boss, Gucci, Viktor & Rolf, and Versace are as graphic and precise as a Bob Fosse show.

INSIDE 02

a double life

Lady by day, Dominitrix by night. Gisele Blindchen leads two existences, one out of Belle de Jour, the other Diary of a Mad Housewife. Today, she'll take the children to school, then a few activities of her own.

04

lady in the dark

Even sixty years after it first appeared on Broadway, "Lady in the Dark" is the kind of show that shimmers with the promise of guilty pleasure. Its subject psychotherapy, is setting New York fashion magazine.

05

urban noir

A look at Tom Ford's first collection for the house of Saint Laurent, this time in color. "Satin Doll" showcases Kate Moss in slinky Thirties-inspired satin dresses set off by curvilinear Art-Deco-style furniture, very new urban nightclub.

Rushing Around Boston

When Friends Divorce

gauge.

know better

2

BALLAD of TOM JONES

TO THE DOGS

TSTORIES

ETYMOLOGY

ODE TO NJ

EIGHT Qs with Alan Hankin

THREE DAVES
Eggers·Sedaris
Foster Wallace

&fiCtiON&P oETRY&pHO TOGRaPhY&

Secret Societies

Secrecy Necessary to Evolution

WHAT I LEARNED BY ROB TODD

Director: André Mora Editor-in-Chief: Lien Ai Ta Editorial Advisor: Jeffrey L. Seglin School: Emerson College Department: Writing, Literature and Publishing Instructor: Lisa Diercks 100, 101

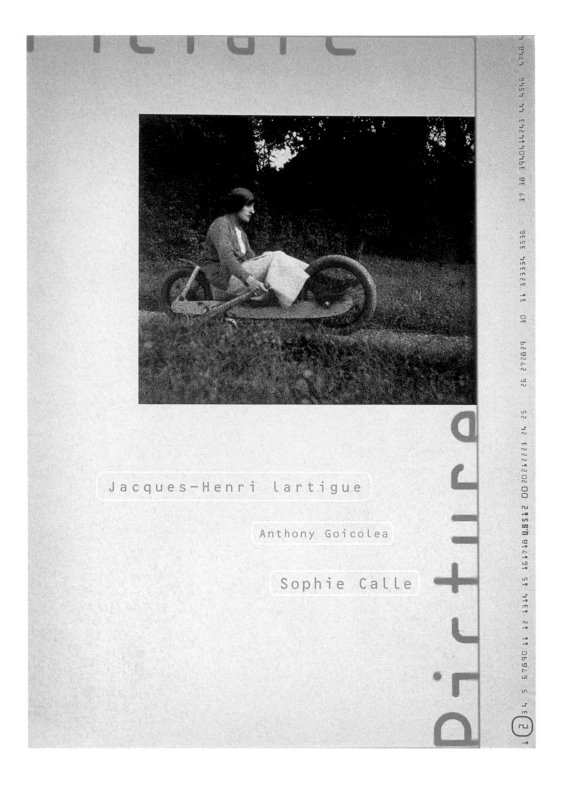

Jacques-Henri Lartigue

Anthony Goicolea

Sophie Calle

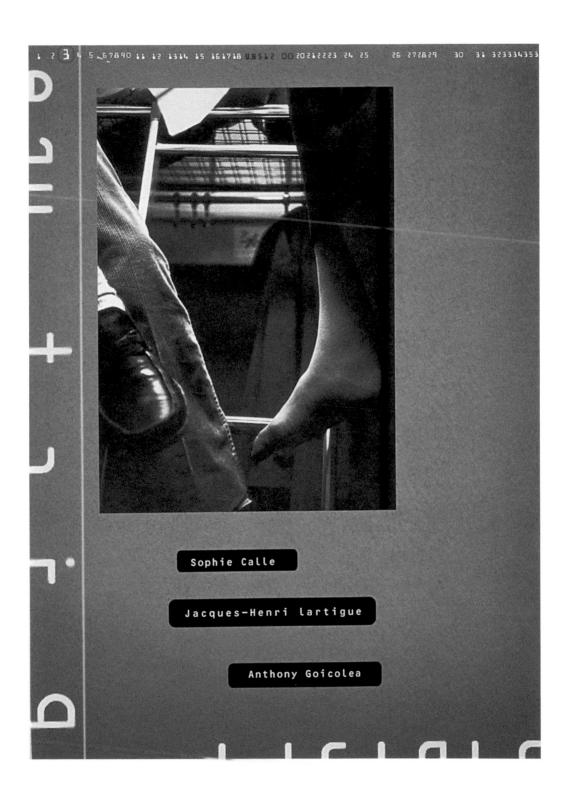

Sophie Calle

Jacques-Henri Lartigue

Anthony Goicolea

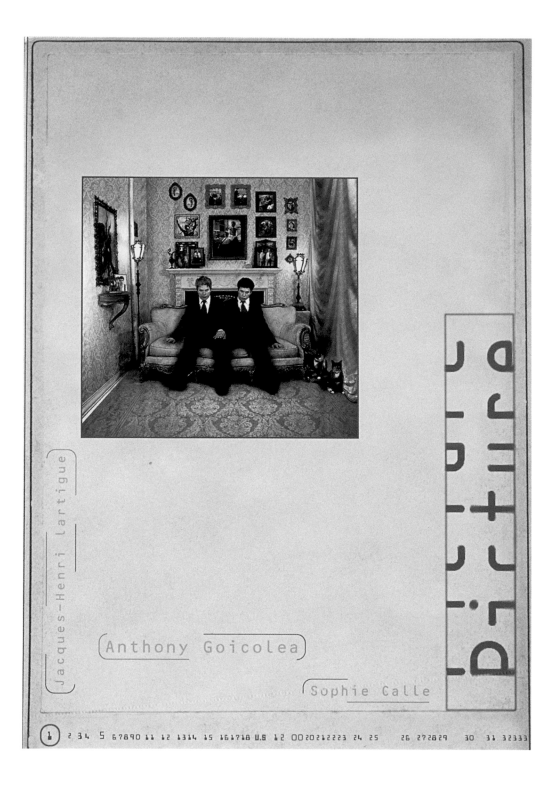

Jacques-Henri Lartigue

Anthony Goicolea

Sophie Calle

Picture Picture

1 2 34 5 67890 11 12 1314 15 161718 U.8 12 0020212223 24 25 26 272829 30 31 32333

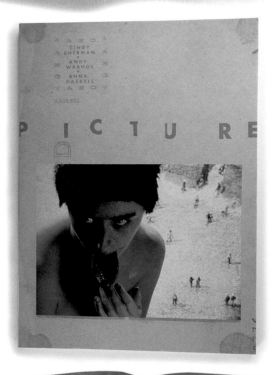

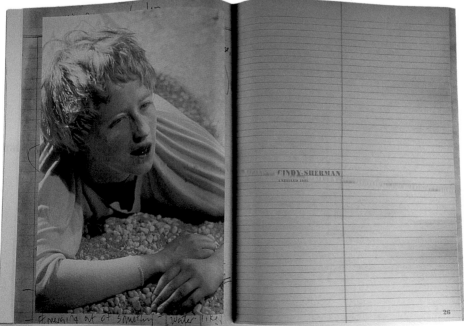

	PREVIOUS PAGE	
[26]	DROSOPHILA STOCK	19.94
	OPPOSITE PAGE	
	DROSOPHILA MORGUE	1.995
	PREVIOUS PAGE	
	DROSOPHILA STOCK	199.4
	OPPOSITE PAGE	
	DROSOPHILA MORGUE	1.995
	PREVIOUS PAGE	
	DROSOPHILA STOCK	19.94
	OPPOSITE PAGE	
	DROSOPHILA MORGUE	19.95
	PREVIOUS PAGE	
	DROSOPHILA STOCK	199.4
	OPPOSITE PAGE	
	DROSOPHILA MORGUE	1.995
	PREVIOUS PAGE	
	DROSOPHILA STOCK	199.4
	OPPOSITE PAGE	
	DROSOPHILA MORGUE	199.5
	PREVIOUS PAGE	
	DROSOPHILA STOCK	19.94
	OPPOSITE PAGE	
	DROSOPHILA MORGUE	1.995
	PREVIOUS PAGE	
	DROSOPHILA STOCK	19.94
	OPPOSITE PAGE	
	DROSOPHILA MORGUE	1.995

GLUCOSE	NEGATIVE	RN
KETONES	NEGATIVE	RN
BILIRUBIN	NEGATIVE	RN
NITRITE	NORMAL	0-1.9
WBC/HPF	3-5	0-5
RBC/HPF	NONE	0-3
CASTS/LPF	NONE	0-10

PREVIOUS PAGE		
ALGAE MOUNT		19.94
OPPOSITE PAGE		
SEX LINKAGE		1.995

Test results were obtained by Abbott MEIA
methodology. Values obtained with different
assay methologies should notbe used inter-
changeably in serial PSA testing.

REPORT

22-3. *Untitled* # 222. 1990

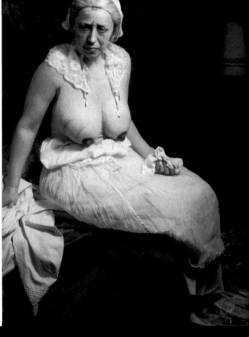

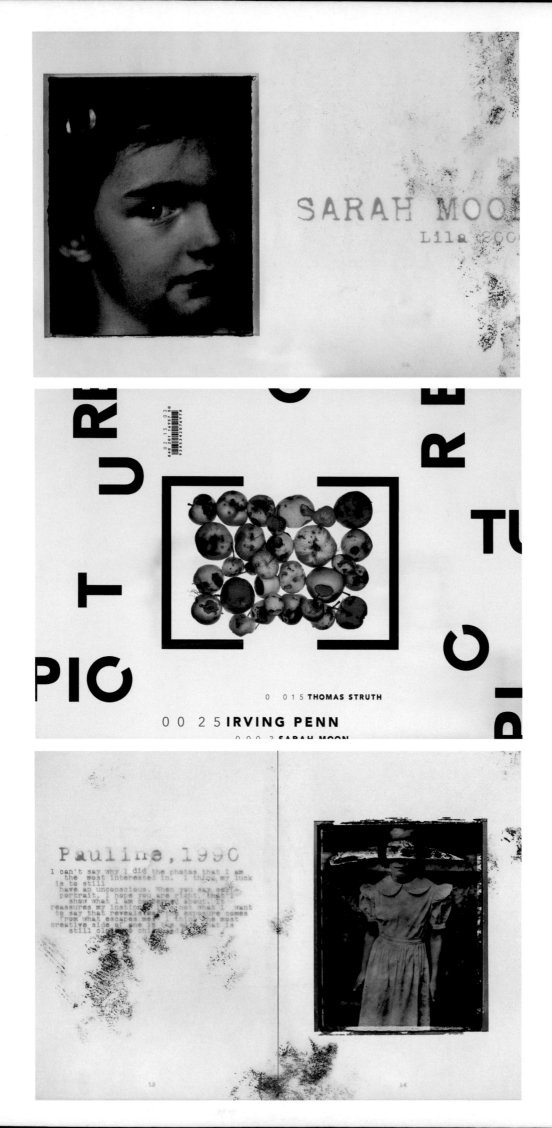

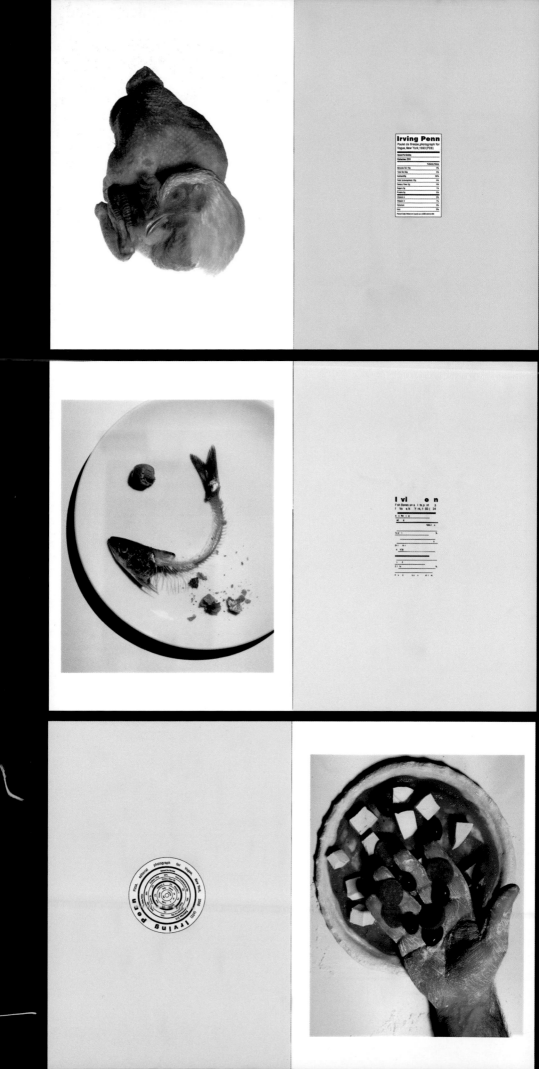

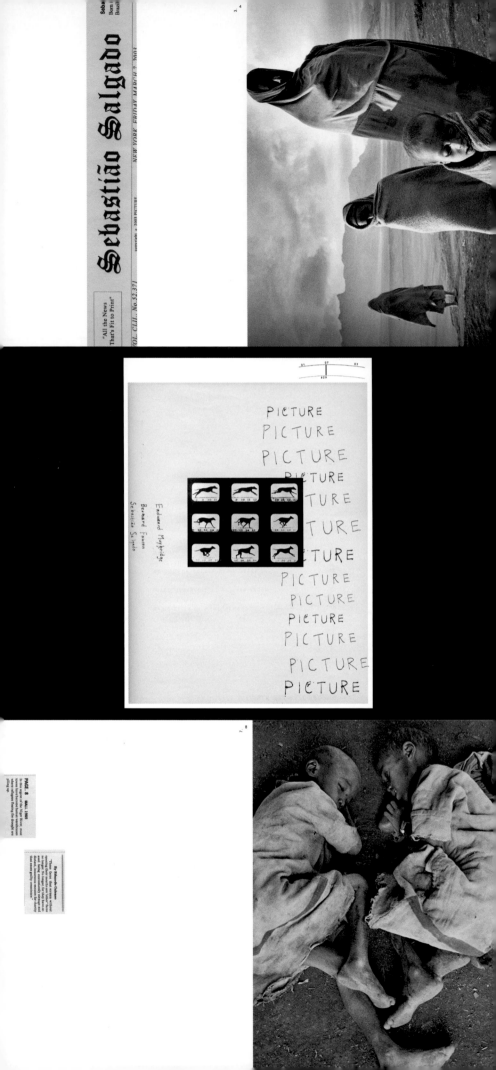

EADWEARD **MUYBRIDGE** 1830-1904 among the most important names associated with the history of early photography is that of Eadweard Muybridge. His photographs of the 1870's and 1880's changed the way in which people understood animal and human movement. The sequences of images in the huge volume entitled Animal Locomotion (1884-7) depicting men women children animals and birds in a variety of attitudes made a great impact on artists and scientists alike. For the first time the artist could see how to depict a horse for example at a particular stage in its movement whether trotting gallopng or cantering and could also take advantage of Muybridge's foreshortened views. the scientist interested in the mechanics of equine motion or the poditiond of a bird's wings in progressive stages dureing its flight would have the data necessary for further research. It is not serprising that in December 1878 the eminent French scientist Etienne-Jules Marey wrote to the Editor of La Nature Gaston Tissandier who had published some of Muybridge's early motion photographs undertaken at the Palo Alto stock farm describing himself as 'lost in admiration over the instantaneous photographs of Muybridge' The magic of Muybridge's work a voyage of discovery that awakens something in all of us. When we look at a Muybridge motion photograph for the first time we can be forgiven for thinking that we have seen it somewhere before. Muybridge's photographs are so imbedded in our minds that they have become symbolic of Western culture. Muybridge came to photography This single plate from a multiple print from the Animal Locomotion publication has been turned into a lantern slide by Muybridge and of Muybridge's work may serve to underline the claim that his studies of females in motion were not just restricted to scientific reserch. There is a deliberately alluring quality to the subject matter. for example at a particular stage in its movement whether trotting gallopng or cantering and could also take in the mechanics of equine motion on artists and scientists alike. For the first time the artist gallopng or cantering and could also take advantage of or the poditiond of a bird's wings in progressive stages dureing gallopng or cantering and could also take advantage of Muybridge's foreshortened views. Norman Smith whether trotting gallopng or cantering stages dureing its flight would have the data necessary for further research. Wild animals and Birds and could also take advantage of wings in progressive stages dureing its flight Etienne-Jules Marey wrote to the Editor of La Nature would have the data Gaston Tissandier at a particular stage in its movement whether trotting a multiple gallopng or cantering and could also take of equine motion or the poditiond of a bird's wings in progressive stages dureing its flight would have the data the eminent French scientist Etienne-Jules Marey wrote to the Editor of La Nature the Palo Alto stock farm describing himself as There is a sence of the pioneer spirit about it; a voyage of discovery for thinking that we have seen it somewhere before. that awakens something in all of us. Muybridge's photographs are the Animal Locomotion publication that awakens the Palo Alto stock farm at a particular stage December 1878 in its movement whether trotting gallopng or cantering and could also take photographs undertaken at Following of equine motion or the poditiond of a bird's wings in progressive stages dureing its flight something in all of us. a voyage of discovery There is a sence of the eminent French scientist Etienne-Jules Marey wrote to the Editor of La Nature the pioneer spirit about it;

33 the Palo Alto stock farm describing himself.

Page.31.32 Pigeon Flying Wild animals and Birds Animals, Animal Locomotion Plate No. 755 1884-5. Muybridge's success in photographing birds had attracted the attention of scientists such as Etienne-Jules Marey as early as 1878. During the Philadelphia years Muybridge had moved from the more old-fashioned wet-plate process to the dry-gelatin process greatly enhancing the amount of detail in the final print.

34

page.21.22 a flying child 1979 page.23 a sleeper 1980

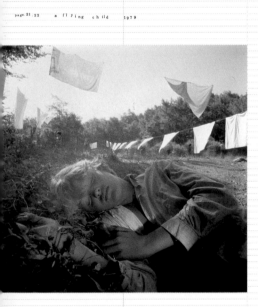

23/24

Bernard Faucon: a french Photographer who's images of boys and manniquins, boys and spaces, boys and rooms, and words written on boys have brought him fame throughout the world. He does not capture moments, but creates them, out of youth, fire, blood, patina, and of course, manniquins.

29

Page.29 Walking Males, Human Carrying a 75lb Weight on Left Shoulder 1884-5 Plate No.26 Animal Locomotion

Page.30 Child Bringing a Bouquet to a Woman 1884-5 Plate No.465 The twenty specimen plates that were specially bound and marked by Muybridge for potential subscribers comprise his own selection from the 781 plates of the published work. Muybridge was clearly touched by some of the categories, as this print shows.

30

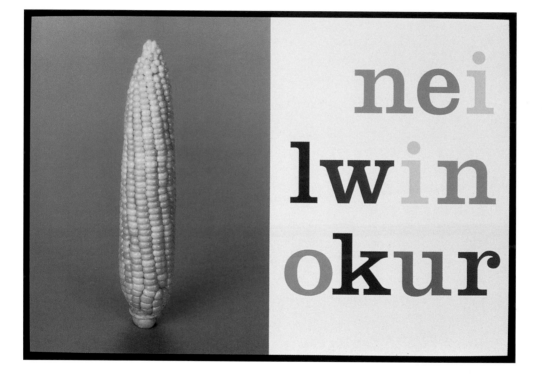

Riviera

"Pass time in one of the new properties created from former haciendas."

TRAVEL&eisure

THE MODERN SHRI LANKA · A NEW MEXICO CITY · THE RIVER MAYA

Into the Yucatán

Though I had seen hundreds of photos of Chichén Itzá, I was still overwhelmed when I encountered the spectacular Mayan site for the first time. But I was also disappointed: the photos hadn't shown the hot sun and parking lot, the theme-park-style visitors' center, and the hordes of tourists that make Chichén Itzá the most-visited archaeological site on Mexico's Yucatán Peninsula. Alas, my experience at Tulum was similar. The complex of temples and palaces set on cliffs overlooking the Caribbean was breathtaking, but the masses of gawkers nearly ruined the ruins for me. Strapped for sightseeing time on that trip (I was in Cancún for a tourism conference), I vowed that my next visit would take me well beyond the heavily traveled Cancún corridor. Recently—titillated by reports of glamorous little hotels opening in restored Yucatecan haciendas—I plotted my return. Not only would I seek out the hidden Yucatán, but I would do it in style.

I begin my journey 200 miles west of Cancún, in Mérida, the capital of the state of Yucatán. (There are actually three separate states on the peninsula: Yucatán in the center, Campeche to the west, and Quintana Roo to the east, bordering the Caribbean.) Mérida is an easy shot: a 90-minute hop from Miami. With its low-rise colonial buildings and wrought-iron balconies, the city looks a bit like New Orleans. The resemblance is no accident, since the fiercely independent Yucatecans historically had closer ties with France than with Mexico City. The French influence touches everything from architecture to food—I find some of the best beignets this side of Paris in Mérida's bakeries.

But the city's most impressive monuments are, expectedly, Spanish. The 1549 Montejo mansion, for example, has an extraordinary sculpted façade of sword-wielding conquistadors surrounded by bursts of children's heads, now a bank, the mansion is considered one of the New World's most important works in the flamboyant 16th-century style known as Plateresque. On the other hand, Mérida's main church, the Catedral de San Ildefonso, with its eggshell-white interior of simple columns and coffered ceilings, is so austere that it could have been designed by Christopher Wren.

Mérida, I quickly discover, is a delightfully uncomplicated, safe city, with palmy plazas, secret courtyards, vibrant markets. I walk everywhere, except when I hop one of the many horse-drawn carriages—used by locals and tourists alike—to ride along the Paseo de Montejo through the city's grandest neighborhood. Shaded by tamarind and tropical oak trees and divided by a landscaped boulevard, the Paseo is an architectural sampler of Beaux-Arts palaces, mosquelike mansions, and exotic châteaux. Some of the buildings appear to be abandoned and are in various states of disrepair; others have been restored as headquarters for banks and businesses.

The highlight is the beautiful Neoclassical Palacio Cantón, now home to the Regional Museum of Anthropology, a fine place for appreciating the richness and sophistication of Mayan culture. I marvel at delicate jade figurines, whimsical pottery, and pastel frescoes—all muted blues and pale peaches—that remind me of those of Minoan Greece. I wind up my afternoon with a pleasant meal of chicken tamales, thick french fries, and cold Montejo beer, just a block from the museum on the terrace of the Hotel Montejo Palace.

While there are plenty of places to stay in Mérida—funky inns in the heart of the old town, international five-star spots out beyond the Paseo de Montejo—it's best to hole up in the countryside at one of the new properties created from former haciendas. Among the first of these Mexican country-house hotels, and perhaps the most luxurious, is Hacienda Katanchel, which lies 16 miles west of Mérida at the end of a narrow, two-mile limestone road (called a sacbé) built centuries ago by the Mayans. Most of Katanchel's 740 acres are choked by thick jungle. The hacienda had been abandoned for 35 years before Mexico City-based archaeologist Aníbal González and his botanist-archaeologist wife, Monica Hernández, bought the property in 1995.

ARCHITECTURE THAT TRANSCENDS BOUNDARIES

INTRODUCTION

the curtain house by shigeru ban tokyo, japan

architecture
enthusiast
magazine for contemporary architecture aesthetics

february 2003
issue 12
www.architecture.com

OUTDOOR HOUSE
BY IGOR GERVISA, MOSCOW 2001

(this spread) Art Director: Jessica J. Hill School: School of Visual Arts Department: Advertising and Graphic Design Department Chair: Richard Wilde Instructor: Kevin O'Calaghan

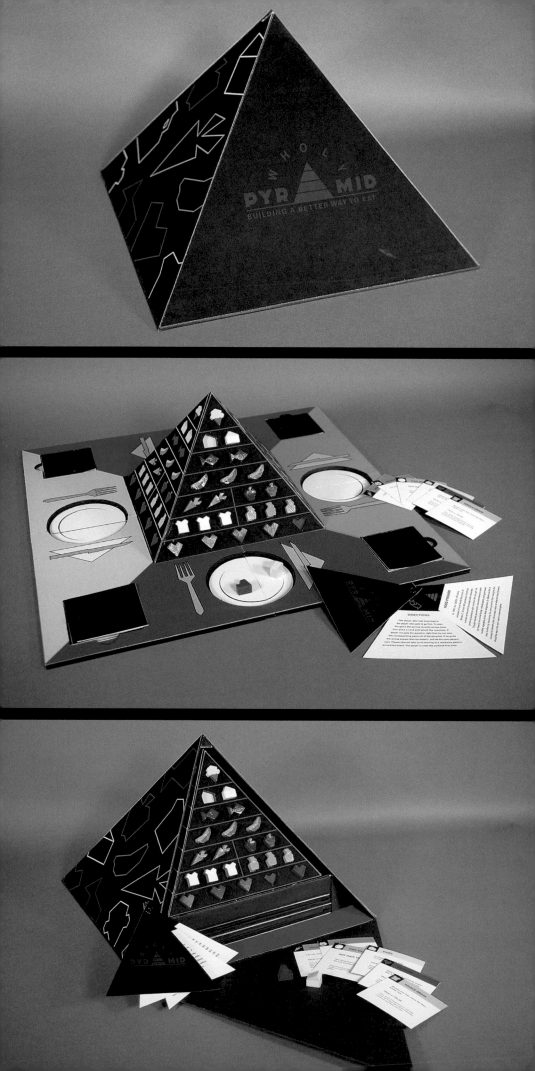

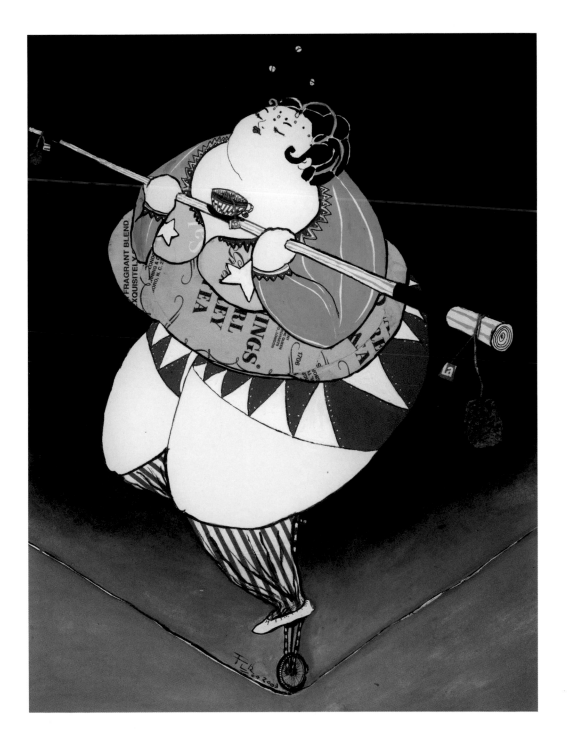

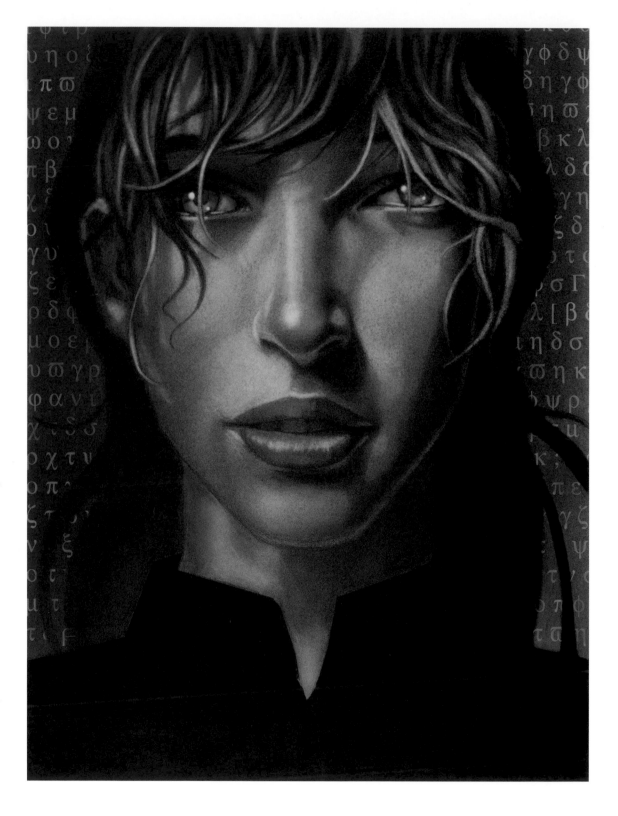

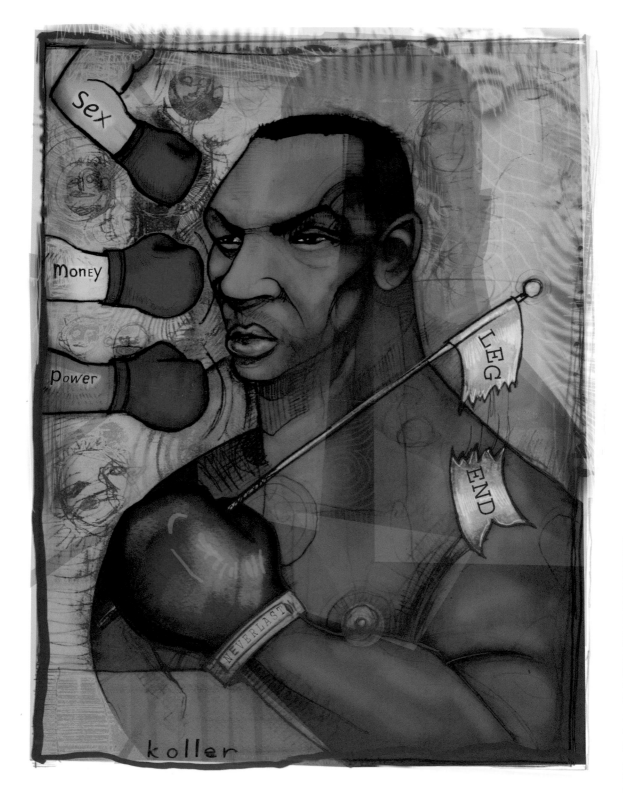

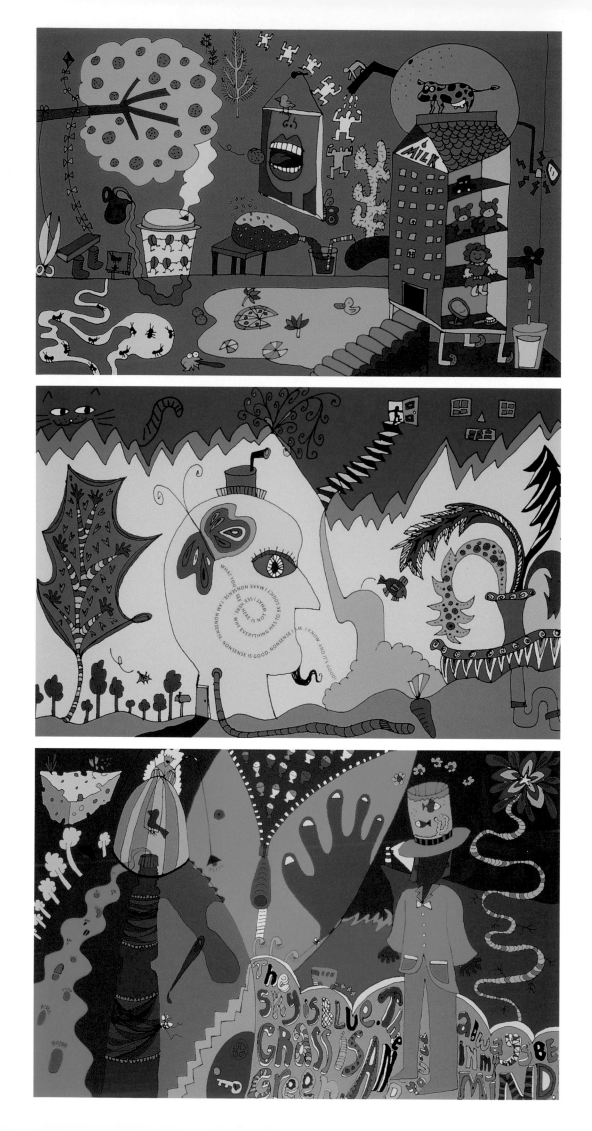

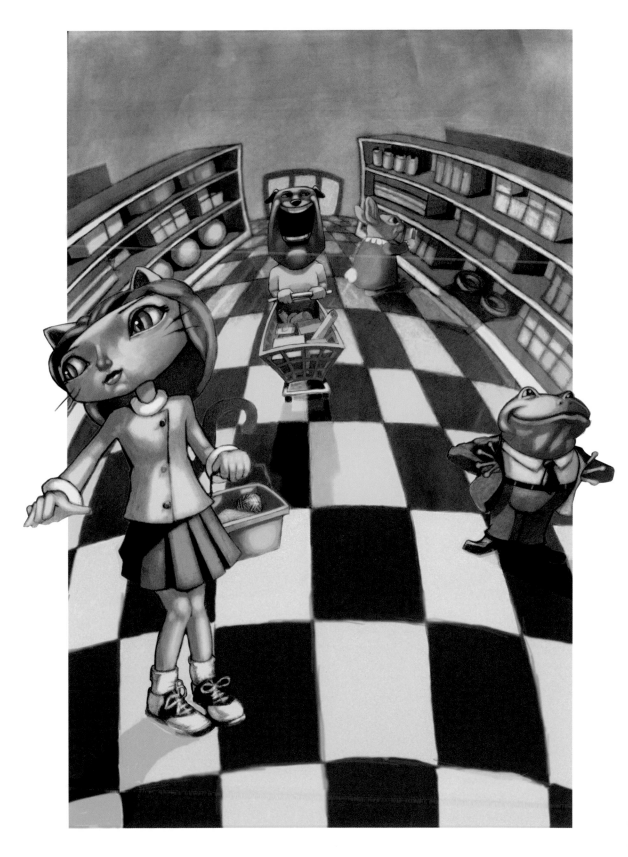

HOTEL CHELSEA 222 west 23rd street new york, new york 10011

HOTEL CHELSEA
222 west 23rd street new york, new york 10011

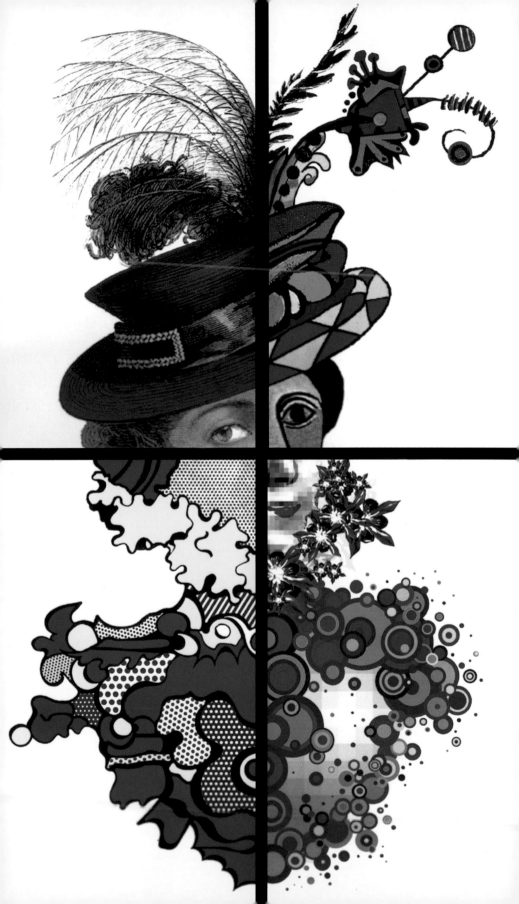

Art Director: Lewis M. Grace Studio: Apparatis Co.

Letterhead 126,127

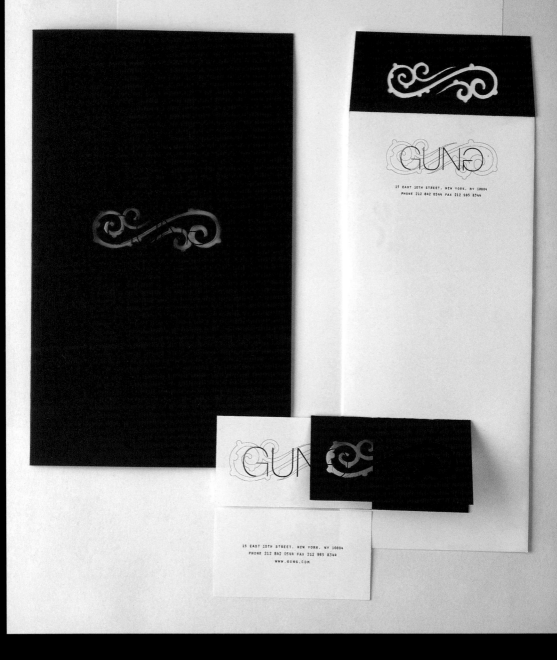

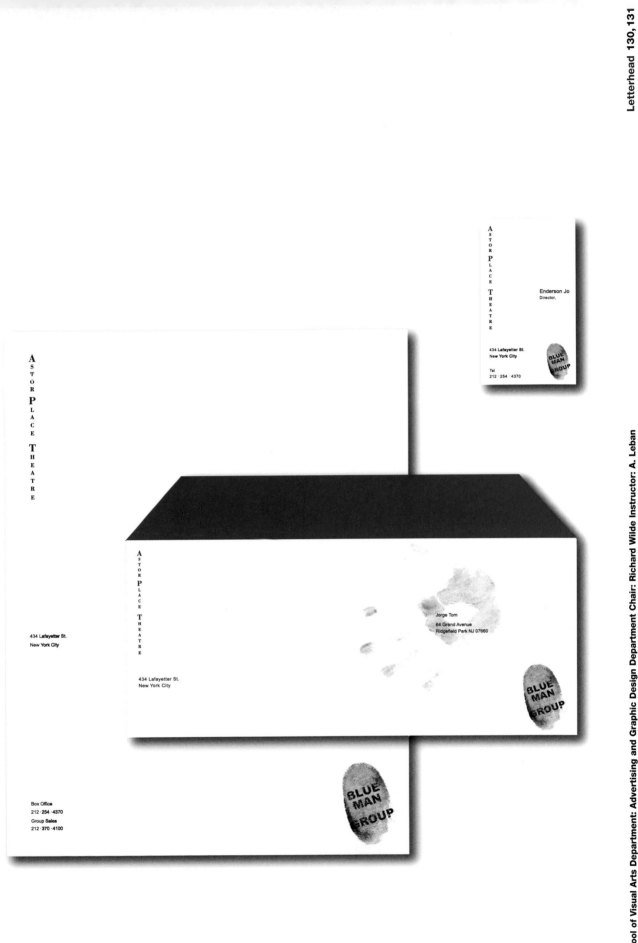

Art Director: Woo Hyun Kim School: School of Visual Arts Department: Advertising and Graphic Design Department Chair: Richard Wilde Instructor: A. Leban

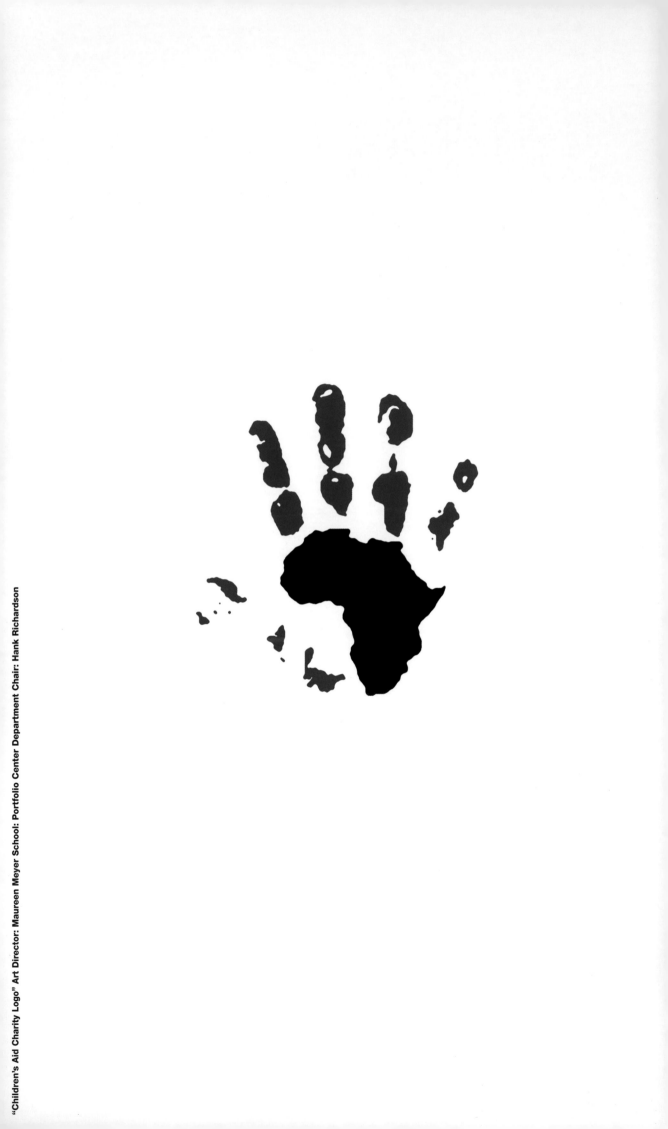

"Children's Aid Charity Logo" Art Director: Maureen Meyer School: Portfolio Center Department Chair: Hank Richardson

METAMORPHOSES

Austin Women's Soccer League

(from top to bottom) (1) "ASCA Logo" Art Director: Robert McGuire School: Southwest Texas State University Instructor: Tom Berno (2) Art Director: G. Dan Covert School: California College of Arts and Crafts Instructor: Eric Heiman (3) Art Director: Ryan Boblett School: Portfolio Center Department Chair: Hank Richardson (4) "AWSL-Austin Women's Soccer League" Art Director: Yuriko Mitsuma Illustrator: Yuriko Mitsuma School: Austin Community College (5) "CCAC" Art Director: Bob Aufuldish and Erin Lampe Designer: G. Dan Covert School: California College of Arts and Crafts Instructor: Bob Aufuldish

(from top to bottom) (1) Art Director: Hyun Jee Kim School: Pratt Institute Instructor: Eric O'Toole (2) Art Directors: Juan J. Cabrero and William Perez Illustrator: Juan J. Cabrero Studio: Studio 1312
(3) "Bellingham Regatta 2003" Art Director: Tricia Imholt School: Washington University Instructor: Kent Smith (4) Art Director: Felicia Soto School: Pratt Institute Instructor: Karen Madsen
(5) "185 World of GRX Design" Art Directors: Priscilla Tsai and Melissa Piuoni School: University of North Carolina at Chaple Hill Department: School of Journalism/Mass Communication Instructor: Linda A. Walsh

Art Director: Hyun Jee Kim School: Pratt Institute Instructor: Eric O'Toole

(from top to bottom) (1) "Offroad by Jeep" Art Director: Stephan Pantel School: Kunstschule Alsterdamm Instructor: Hans Manzewski (2) "Peace" Art Director: Yuriko Mitsuma Illustrator: Yuriko Mitsuma School: Austin Community College (3) "Briquets" Art Director: Luke Markowski School: Western Washington University Instructor: Cristina de Almeida (4) "Literary Cuisine" Art Director: Clive Piercy Designer: Meidawaty Hartono School: Art Center College of Design Instructor: Clive Piercy (5) Art Director: Hyun Jee Kim School: Pratt Institute Instructor: Eric O'Toole

Logos 138,139

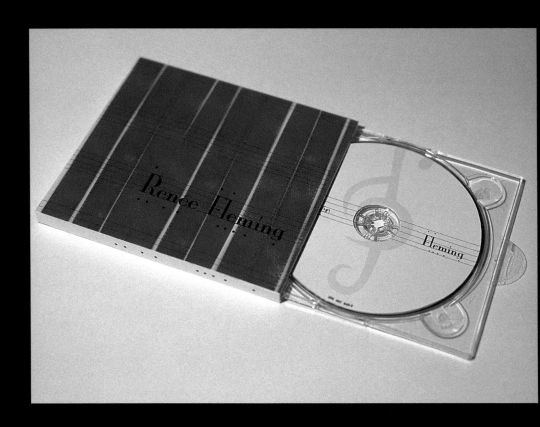

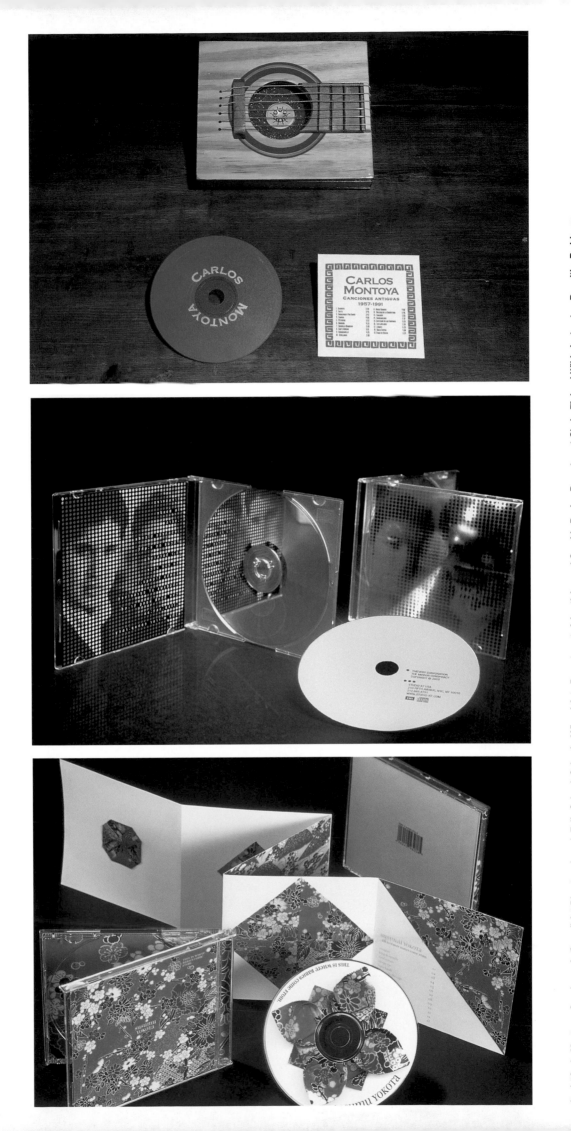

(top) "Carlo Montoya: Canciones Antiguas" Art Director: Joseph Felix School: School of Visual Arts Department: Advertising and Graphic Design Department Chair: Richard Wilde Instructor: Roswitha Rodrigues

(middle) "Mirror Conspiracy Theory" Art Director: Dmitry Paperny School: School of Visual Arts Department: Advertising and Graphic Design Department Chair: Richard Wilde Instructor: Roswitha Rodrigues

(bottom) "Susumu Yokota - This Is Where Babies Come From" Art Director: Nicolaus H. Taylor School: School of Visual Arts Department: Advertising and Graphic Design Department Chair: Richard Wilde Instructor: Tracy Boychuk Music CDs 140, 141

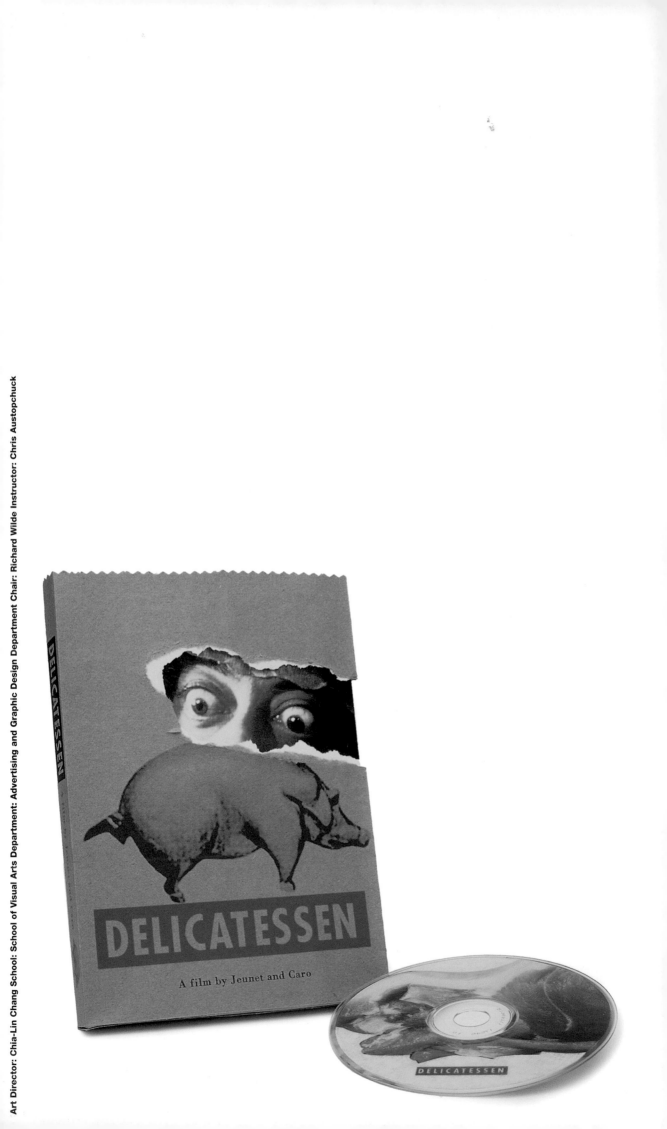

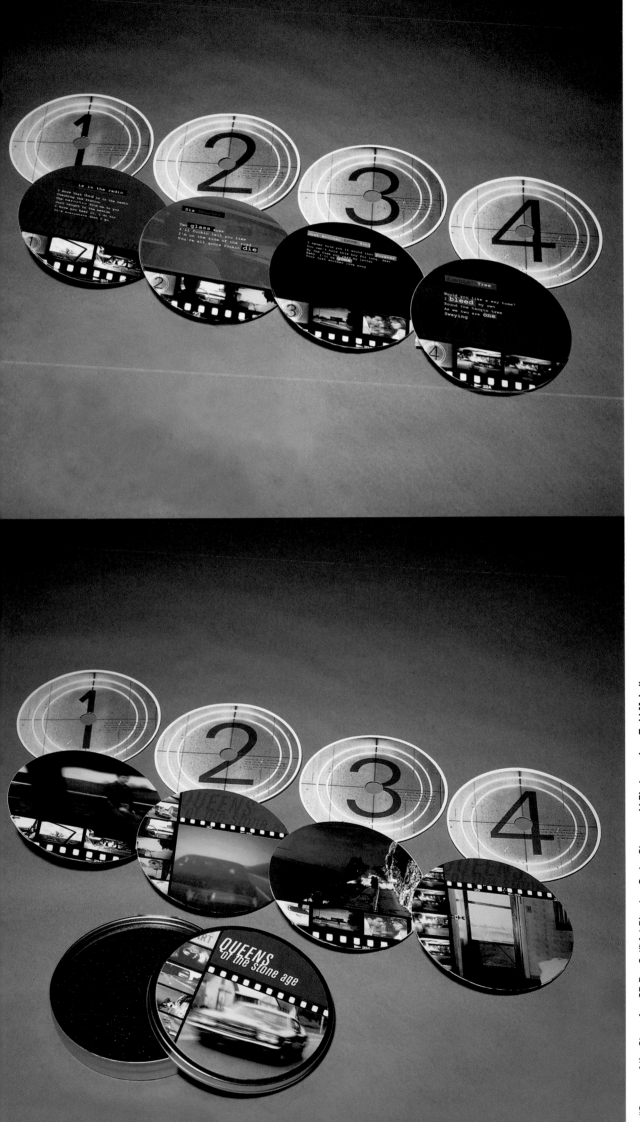

"Queens of the Stone Age CD Box Set" Art Director: Carter Storozynski Photographer: Todd McLellan Music CDs 142, 143

School: School of Visual Arts Department: Advertising and Graphic Design Department Chair: Richard Wilde Instructor: Stacey Drummond

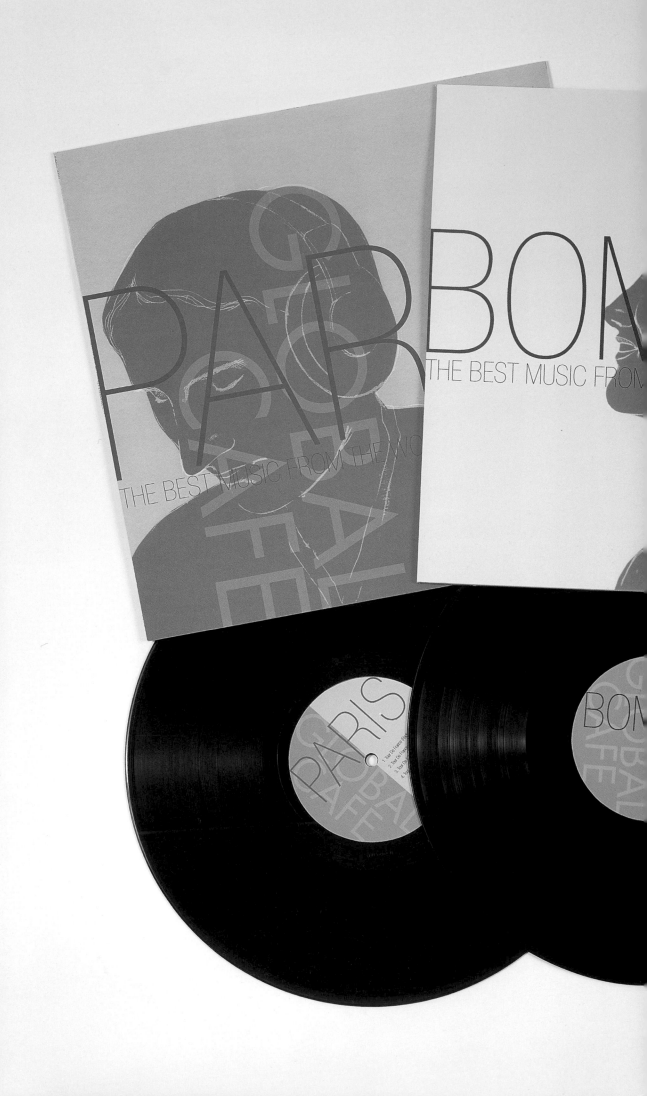

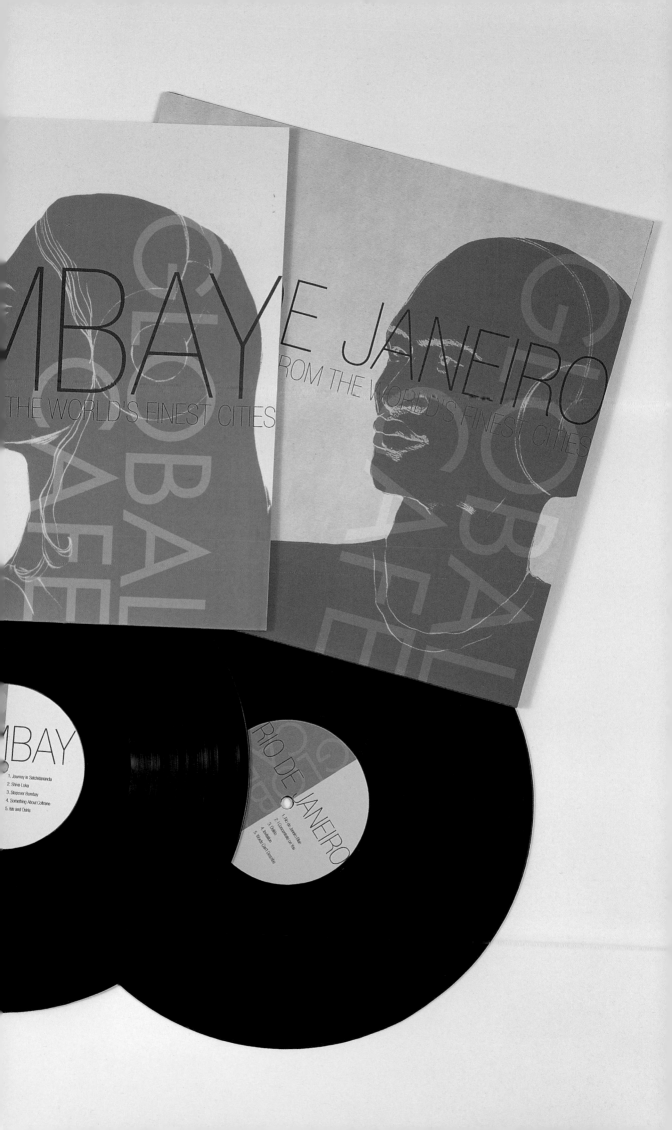

JIM BRICKMAN

For Jim Brickman, the prescription for musical success has always been easy : take finely-crafted

original melodies expertly played by a remarkably gifted pianist, then share them with an ever-

growing global audience. Simple. As the admired pianist/composer his newest CD and PBS special

Love Songs & Lullabies follows the success of

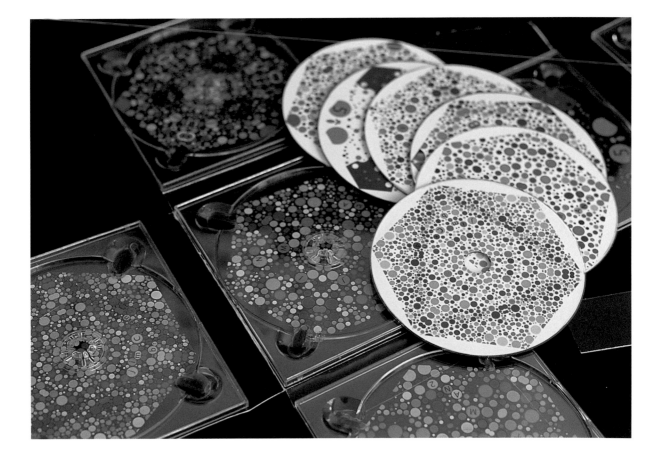

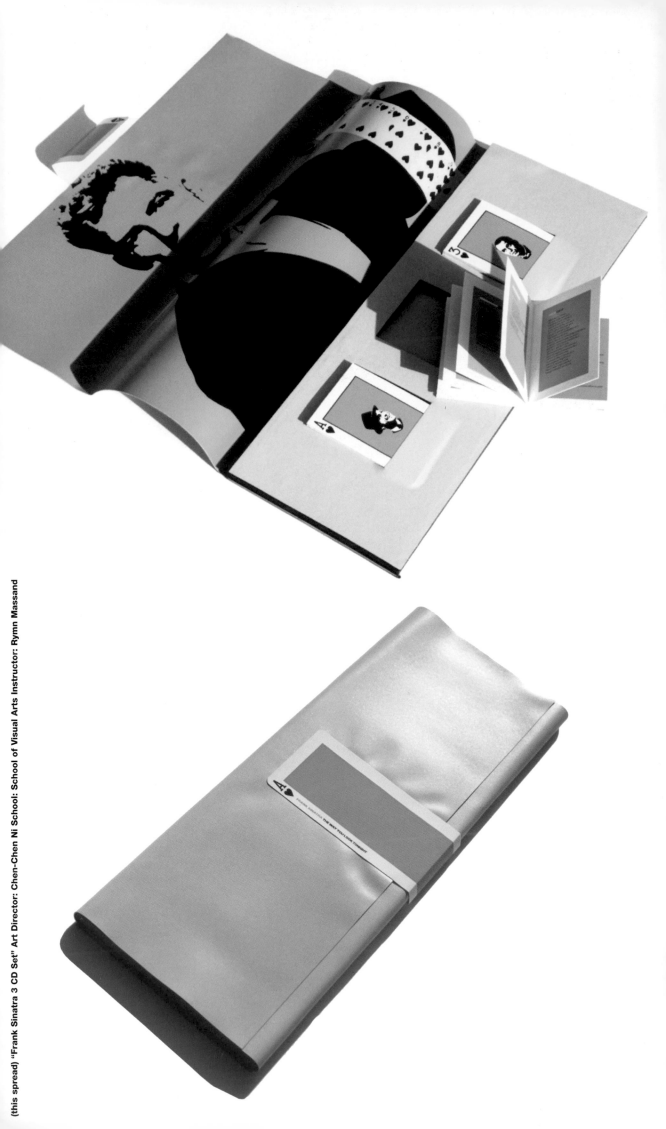

(this spread) "Frank Sinatra 3 CD Set" Art Director: Chen-Chen Ni School: School of Visual Arts Instructor: Rymn Massand

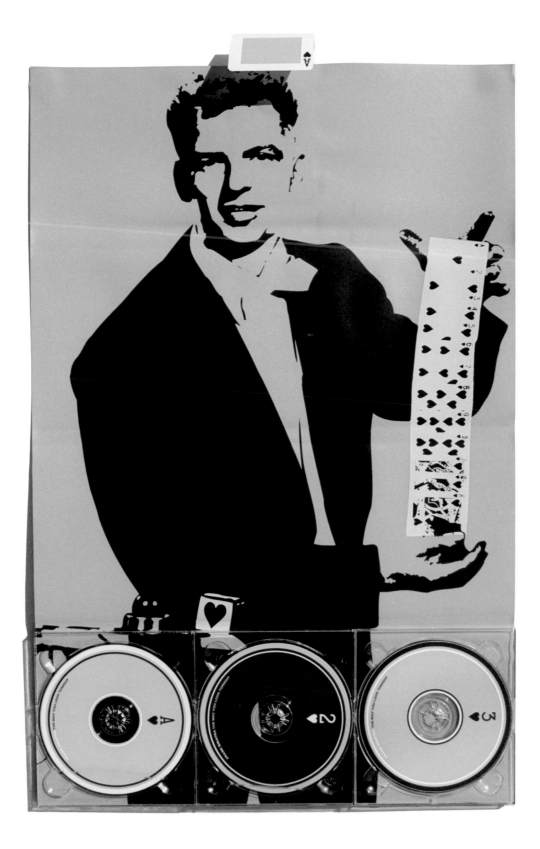

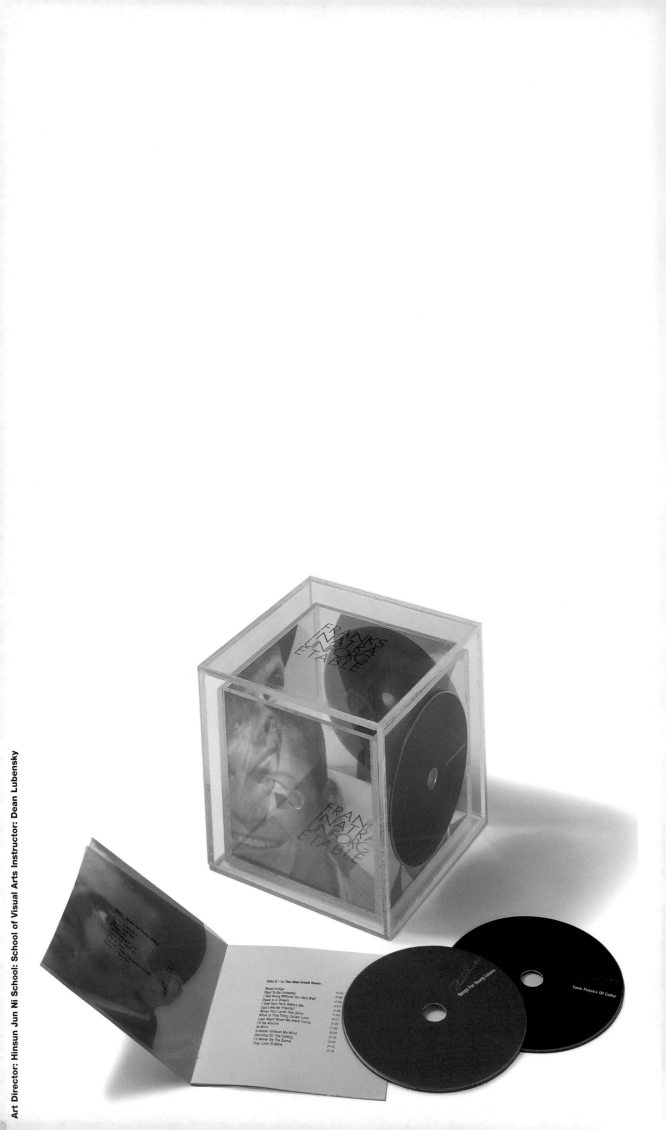

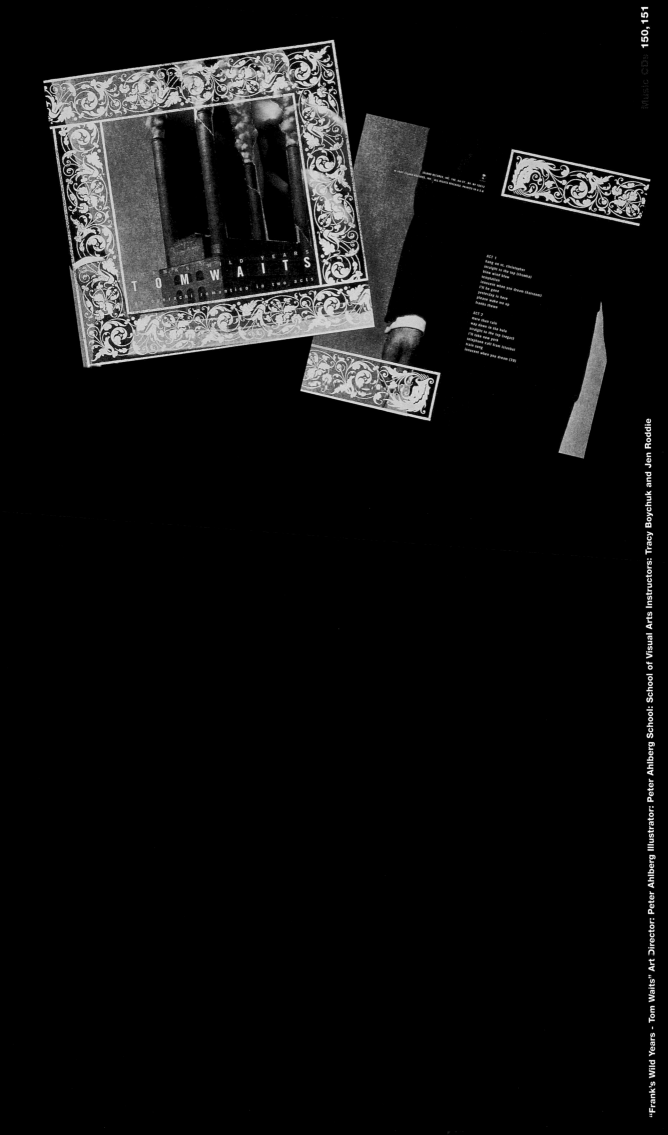

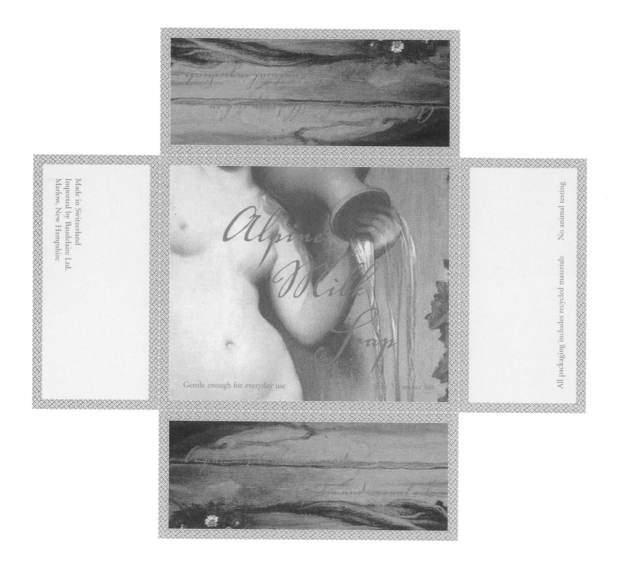

Alpine Milk Soap

Gentle enough for everyday use

Made in Switzerland
Imported by Baudelaire Ltd.
Marlow, New Hampshire

No animal testing

All packaging includes recycled materials

(This spread) "Apiana Soap" Art Director: Sarah J. Munt School: Parsons School of Design Instructor: Charles Hively

APIANA

Alpine

Milk Soap

Gentle enough for everyday use One 5.5 ounce bar

A luxurious triple-milled soap rich in

honey & other natural ingredients

A pure vegetable soap made

with palm and coconut oils

Made in Switzerland
Imported by Baudelaire Ltd.
Marlow, New Hampshire

No animal testing

All packaging includes recycled materials

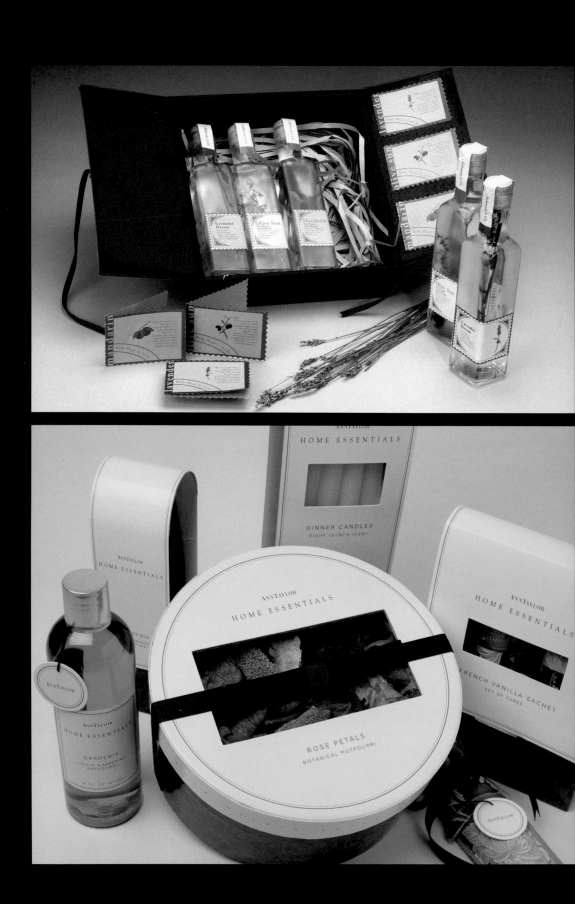

HOME ESSENTIALS

DINNER CANDLES
EIGHT 12-INCH IVORY

ANNTAYLOR
HOME ESSENTIALS

ANNTAYLOR
HOME ESSENTIALS

FRENCH VANILLA SACHET
SET OF THREE

ANNTAYLOR
HOME ESSENTIALS

ROSE PETALS
BOTANICAL POTPOURRI

ANNTAYLOR
HOME ESSENTIALS

GARDENIA
LIQUID SIMMERING
POTPOURRI

ANNTAYLOR

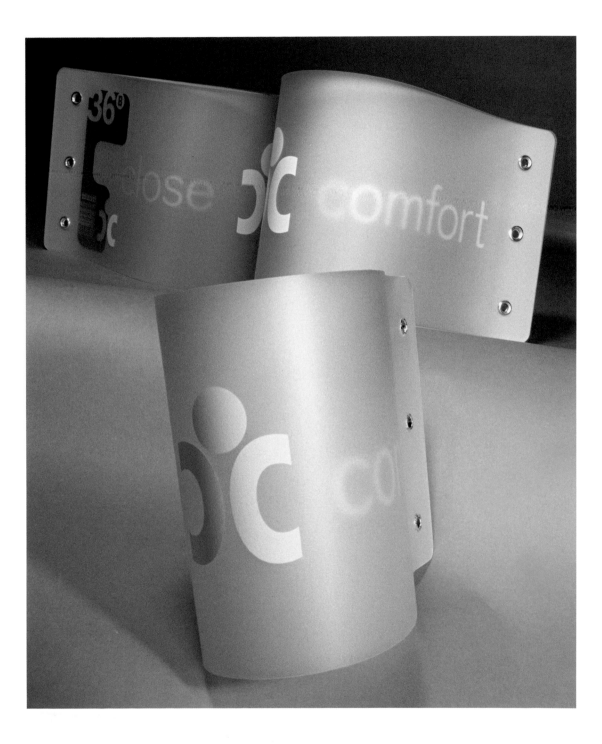

"Close Comfort" Designer: Jeremy Smallwood School: Portfolio Center Instructor: Stephanie Grendzinski

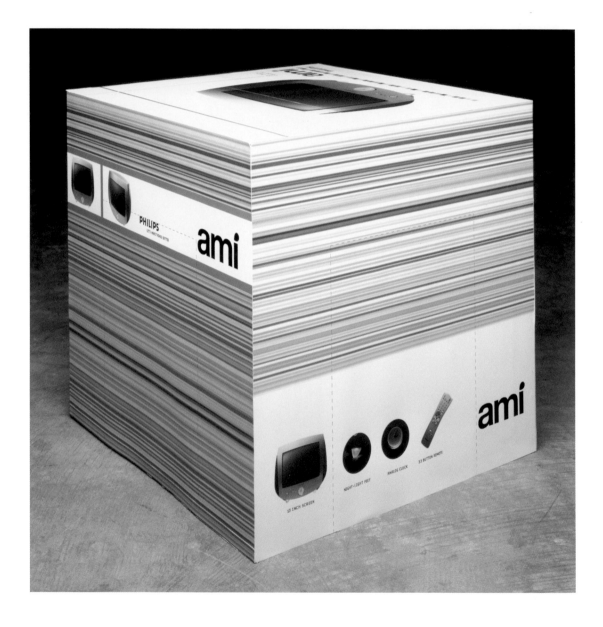

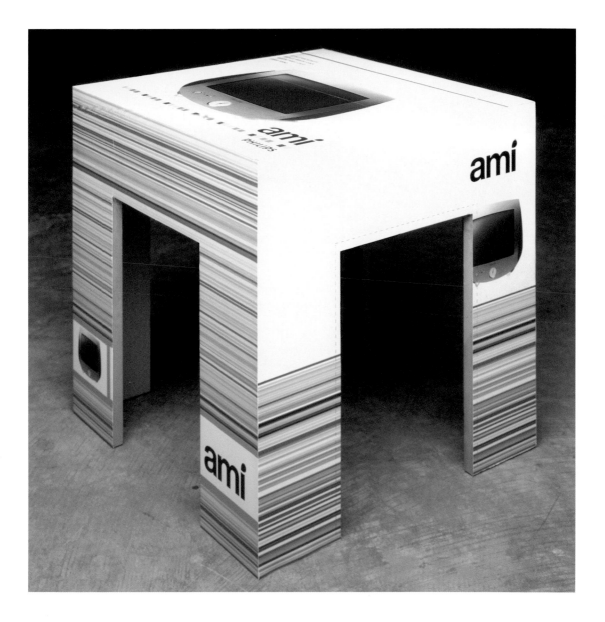

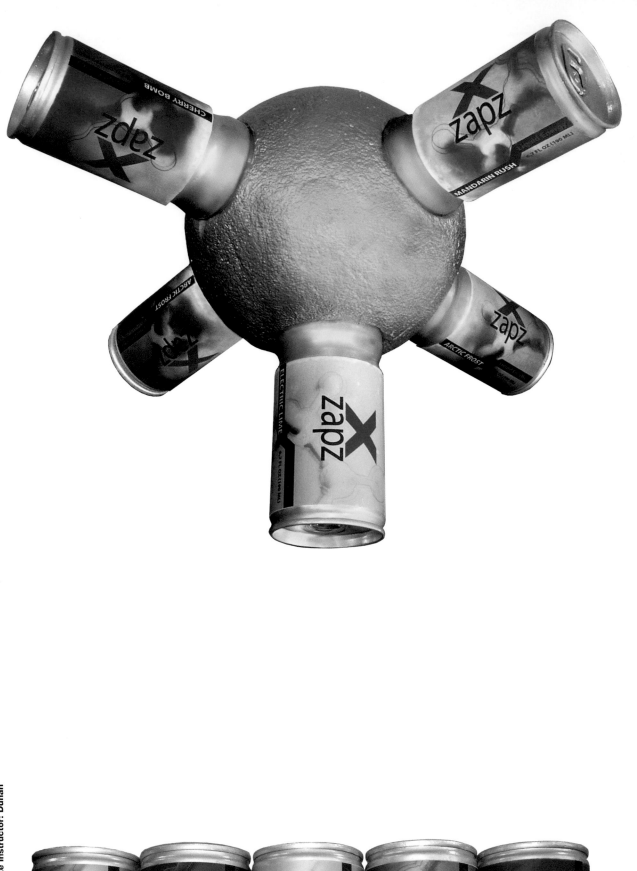

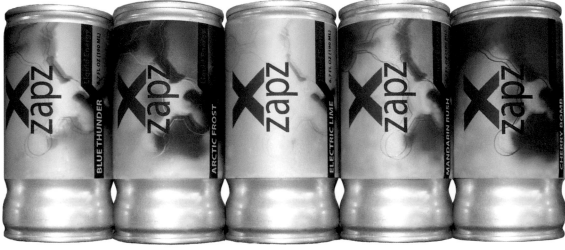

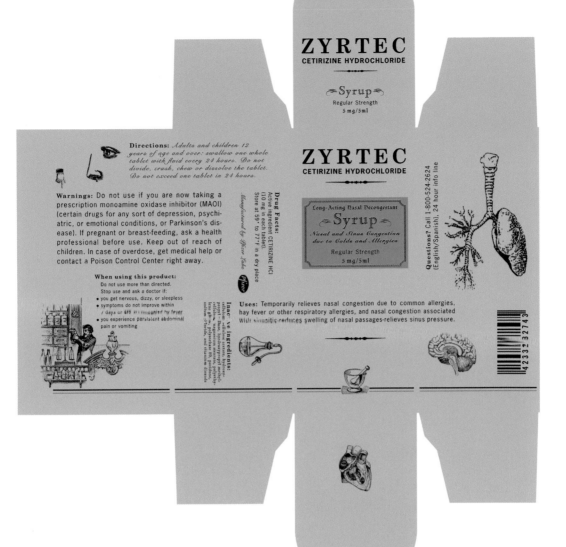

ZYRTEC
CETIRIZINE HYDROCHLORIDE

Syrup
Regular Strength
5 mg/5ml

ZYRTEC
CETIRIZINE HYDROCHLORIDE

Long-Acting Nasal Decongestant
Syrup
Nasal and Sinus Congestion
due to Colds and Allergies
Regular Strength
5 mg/5ml

Directions: Adults and children 12 years of age and over: swallow one whole tablet with fluid every 24 hours. Do not divide, crush, chew or dissolve the tablet. Do not exceed one tablet in 24 hours.

Warnings: Do not use if you are now taking a prescription monoamine oxidase inhibitor (MAOI) (certain drugs for any sort of depression, psychiatric, or emotional conditions, or Parkinson's disease). If pregnant or breast-feeding, ask a health professional before use. Keep out of reach of children. In case of overdose, get medical help or contact a Poison Control Center right away.

When using this product:
Do not use more than directed.
Stop use and ask a doctor if:
• you get nervous, dizzy, or sleepless
• symptoms do not improve within 7 days or are accompanied by fever
• you experience persistent abdominal pain or vomiting

Drug Facts:
Active ingredient CETIRIZINE HCl (10 mg in each tablet).
Store at 59° to 77°F in a dry place.

Manufactured by Pfizer Labs

Inactive ingredients: cellulose—cellulose acetate, hydroxypropyl methyl-cellulose—blue, hydroxypropyl methyl-cellulose, magnesium stearate, polyethylene glycol, polysorbate 80, povidone, sodium chloride, and titanium dioxide

Uses: Temporarily relieves nasal congestion due to common allergies, hay fever or other respiratory allergies, and nasal congestion associated with sinusitis-reduces swelling of nasal passages-relieves sinus pressure.

Questions? Call 1-800-524-2624 (English/Spanish), 24 hour info line

4 23232 32743

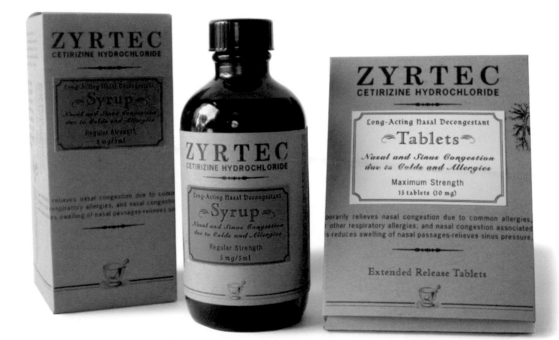

ZYRTEC
CETIRIZINE HYDROCHLORIDE

Long-Acting Nasal Decongestant
Syrup
Nasal and Sinus Congestion
due to Colds and Allergies
Regular Strength
5 mg/5ml

...relieves nasal congestion due to common respiratory allergies, and nasal congestion... swelling of nasal passages-relieves sin...

ZYRTEC
CETIRIZINE HYDROCHLORIDE

Long-Acting Nasal Decongestant
Syrup
Nasal and Sinus Congestion
due to Colds and Allergies
Regular Strength
5 mg/5ml

ZYRTEC
CETIRIZINE HYDROCHLORIDE

Long-Acting Nasal Decongestant
Tablets
Nasal and Sinus Congestion
due to Colds and Allergies
Maximum Strength
15 tablets (10 mg)

...porarily relieves nasal congestion due to common allergies, ...r other respiratory allergies, and nasal congestion associated ...s-reduces swelling of nasal passages-relieves sinus pressure

Extended Release Tablets

"Zyrtec" Art Director: Joly Neelankavil Designer: Joly Neelankavil Illustrator: Joly Neelankavil School: Art Center College of Design Instructor: Gloria Kondrup

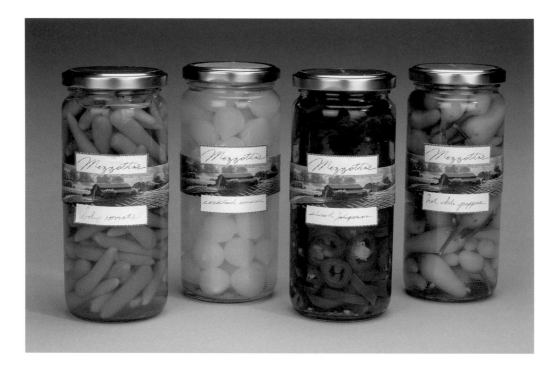

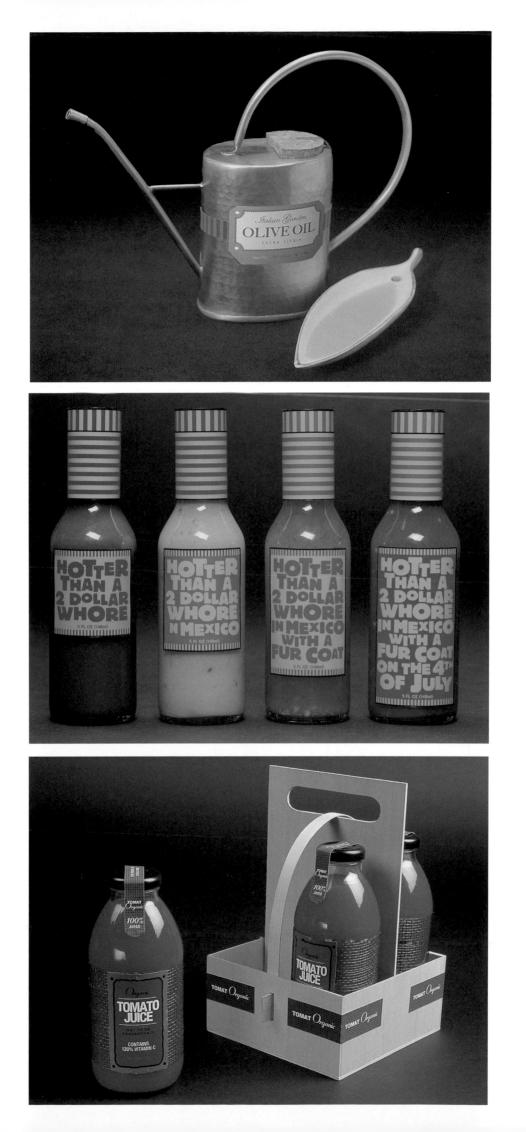

(top) "Italian Garden Olive Oil" Art Director: Dmitry Paperny Designer: Dmitry Paperny Copywriter: Dmitry Paperny School: School of Visual Arts Instructor: Roswitha Rodrigues
(middle) "Hotter Than Hot Sauces" Designer: Summer J. Daughenbaugh Photographer: Richard Copywriter: Summer J. Daughenbaugh School: Penn State University Instructor: Kristin Breslin-Sommese (bottom) "Tomato Organic
Tomato Juice" Art Director: Dmitry Paperny Designer: Dmitry Paperny Photographer: Juren David Illustrator: Dmitry Paperny Copywriter: Dmitry Paperny School: Dmitry Paperny School of Visual Arts Instructor: Roswitha Rodrigues

Packaging 164, 165

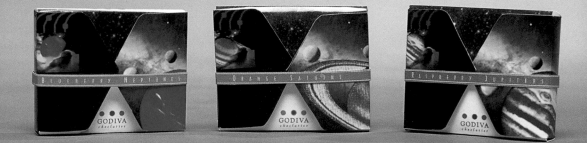

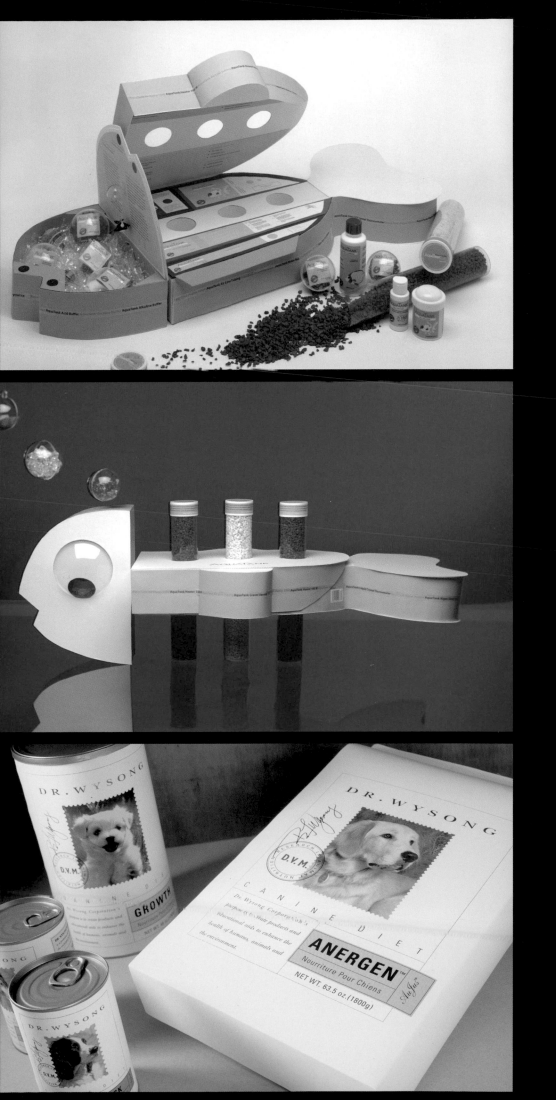

(top and middle) "AquaTank - My first fish tank" Art Director: Yuriko Mitsuma Designer: Yuriko Mitsuma School: Austin Community College Instructor: Linda Smarzik
(bottom) "Dr. Wysong Dog Food" Designer: Alberto Rojas Photographer: Stephanie Ginger School: Academy of Art College Instructor: Thomas McNutty

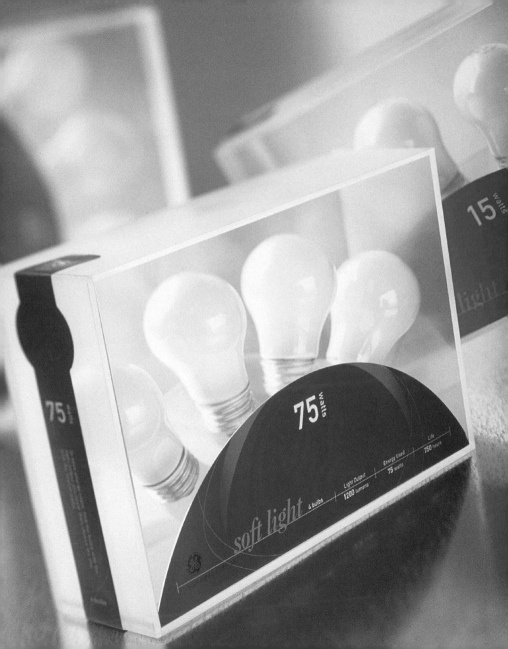

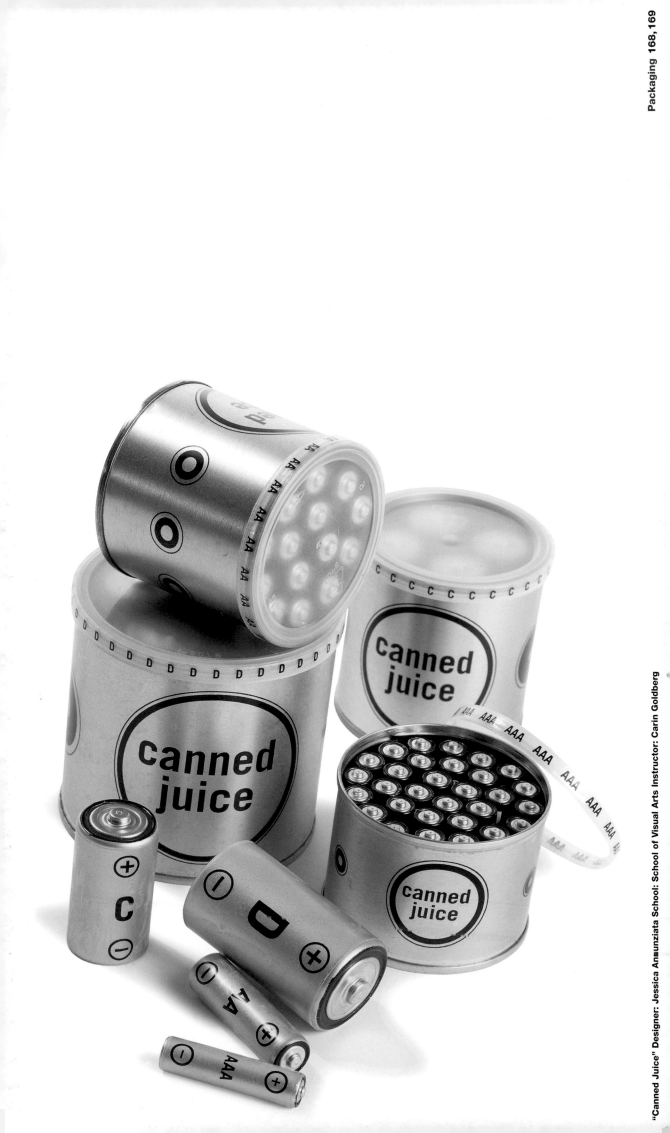

"Canned Juice" Designer: Jessica Amunziata School: School of Visual Arts Instructor: Carin Goldberg

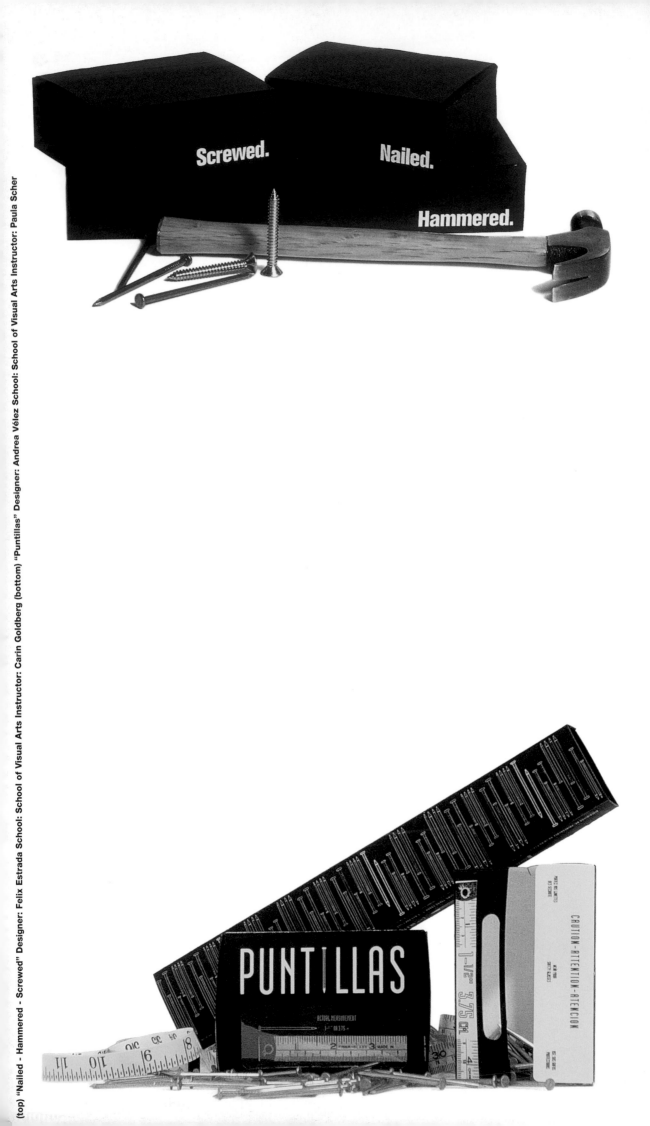

(top) "Nailed - Hammered - Screwed" Designer: Felix Estrada School: School of Visual Arts Instructor: Carin Goldberg (bottom) "Puntillas" Designer: Andrea Vélez School: School of Visual Arts Instructor: Paula Scher

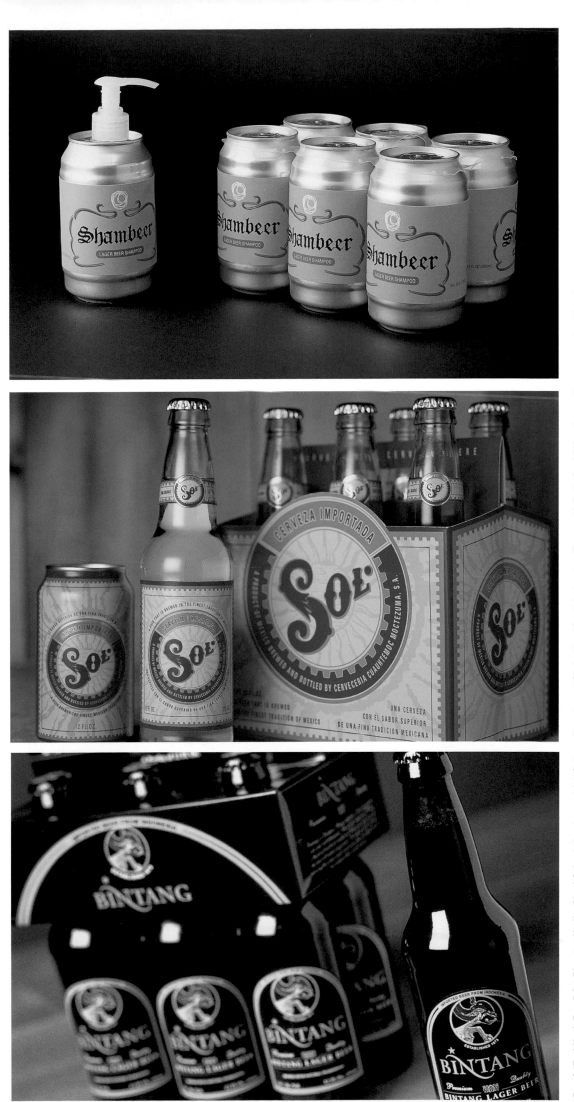

(left Page) "Red Hook Beer" Art Director: Noriko Ohori School: Academy of Art College Department Chair: Mary Scott Instructor: Thomas McNulty (top) "Shambeer - Shampoo made of beer"
Designer: Tamar Onn School: School of *Visual* Arts Instructor: Rosi Rodrigues (middle) "Cerveza Sol" Designer: Alberto Rojas Photographers: Jeff Johnson School: Academy of Art College
Instructor: Thomas McNulty (bottom) "Bintang Packaging" Art Director: Indrawn Boediman School: Academy of Art College Department Chair: Mary Scott Instructor: Coco Qiu Packaging 172,173

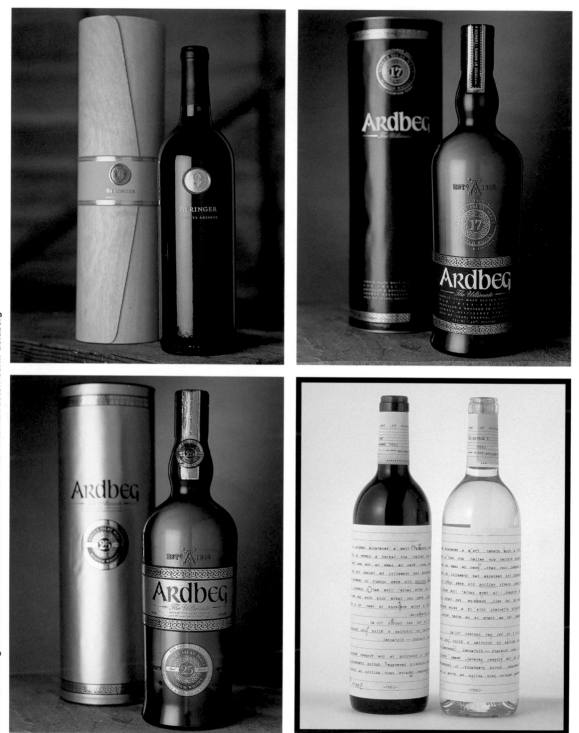

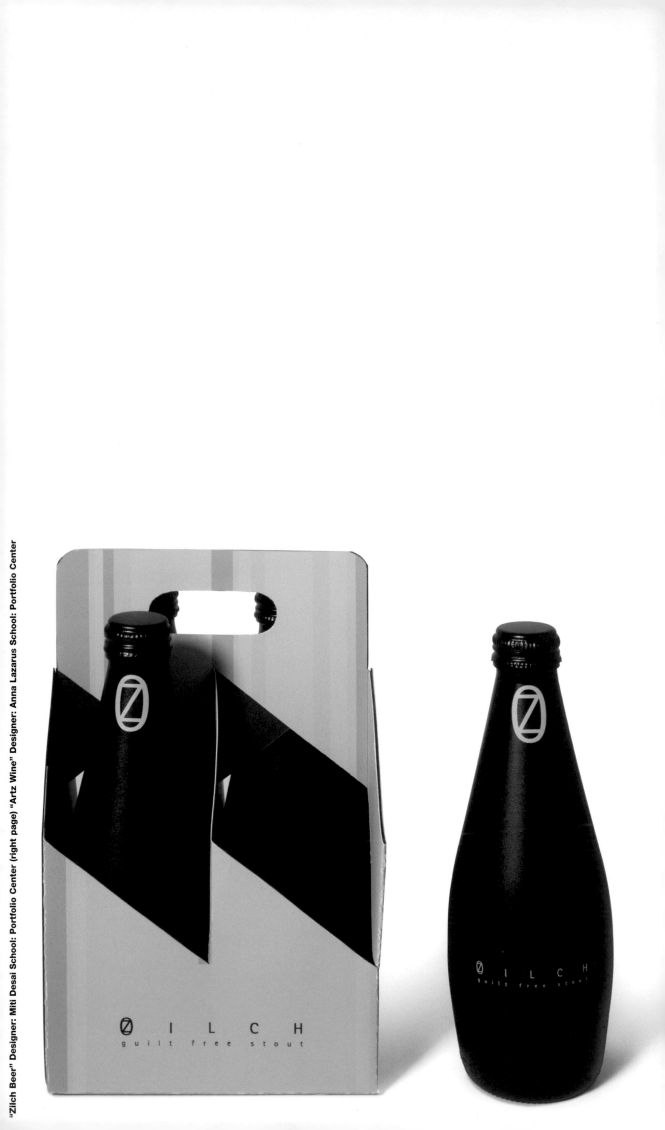

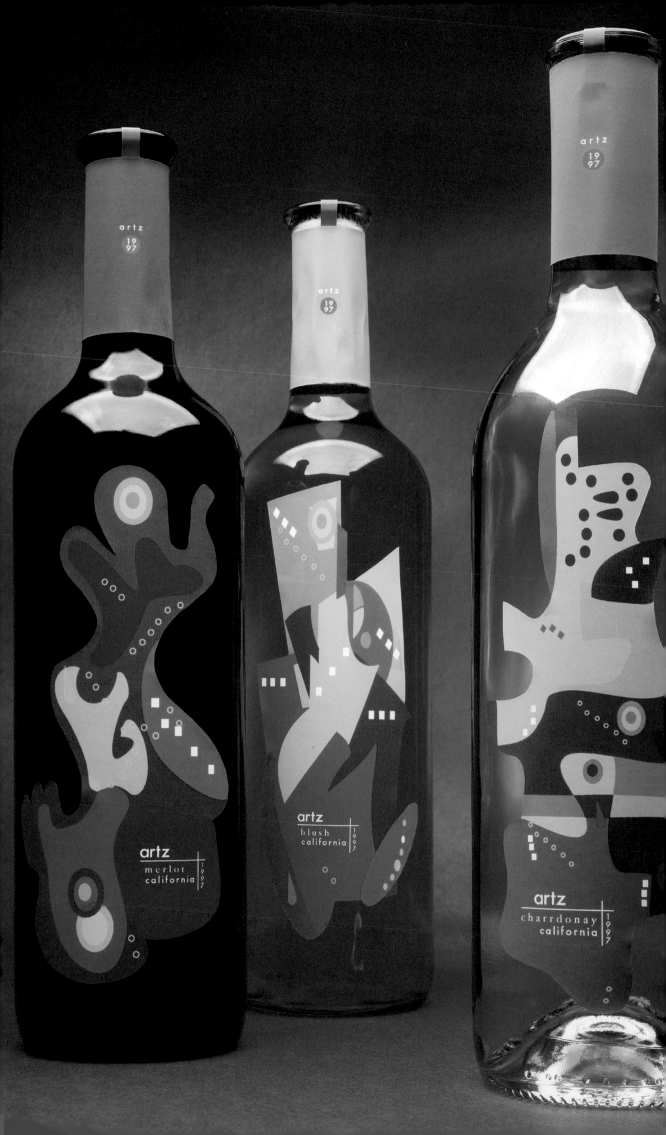

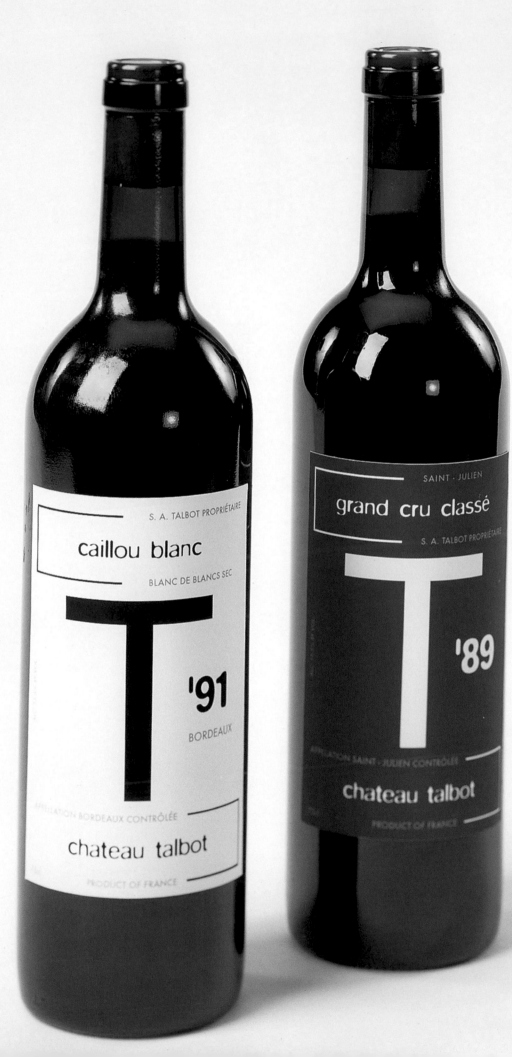

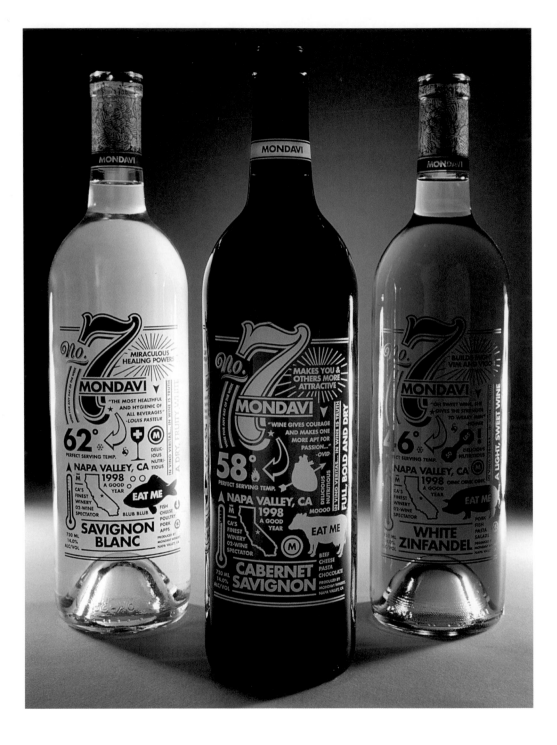

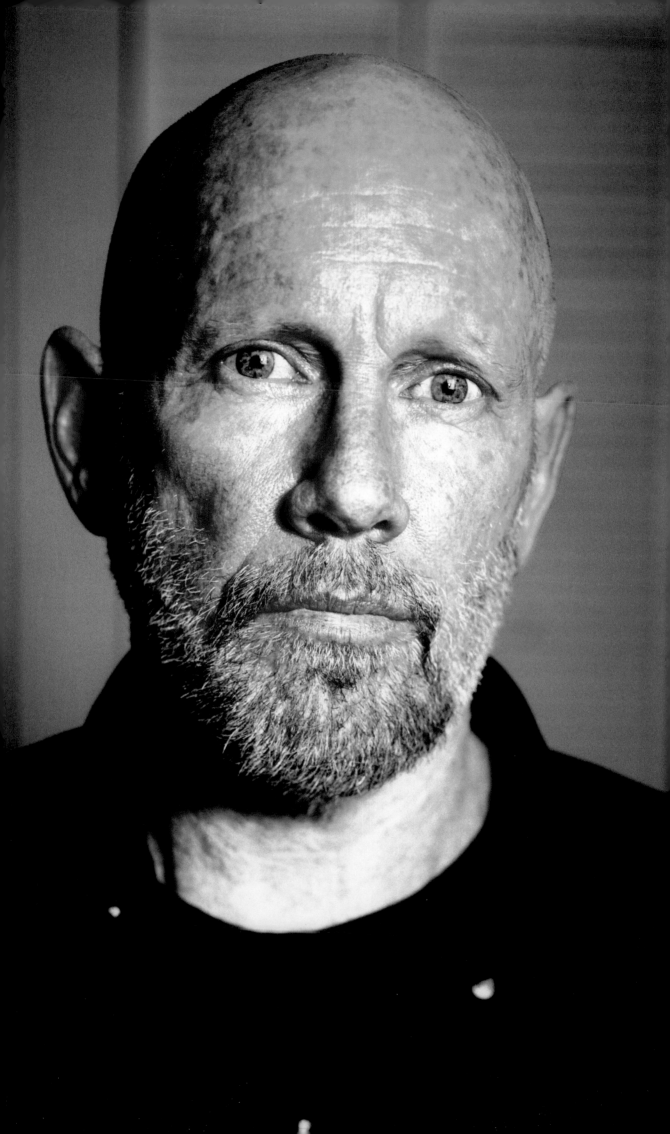

"Old Truck" Photographer: Tim Wedig School: Art Institute of Atlanta Instructor: Phil Bekker

(left page) "NYC" Photographer: Fernanda Freixosa School: Miami Ad School Instructor: Darryl Strawser (this page) "Yellow Bridge" Photographer: Alexander Herring School: Art Institute of Atlanta Instructor: Phil Bekker (next left page) "JM" Photographer: Whit Lane School: Portfolio Center (next right page) "Untitled" Photographer: Gine McClain School: Portfolio Center Photography 192, 193

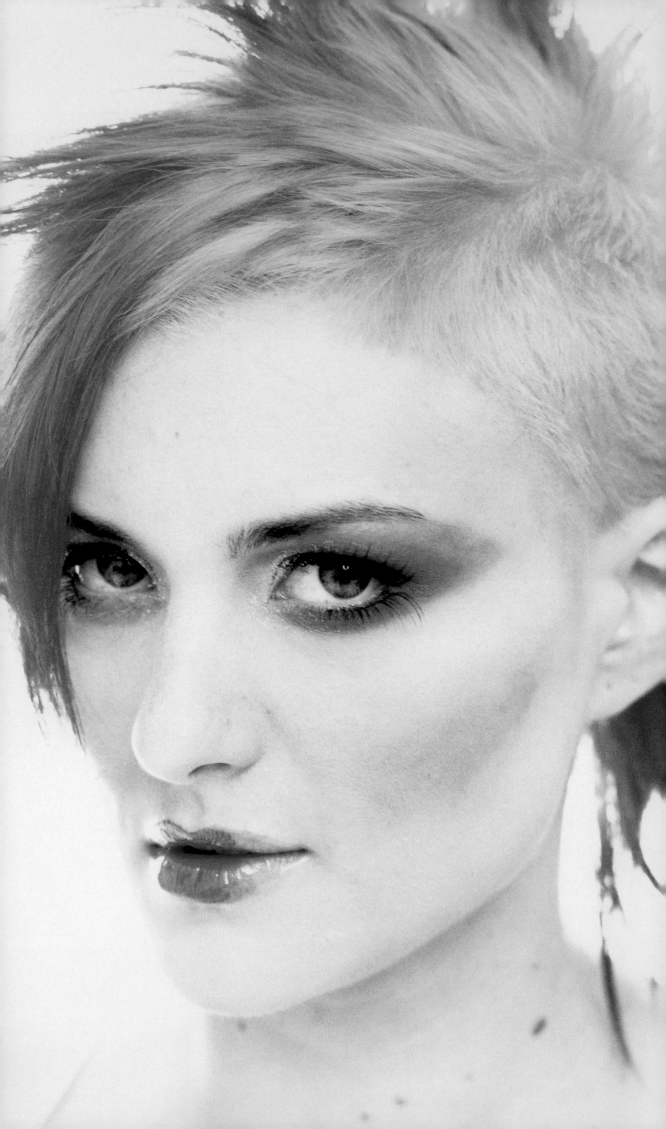

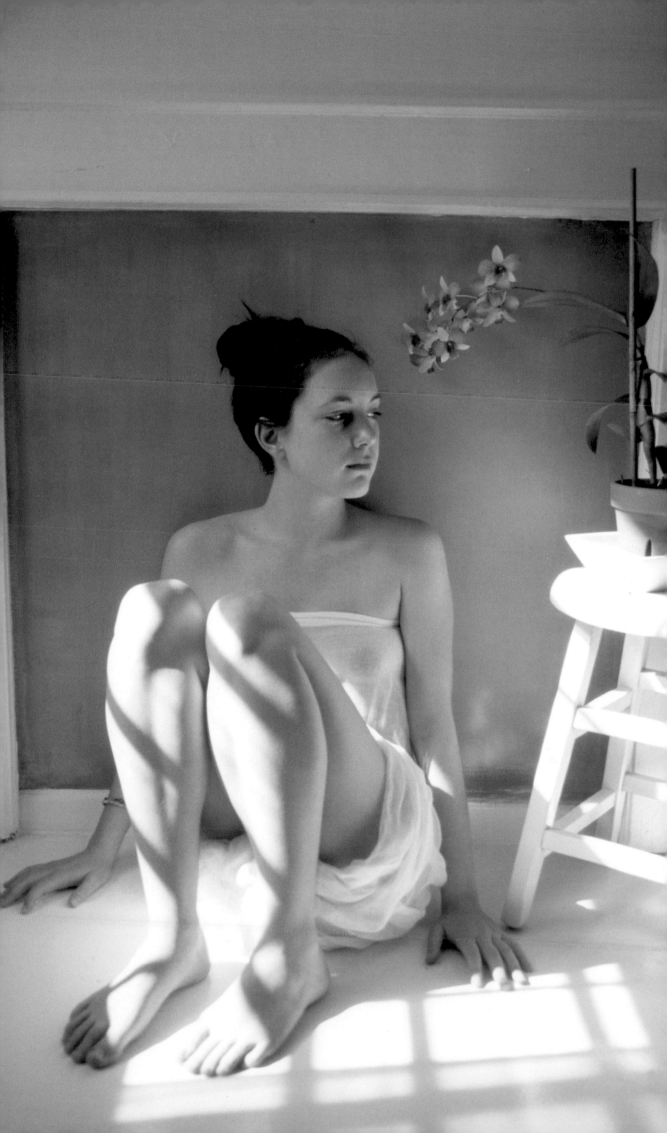

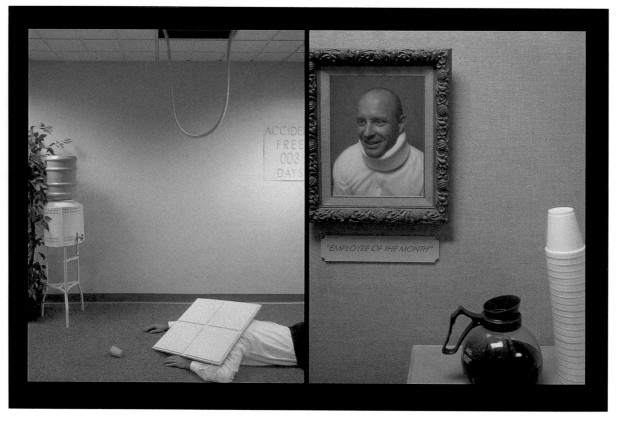

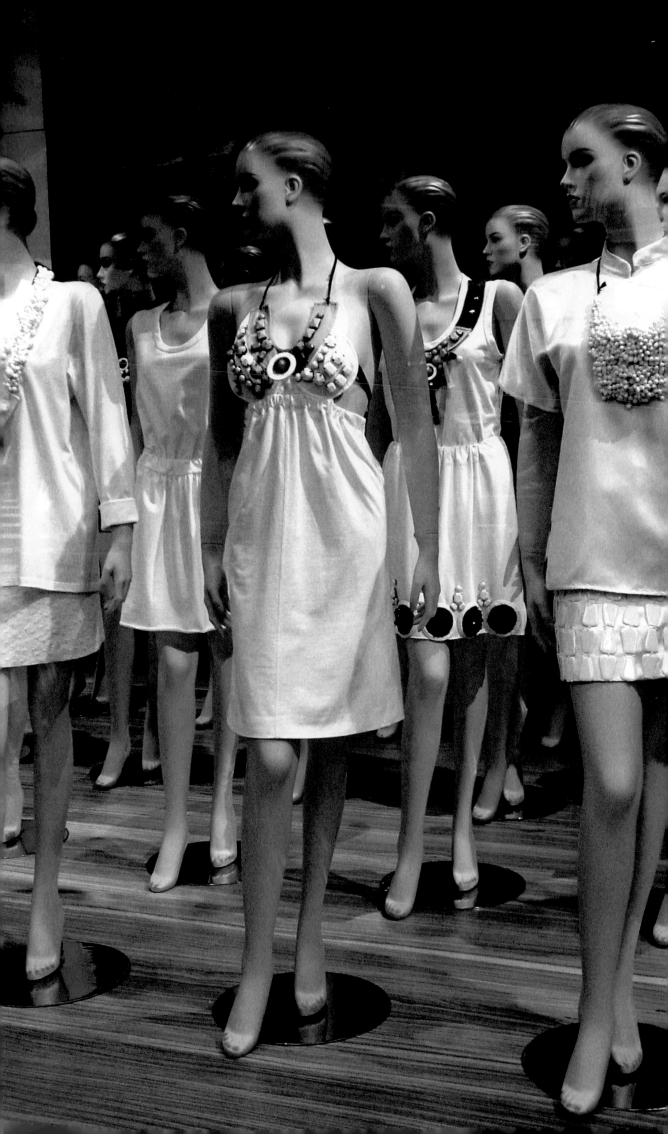

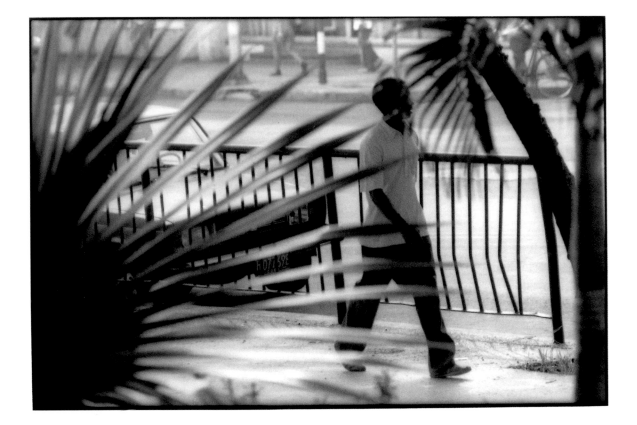

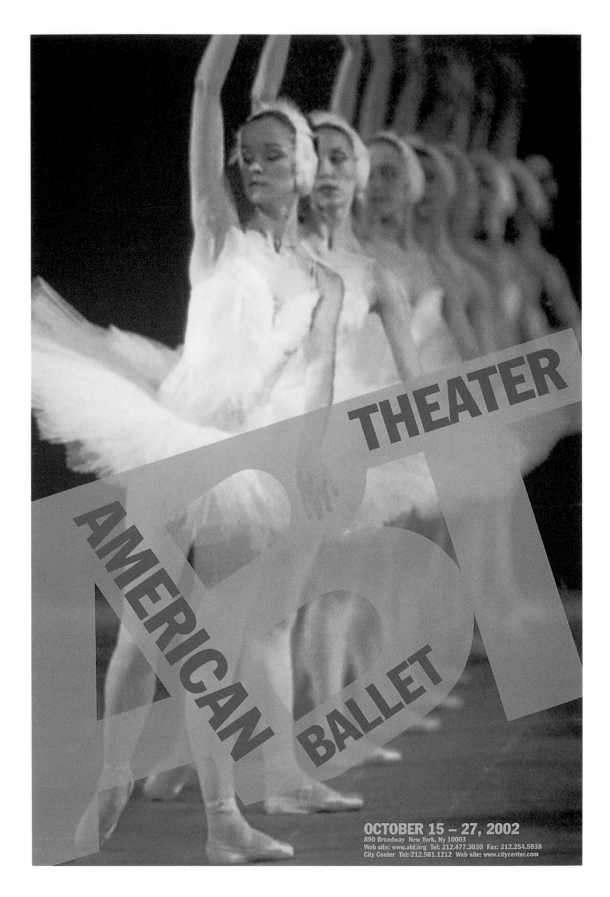

THEATER

AMERICAN BALLET

OCTOBER 15 – 27, 2002
890 Broadway New York, Ny 10003
Web site: www.abt.org Tel: 212.477.3030 Fax: 212.254.5938
City Center Tel: 212.581.1212 Web site: www.citycenter.com

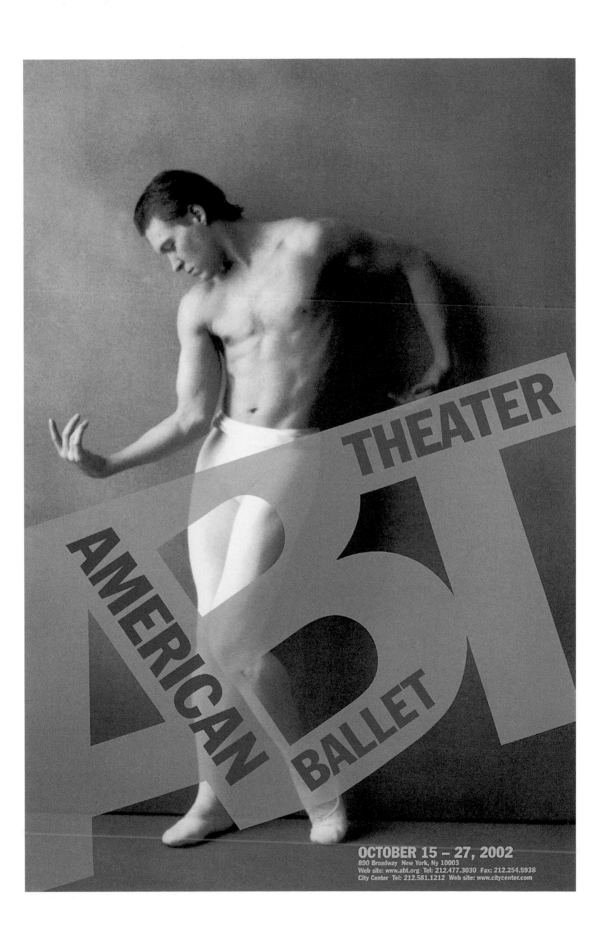

THE WORK OF
CHARLES & RAY EAMES
11/04/02 - 02/29/03
MoMA

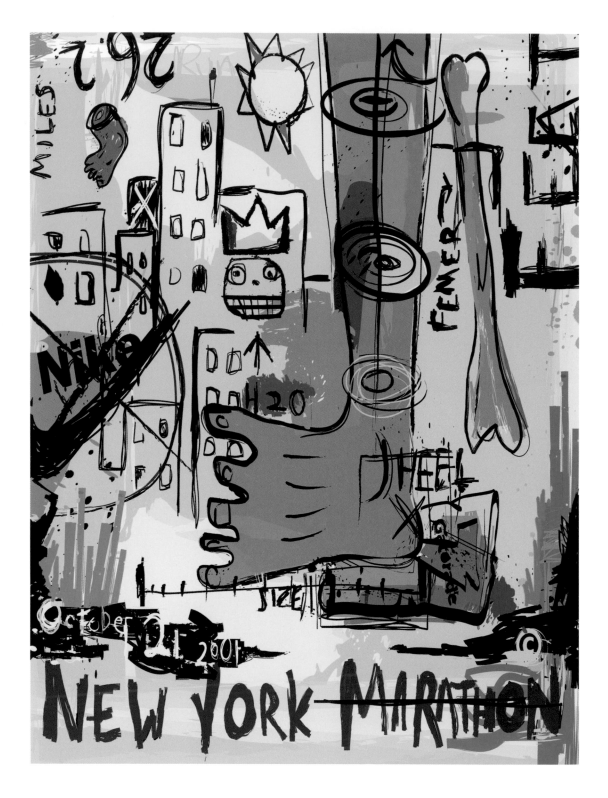

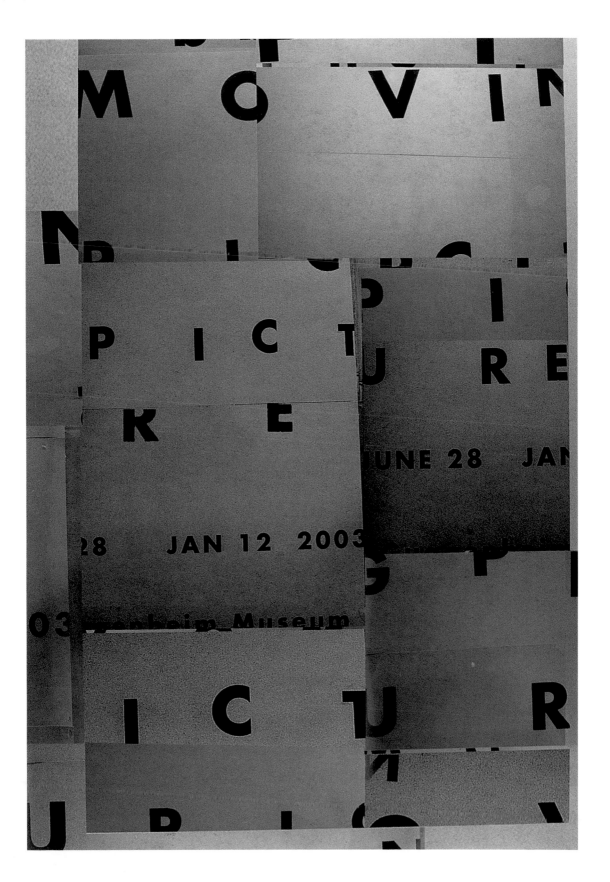

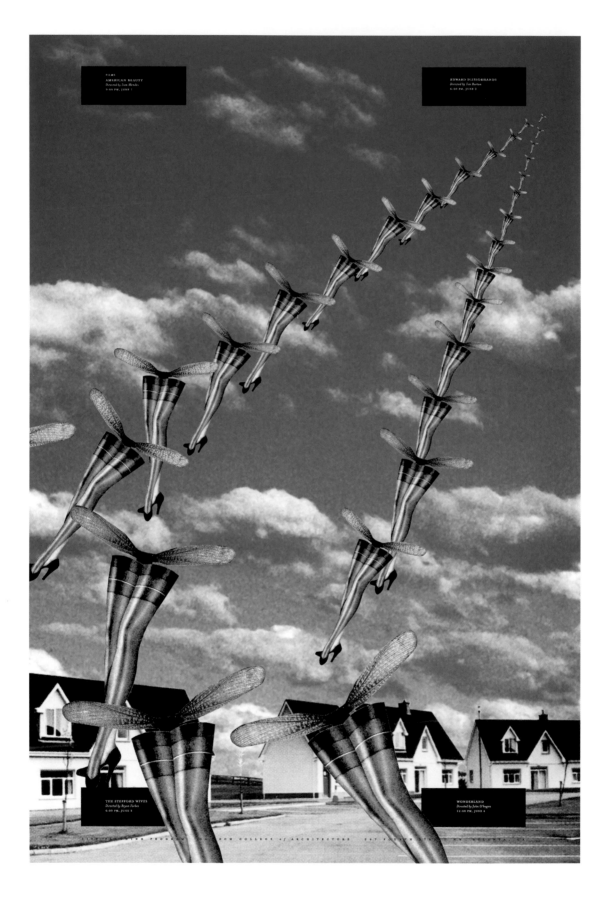

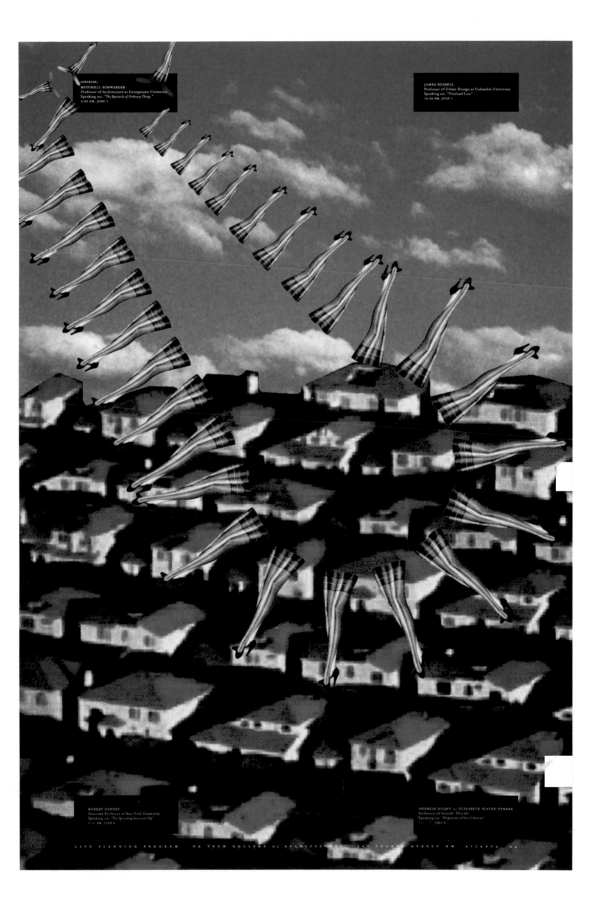

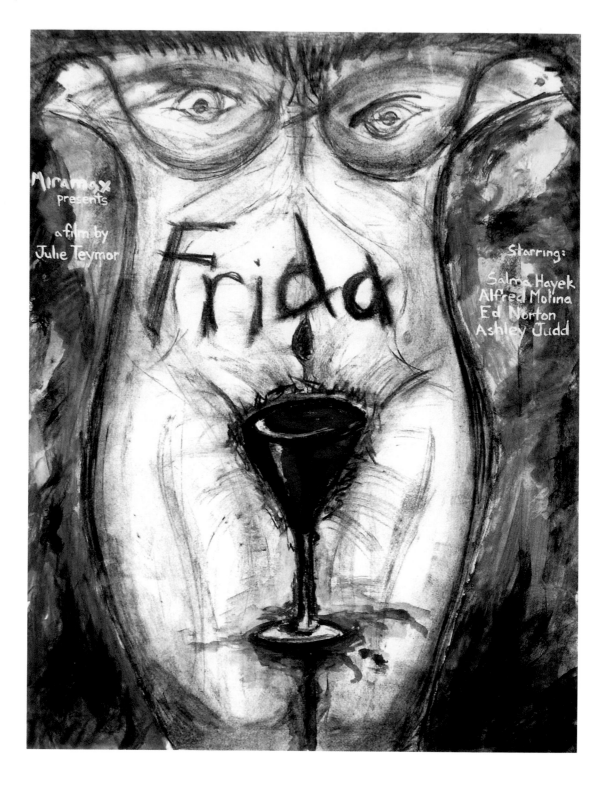

Miramax
presents

a film by
Julie Teymor

Frida

Starring:
Salma Hayek
Alfred Molina
Ed Norton
Ashley Judd

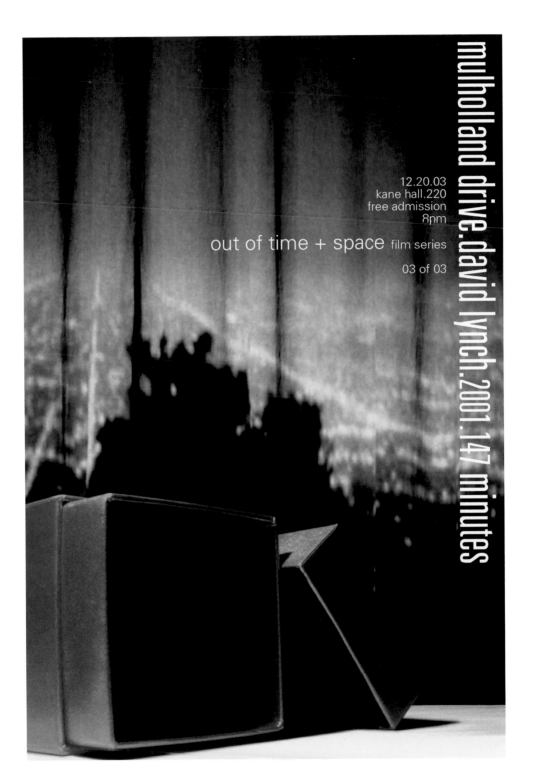

mulholland drive.david lynch.2001.147 minutes

12.20.03
kane hall.220
free admission
8pm

out of time + space film series

03 of 03

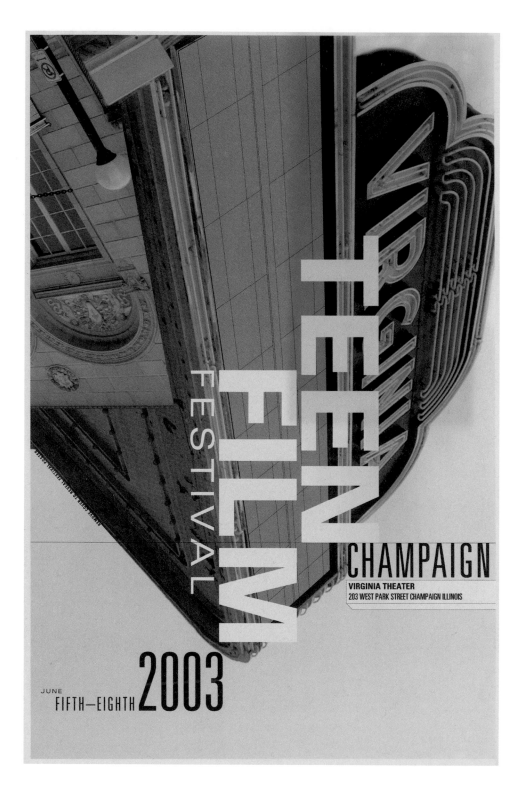

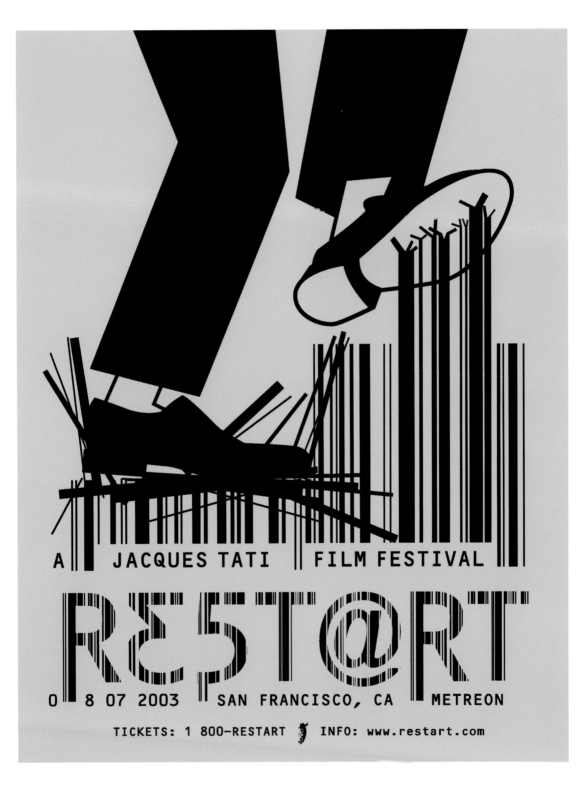

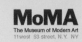

MoMA
The Museum of Modern Art
11west 53 street, N.Y. NY

contemporary perception

may 15th — june 23rd, 2003

herbert bayer

herbert bayer at the moma

"exhibition design was discovered to be a new
medium of communication, which goes far beyond
the use of graphics in two dimensions. it embraces
all possible visual media,all dimension of space, and
includes oral-aural techniques. it is a new dimension
in the art of conveying complex information and has
developed through an exciting history with many new
discoveries. fascination with optical effects for display
purposes, to make exhibits exciting and eye-catching,
anticipated some of the optical art of today."

© 2001 The Museum of Modern Art, N.Y. printed in the USA 38474 (212) 708-9400 www.moma.org

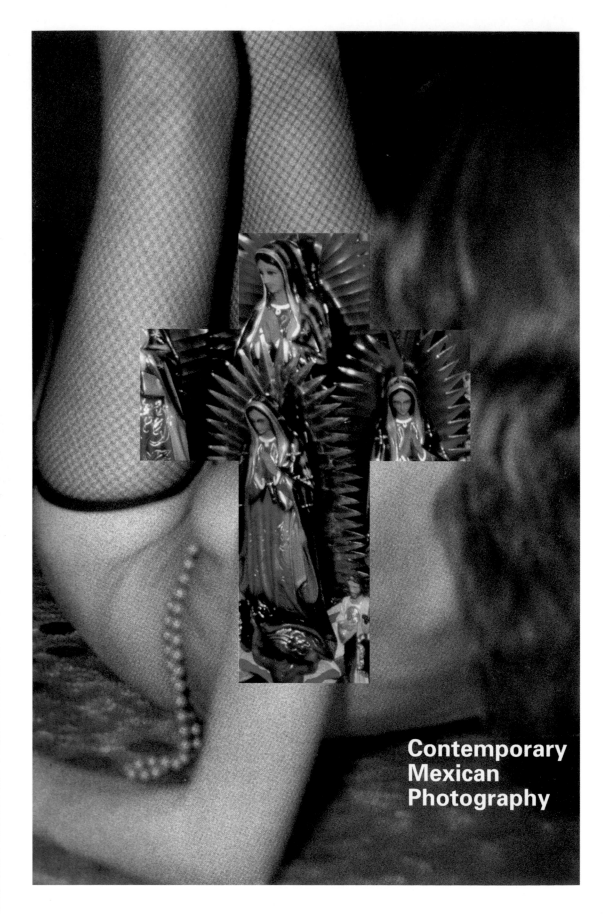

Contemporary
Mexican
Photography

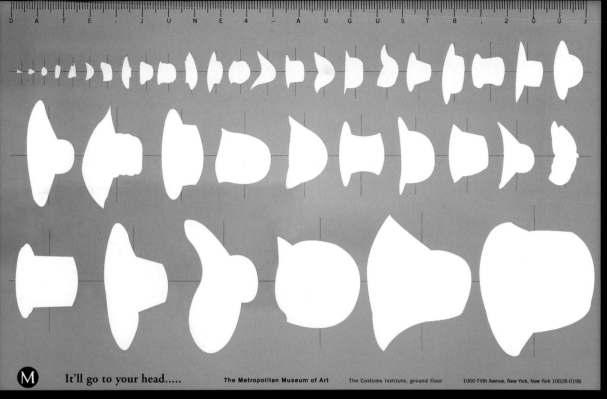

It'll go to your head..... The Metropolitan Museum of Art The Costume Institute, ground floor 1000 Fifth Avenue, New York, New York 10028-0198

Art Director: Yumi Yeunkyum Kim Design: Yumi Yeunkyum Kim Photography: Yumi Yeunkyum Kim School: Pratt Institute Instructor: Bob Gill

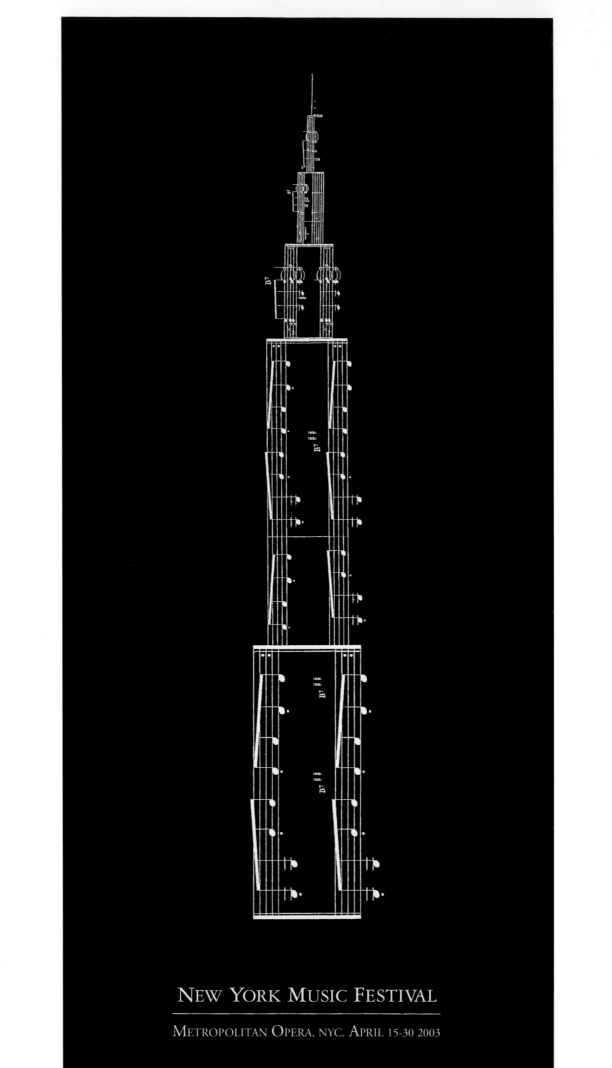

NEW YORK MUSIC FESTIVAL

METROPOLITAN OPERA, NYC. APRIL 15-30 2003

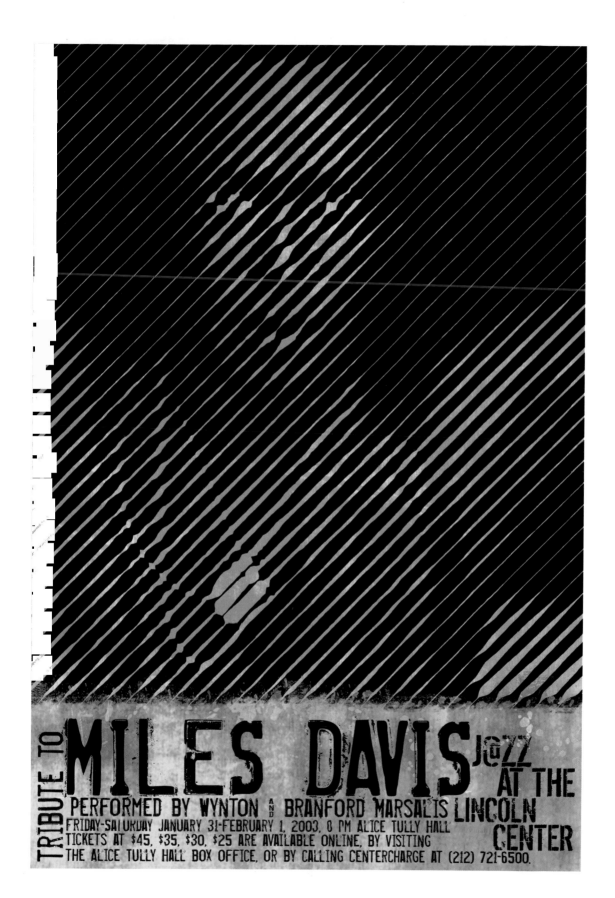

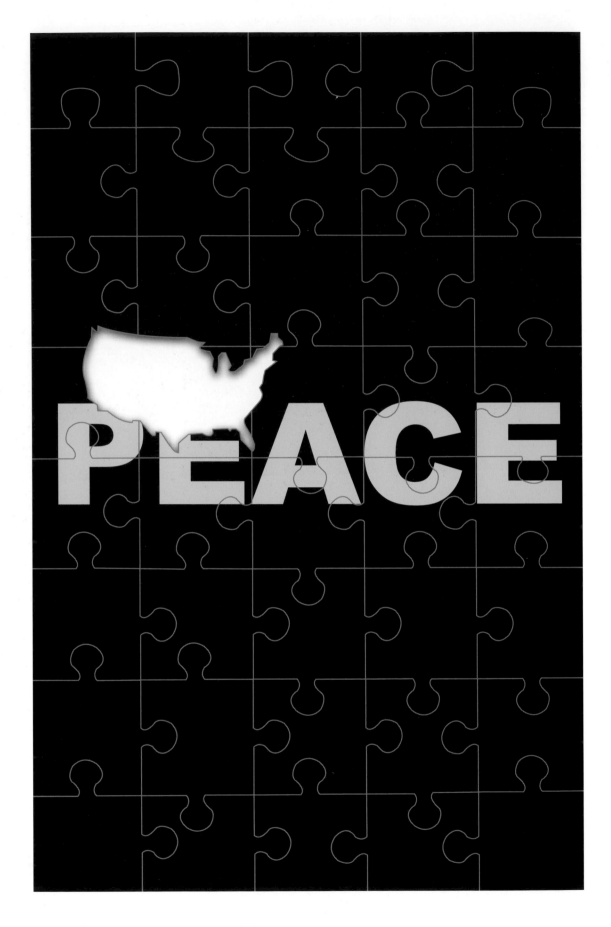

Alzheimer's Disease patients suffer from fading memory. Recognize that you can volunteer your help. Please visit www.alzheimers.org/volunteer or call (212) 333 3000 for more information.

I HELPED KILL 430,000 PEOPLE LAST YEAR

In April of 2002 Philip Morris Companies Inc. was granted the authority to change their name to Altria Group Inc. What does Philip Morris have to hide? Altria

Altria" Designer: G. Dan Covert Photographer: G. Dan Covert Copywriter: G. Dan Covert Other: Mike Hurd (Model) School: California College of Arts and Crafts Instructor: Michele Wetherbee

WORLD PEACE BEGINS WITH YOUR INNER PEACE

(top) Designer: Joo Young Lee School: School of Visual Arts Instructor: Andrew Castrucci (bottom) Art Director: Nicole Sciortino Designer: Nicole Sciortino Photographer: Helene Palser School: School of Visual Arts Instructor: Genevelve Williams

FREEDOM TO CHOOSE

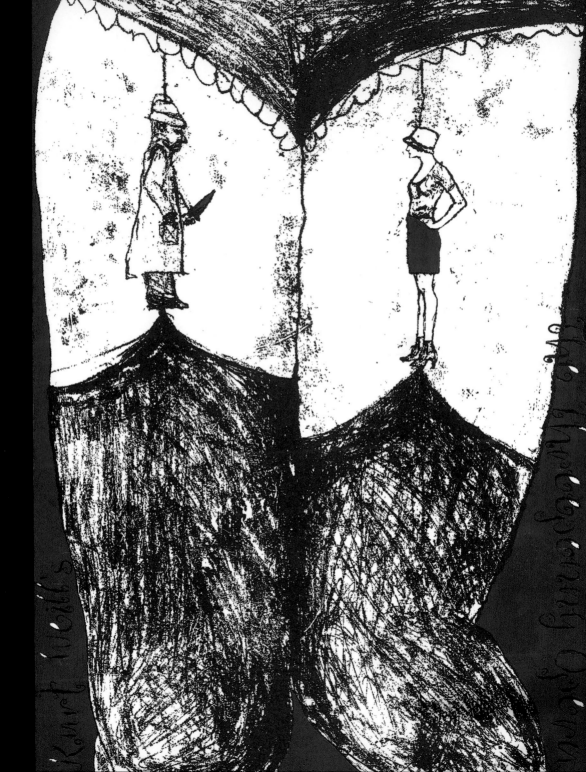

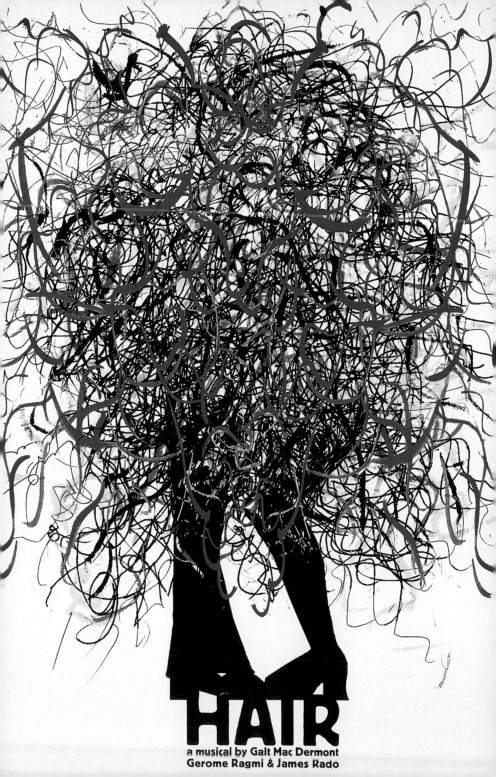

HAIR

a musical by Galt Mac Dermont
Gerome Ragmi & James Rado

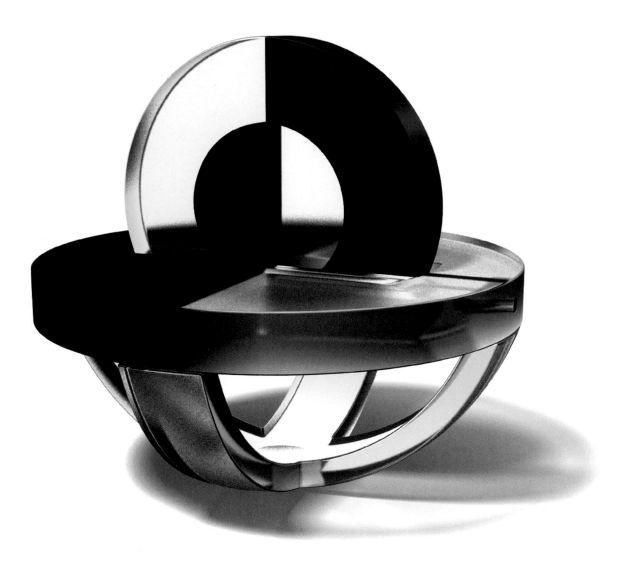

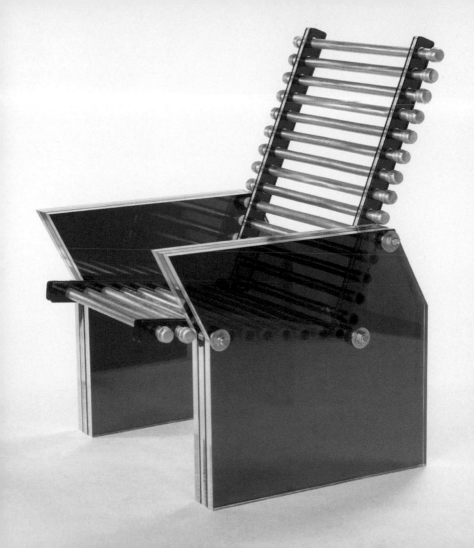

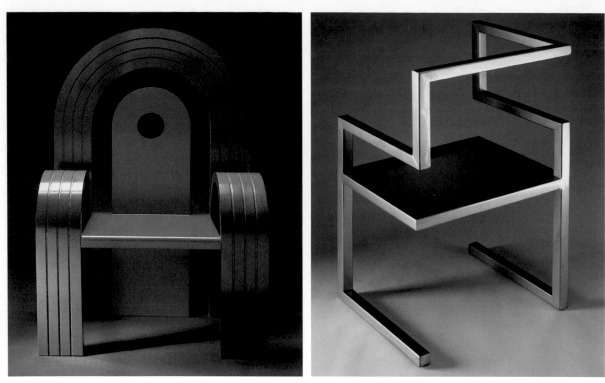

(left) "Art Deco Chair" Designer: Scott McBride School: Portfolio Center Instructor: Hank Richardson (right) "2017" Designer: Eric Miller School: Portfolio Center Instructor: Hank Richardson

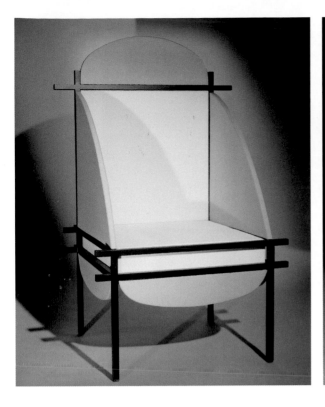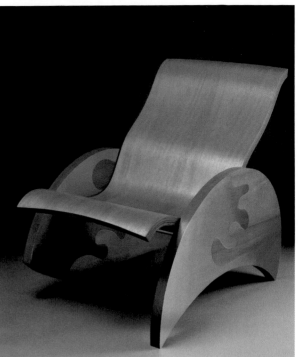

(left) "Myriad Chair" Designer: Elizabeth Linde School: Portfolio Center Instructor: Hank Richardson (right) "Propa Chair" Designer: Lee Chappell Monroe Photographer: Reo Way School: Portfolio Center Instructor: Hank Richardson Products 230,231

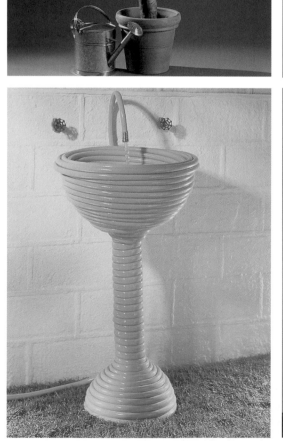

(top left) "Pipe Sink" Art Director: Boworndej Wangkeo Photographer: Myko Photography School: School of Visual Arts Instructor: Kevin O'Callaghan (top right) "Gasmask Planter" Designer: Dorothy DiComo School: School of Visual Arts Instructor: Kevin O'Callaghan (middle right) "Wine Glasses" Art Director: Boworndej Wangkeo Instructor: Kevin O'Callaghan Art Director: Boworndej Wangkeo Photography School: School of Visual Arts Instructor: Kevin O'Callaghan Designer: Adria Ingegneri Designer: Adria Ingegneri Photographers: Donna Aristo, Aristo Studios School: School of Visual Arts Photographer: Myko Photography School: School of Visual Arts Instructor: Kevin O'Callaghan (bottom left) Art Director: Adria Ingegneri Designer: Adria Ingegneri Designer: Dorothy DiComo School: School of Visual Arts Instructor: Kevin O'Callaghan (bottom right) "Tulip Lights" Designer: Dorothy DiComo School: School of Visual Arts Instructor: Kevin O'Callaghan

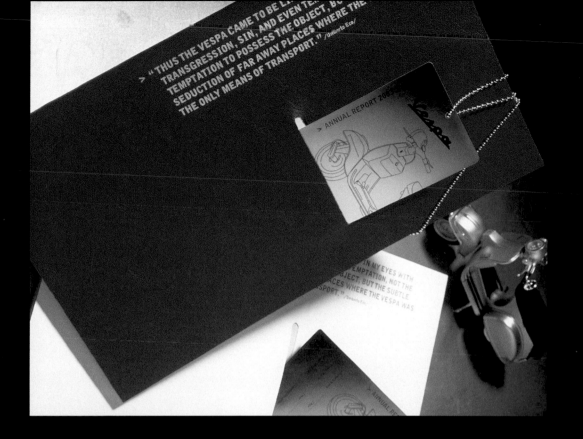

> " THUS THE VESPA CAME TO BE LI...
TRANSGRESSION, SIN, AND EVEN TE...
TEMPTATION TO POSSESS THE OBJECT, BU...
SEDUCTION OF FAR AWAY PLACES WHERE THE...
THE ONLY MEANS OF TRANSPORT. " /Umberto Eco/

> ANNUAL REPORT 200...

...IN MY EYES WITH
...MPTATION, NOT THE
...JECT, BUT THE SUBTLE
...ACES WHERE THE VESPA WAS
...PORT. " /Umberto Eco/

> ANNUAL RE...

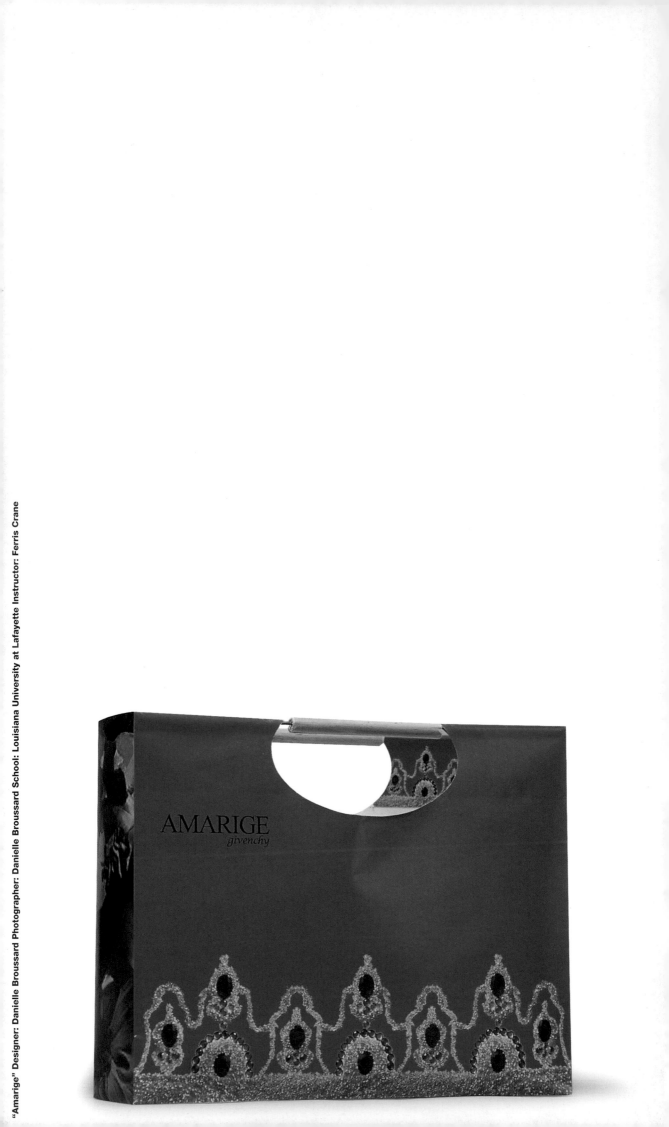

AMARIGE
givenchy

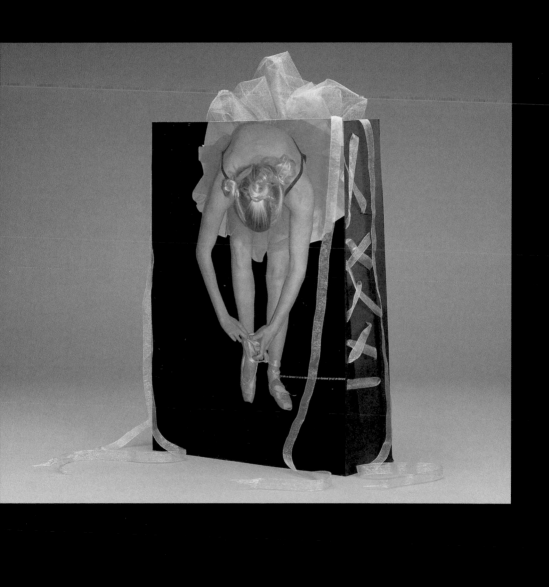

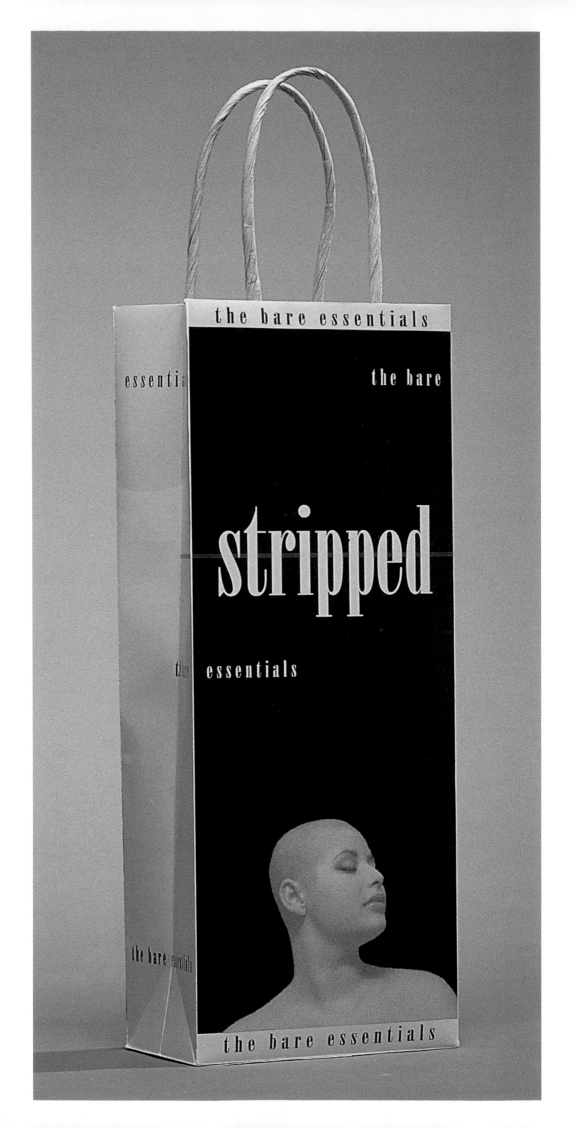

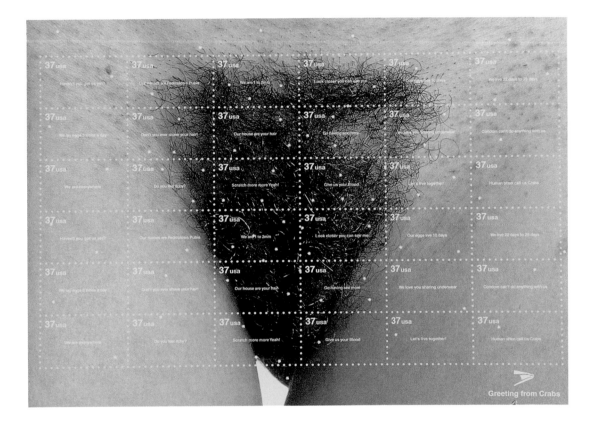

Art Director: Mototsugu Komatsu Designer: Mototsugu Komatsu School: School of Visual Arts Department: Advertising/Graphic Design Instructor: James Victore

FGREDUCED DESIGNED BY MINE SUDA

ABCDEFGHIJKLM NOPQRSTUVWXYZ

This is a modification of Franklin Gothic font. First I made very thick outlines around each letter, then removed it. What is left has unique form that would hardly be imagined by the original shape of the font. It required a little adjustment for every letter to complete as a font.

Mine Suda

511 E 73 ST #27 New York, NY 10021
212-744-8410 m74@earthlink.net

ANATOMY DESIGNED BY MINE SUDA

ABCDEFGHIJKLM NOPQRSTUVWXYZ

All letters are basically based on the same guidelines which is the combination of a flat rectangle and an oval in it. Some letters do not exactly follow the guide so that they can keep the same appearance and the quality as others.

Mine Suda

511 E 73 ST #27 New York, NY 10021
212-744-8410 m74@earthlink.net

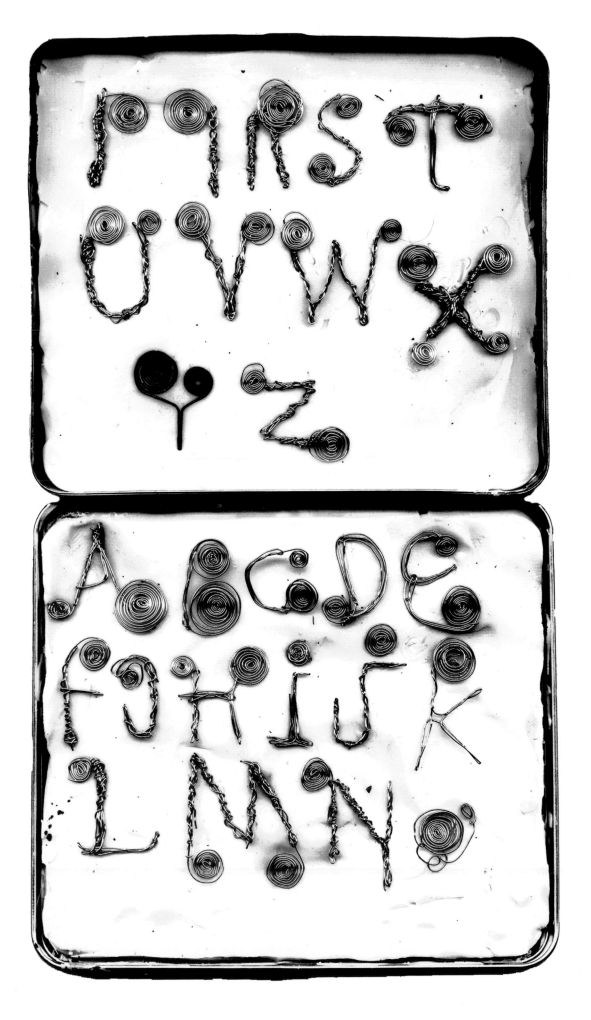

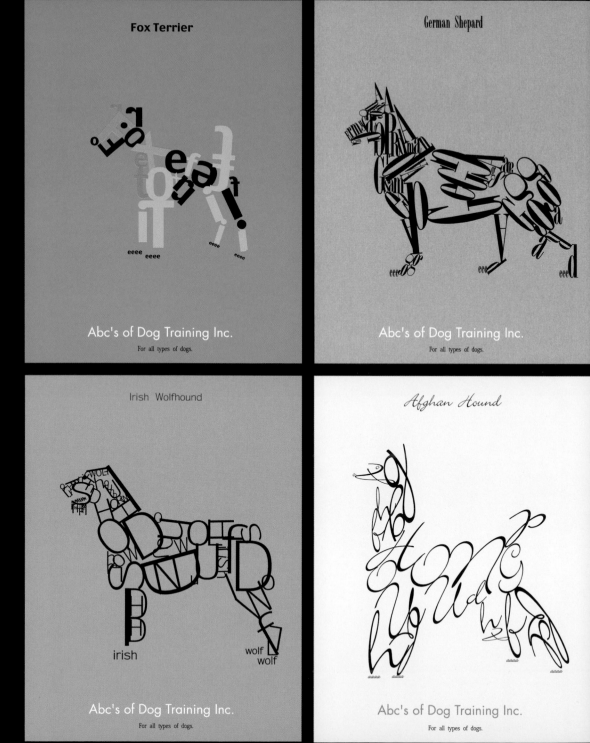

Fox Terrier

German Shepard

Abc's of Dog Training Inc.

For all types of dogs.

Abc's of Dog Training Inc.

For all types of dogs.

Irish Wolfhound

irish

wolf
wolf

Afghan Hound

Abc's of Dog Training Inc.

For all types of dogs.

Abc's of Dog Training Inc.

For all types of dogs.

IndexVerzeichnisseIndices

Page 52
Art Director: Nina Vesela
Copywriter: Nina Vesela
School: School of Visual Arts
Department: Advertising and Graphic Design
Department Chair: Richard Wilde
Instructor: Jeffrey Metzner

Page 53
Art Director: Timur Yevtuhov
Photographer: Timur Yevtuhov
Copywriter: Timur Yevtuhov
School: School of Visual Arts
Department: Advertising and Graphic Design
Department Chair: Richard Wilde
Instructor: A. Leban

Page 54, 55
Art Director: Matthew Herr
Copywriter: Matthew Herr
School: School of Visual Arts
Department: Advertising and Graphic Design
Department Chair: Richard Wilde
Instructor: Vincent Tulley

Page 56
Art Director: Sherrod Melvin
Copywriter: Sherrod Melvin
School: School of Visual Arts
Department: Advertising and Graphic Design
Department Chair: Richard Wilde
Instructor: Mike Campbell

Page 57
Art Director: Marie Zito
Copywriter: Marie Zito
School: School of Visual Arts
Department: Advertising and Graphic Design
Department Chair: Richard Wilde
Instructor: Jack Mariucci

Page 58
"Toys"
Art Director: Suraches Tavieng
Copywriter: Humberto Jiron
School: Academy of Art College
Instructor: John Butler

Page 59
Art Director: Joshua Larson
Copywriter: Joshua Larson
School: School of Visual Arts
Department: Advertising and Graphic Design
Department Chair: Richard Wilde
Instructor: Jeffrey Metzner

Page 60
Art Director: Emily St. Germaine
Copywriter: Emily St. Germaine
School: School of Visual Arts
Department: Advertising and Graphic Design
Department Chair: Richard Wilde
Instructor: Jack Mariucci

Page 61
"Punch Bag"
Art Director: Timur Yevtuhov
Photographer: Timur Yevtuhov
Copywriter: Timur Yevtuhov
School: School of Visual Arts
Department: Advertising and Graphic Design
Department Chair: Richard Wilde
Instructor: Sal Devito

Page 62
Art Director: Alison Beller
Copywriter: Alison Beller
School: School of Visual Arts
Department: Advertising and Graphic Design
Department Chair: Richard Wilde
Instructor: Jeffrey Metzner

Page 63
Art Director: Carter Storozynski
Copywriter: Carter Storozynski
School: School of Visual Arts
Department: Advertising and Graphic Design
Department Chair: Richard Wilde
Instructor: Jeffrey Metzner

Page 64
"Italian," "Ilegal" and "Insurance"
Art Director: Rob Schnabel
Copywriter: Rob Schnabel
School: School of Visual Arts
Department: Advertising and Graphic Design
Department Chair: Richard Wilde
Instructor: Jack Mariucci

Page 65
Art Director: Emily Inn
Copywriter: Emily Inn
School: School of Visual Arts
Department: Advertising and Graphic Design
Department Chair: Richard Wilde
Instructor: Jeffrey Metzner

Page 66, 67
"Fed Ex 2002 Annual Reports"
Art Director: Jerry Orta
Photographer: Jerry Orta
School: Austin Community College
Instructor: Linda Smarzik

Page 68, 69
"AMC Entertainment"
Art Director: Joannie Casenas
School: Academy of Art College
Department Chair: Mary Scott
Instructor: Tom Siev

Page 70
"Dracula Book Cover"
Art Director: Jerry Colandrea
Illustrator: Jerry Colandrea
School: School of Visual Arts
Instructor: Dean Lubensky

Page 71
"The Bouncing Bullet"
Art Director: David Lynn
Illustrator: David Lynn
School: Western Washington University
Instructor: Kent Smith

Page 72, 73
Art Director: Leslie W. Myers

Page 74
"WWI Raids"
Art Director: Phillipp Eggert
Photographer: Mel Wright
Illustrator: Phillipp Eggert
Copywriter: Phillipp Eggert
School: School of Visual Arts
Instructor: Carin Goldberg

Page 75
Art Director: Arnoud Verhaeghe
School: Parsons School of Design
Instructor: Charles Hively

Page 76
Art Director: Boris Rapaport
School: School of Visual Arts
Department: Advertising and Graphic Design
Department Chair: Richard Wilde
Instructor: Paula Scher

Page 77
"History of Wine/History of Beer/History of Vodka"
Art Director: Dmitry Paperny
School: School of Visual Arts
Instructor: Roswitha Rodrigues

Page 77
Art Director: Kahyun Sung
School: School of Visual Arts
Instructor: Louise Fili

Page 77
"Albert Camus Book Series"
Art Director: Felix Estrada
School: School of Visual Arts
Instructor: Carin Goldberg

Page 78
"Operation Tooth"
Art Director: Al Landron
Copywriter: Al Landron
School: Tyler School of Art
Instructor: Kelly Holohan

Page 79
"The Coffee Tablebook"
Art Director: Andrea Vélez
School: School of Visual Arts
Department: Advertising and Graphic Design
Department Chair: Richard Wilde
Instructor: Paula Scher

Page 80, 81
Art Director: Patrick Cahalan
School: School of Visual Arts
Department: Advertising and Graphic Design
Department Chair: Richard Wilde
Instructor: Chris Austopchuk

Page 82
"Manson Theatre"
Art Director: Eric Pramana
School: Academy of Art College
Instructor: Jamie Calderon

Page 83
"Jackie O"
Art Director: Eric Yeager
School: Tyler School of Arts
Instructor: Kelly Holohan

Page 84, 85
"Grassy Roads of Wonder"
Art Director: Bryan Louie
School: University of Delaware
Instructor: Kelly Holohan
Instructor: Hendrik-Jon Francke

Page 86
"Psy/Ops"
Art Director: Tonje Vetleseter
School: Academy of Art College
Department Chair: Mary Scott
Instructor: Ariel Grey

Page 87
"Adopt Now"
Art Director: Anik Palulian
School: School of Visual Arts
Department: Advertising and Graphic Design
Department Chair: Richard Wilde
Instructor: James Victore

Page 88, 89
Art Director: Nina Vesela
Photographer: Nina Vesela
Illustrator: Nina Vesela
School: School of Visual Arts
Instructor: A. Leban

Page 90, 91
"Offroad by Jeep"
Art Director: Stephan Pentel
School: Kunstschule Alsterdamm
Instructor: Hans Manzewski

Page 92, 93
Art Director: Dwayne Lutchna
School: School of Visual Arts
Department: Advertising and Graphic Design
Department Chair: Richard Wilde
Instructor: Paula Scher

Page 94
"Temple"
Art Director: Michael Moreau
School: Portfolio Center
Department Chair: Hank Richardson

Page 95
"The Essence of Calyx and Corolla"
Art Director: Dorothy Lin
School: Pratt Institute
Instructor: Graham Hanson

Page 96, 97
"Baboo the Circle Store"
Art Director: Karin Folman
Photographer: Karin Folman
Copywriter: Karin Folman
School: School of Visual Arts
Department: Advertising and Graphic Design
Department Chair: Richard Wilde
Instructor: Paula Scher

Page 98, 99
Art Director: Roberto Vargas
School: School of Visual Arts
Department: Advertising and Graphic Design
Department Chair: Richard Wilde

Page 140
"Renée Fleming"
Art Director: Kahyun Sung
School: School of Visual Arts
Department: Advertising and Graphic Design
Department Chair: Richard Wilde
Instructor: Sara Giovanitti

Page 141
"Carlo Montoya: Canciones Antiguas"
Art Director: Joseph Felix
School: School of Visual Arts
Department: Advertising and Graphic Design
Department Chair: Richard Wilde
Instructor: Roswitha Rodrigues

Page 141
"Mirror Conspiracy Theory"
Art Director: Dmitry Paperny
School: School of Visual Arts
Department: Advertising and Graphic Design
Department Chair: Richard Wilde
Instructor: Roswitha Rodrigues

Page 141
"Susumu Yokota–This is where Babies come from"
Art Director: Nicolaus H. Taylor
School: School of Visual Arts
Department: Advertising and Graphic Design
Department Chair: Richard Wilde
Instructor: Tracy Boychuk

Page 142
Art Director: Chia-Lin Chang
School: School of Visual Arts
Department: Advertising and Graphic Design
Department Chair: Richard Wilde
Instructor: Chris Austopchuck

Page 143
"Queens of the Stone Age CD Box Set"
Art Director: Carter Storozynski
Photographer: Todd McLellan
School: School of Visual Arts
Department: Advertising and Graphic Design
Department Chair: Richard Wilde
Instructor: Stacey Drummond

Page 144, 145
Art Director: Minsun Jun
School: School of Visual Arts
Department: Advertising and Graphic Design
Department Chair: Richard Wilde
Instructor: Dean Lubensky

Page 146, 147
"Jim Brickman's Simple Things"
Art Director: Seungmin Chung
School: School of Visual Arts
Instructor: Stephan Sagmeister

Page 148, 149
"Frank Sinatra 3 CD Set"
Art Director: Chen-Chen Ni
School: School of Visual Arts
Instructor: Rymn Massand

Page 150
Art Director: Hinsun Jun Ni
School: School of Visual Arts
Instructor: Dean Lubensky

Page 151
"Frank's Wild Years–Tom Waits"
Art Director: Peter Ahlberg
Illustrator: Peter Ahlberg
School: School of Visual Arts
Instructors: Tracy Boychuk and Jen Roddie

Page 152, 153
"Apiana Soap"
Art Director: Sarah J. Munt
School: Parsons School of Design
Instructor: Charles Hively

Page 154
"Solomon & Co. Aromatherapy"
Designer: Stephanie Whitaker
School: Western Washington University

Page 154
"Ann Taylor Essentials"
Designer: Alberto Rojas
Photographer: Jeff Johnson
School: Academy of Art College
Instructor: Michael Osborne

Page 155
"Close Comfort"
Designer: Jeremy Smallwood
School: Portfolio Center
Instructor: Stephanie Grendzinski

Page 156
"Citre Hair and Body Care Packaging"
Art Director: Indrawn Boediman
School: Academy of Art College
Department Chair: Mary Scott
Instructor: Coco Qiu

Page 156
"Dani Skin Care Packaging"
Art Director: Yunmi Chung
School: Academy of Art College
Department Chair: Mary Scott
Instructor: Thomas McNulty

Page 157
"Cetaphil Skin Care Packaging"
Art Director: Jenn Kelly
School: Academy of Art College
Department Chair: Mary Scott
Instructor: Thomas McNulty

Page 158
"Fresh Boy"
Designer: Alana McCann
Copywriter: Alana McCann
School: Penn State University
Instructor: Kristin Breslin Sommese

Page 159
Designer: Araba Simpson
School: School of Visual Arts
Instructor: Paula Scher

Page 160, 161
"Ami: TV Packaging"
Designer: Wade Thompson
School: Portfolio Center
Instructor: Labeica

Page 162
"zapz"
Art Director: Felicia Soto
School: Pratt Institute
Instructor: Duhan

Page 163
"Zyrtec"
Art Director: Joly Neelankavil
Designer: Joly Neelankavil
Illustrator: Joly Neelankavil
School: Art Center College of Design
Instructor: Gloria Kondrup

Page 164
"Mezzetta's"
Designer: Luke Markowski
School: Western Washington University
Instructor: Kent Smith

Page 165
"Italian Garden Olive Oil"
Art Director: Dmitry Paperny
Designer: Dmitry Paperny
Photographer: Alexei Lebeden
Illustrator: Dmitry Paperny
Copywriter: Dmitry Paperny
School: School of Visual Arts
Instructor: Roswitha Rodrigues

Page 165
"Hotter Than Hot Sauces"
Designer: Summer J. Daughenbaugh
Photographer: Richard
Copywriter: Summer J. Daughenbaugh
School: Penn State University
Instructor: Kristin Breslin Sommese

Page 165
"Tomato Organic Tomato Juice"
Art Director: Dmitry Paperny
Designer: Dmitry Paperny
Photographer: Juren David
Illustrator: Dmitry Paperny
Copywriter: Dmitry Paperny
School: School of Visual Arts
Instructor: Roswitha Rodrigues

Page 166
Designer: David A. Caruso
Photographer: Blane Faul
School: Louisiana University at Lafayette
Instructor: Ferris Crane

Page 167
"AquaTank–My First Fish Tank"
Art Director: Yuriko Mitsuma
Designer: Yuriko Mitsuma
School: Austin Community College
Instructor: Linda Smarzik

Page 167
"Dr. Wysong Dog Food"
Designer: Alberto Rojas
Photographer: Stephanie Ginger
School: Academy of Art College
Instructor: Thomas McNutty

Page 168
"GE Light Bulbs Packaging"
Art Director: Indrawn Boediman
School: Academy of Art College Department
Chair: Mary Scott
Instructor: Coco Qiu

Page 169
"Canned Juice"
Designer: Jessica Annunziata
School: School of Visual Arts
Instructor: Carin Goldberg

Page 170
"Nailed–Hammered–Screwed"
Designer: Felix Estrada
School: School of Visual Arts
Instructor: Carin Goldberg

Page 170
"Puntillas"
Designer: Andrea Vélez
School: School of Visual Arts
Instructor: Paula Scher

Page 171
"Glidden Paints Packaging"
Art Director: Yuting Chang
School: Academy of Art College
Department Chair: Mary Scott
Instructor: Thomas McNulty

Page 171
"Purina Dog Food"
Art Director: Noriko Ohori
School: Academy of Art College
Department Chair: Mary Scott
Instructor: Thomas McNulty

Page 172
"Red Hook Beer"
Art Director: Noriko Ohori
School: Academy of Art College
Department Chair: Mary Scott
Instructor: Thomas McNulty

Page 173
"Shambeer–Shampoo made of beer"
Designer: Tamar Onn
School: School of Visual Arts
Instructor: Roswitha Rodrigues

Page 173
"Cerveza Sol"
Designer: Alberto Rojas
Photographers: Jeff Johnson
School: Academy of Art College
Instructor: Thomas McNulty

Page 173
"Bintang Packaging"
Art Director: Indrawn Boediman
School: Academy of Art College
Department Chair: Mary Scott
Instructor: Coco Qiu

Page 174
"Dunlivet Scotch"
Art Director: Dolly Chen
School: Academy of Art College
Department Chair: Mary Scott
Instructor: Michael Osborne

Page 216
"New York Music Festival"
Designer: Metin Sozen
School: Portfolio Center
Instructor: Hank Richardson

Page 217
"Miles Davis Tribute"
Art Director: Freddie Topete
Designer: Freddie Topete
Illustrator: Freddie Topete
School: School of Visual Arts
Instructor: Dean Lubensky

Page 218
Designer: Woo Hyun Kim
School: School of Visual Arts
Instructor: A. Leban

Page 219
"Alzheimer's poster"
Designer: Ryan Slone
School: Portfolio Center
Instructor: Martha Gill

Page 220
"The New York Public Library"
Designer: Jennifer Kim
School: Pratt Institute
Department: Graduate Communications
Design Instructor: Bob Gill

Page 221
"Altria"
Designer: G. Dan Covert
Photographer: G. Dan Covert
Copywriter: G. Dan Covert
Other: Mike Hurd (Model)
School: California College of Arts and Crafts
Instructor: Michele Wetherbee

Page 222
Art Director: Timur Yevtuhov
Designer: Timur Yevtuhov
School: School of Visual Arts
Department: Graphic Design/Advertising
Instructor: Adrienne Leban

Page 223
Designer: Joo Young Lee
School: School of Visual Arts
Instructor: Andrew Castrucci

Page 223
Art Director: Nicole Sciortino
Designer: Nicole Sciortino

Page 224
Art Director: Ji Hwan Yoon
School: School of Visual Arts
Instructor: Condoc

Page 225
"Globalization Poster"
Designer: Gary Wood
School: Tyler School of Art
Instructor: Kelly Holohan

Page 226
"Three Penny Opera"
Art Director: Anka Pinczer
Designer: Anka Pinczer
School: School of Visual Arts
Instructor: Rafal Olbinski

Page 227
Art Director: Anka Pinczer
Designer: Anka Pinczer
School: School of Visual Arts
Instructor: Rafal Olbinski
Photographer: Helene Palser

Page 228
"Chair Design"
Designer: Miti Desai
School: Portfolio Center
Instructor: Hank Richardson

Page 229
"Flux"
Designer: Christine Taylor
School: Portfolio Center
Instructor: Hank Richardson

Page 230
"Art Deco Chair"
Designer: Scott McBride
School: Portfolio Center
Instructor: Hank Richardson

Page 230
"2017"
Designer: Eric Miller
School: Portfolio Center
Instructor: Hank Richardson

Page 231
"Myriad Chair"
Designer: Elizabeth Linde
School: Portfolio Center
Instructor: Hank Richardson

Page 231
"Propa Chair"
Designer: Lee Chappell Monroe
Photographer: Roo Way
School: Portfolio Center
Instructor: Hank Richardson

Page 232
"Pipe Sink"
Art Director: Boworndej Wangkeo
Photographer: Myko Photography
School: School of Visual Arts
Instructor: Kevin O'Callaghan

Page 232
"Gasmask Planter"
Designer: Dorothy DiComo
School: School of Visual Arts
Instructor: Kevin O'Callaghan

Page 232
"Sunflower Lamp"
Art Director: Boworndej Wangkeo
Photographer: Myko Photography
School: School of Visual Arts
Instructor: Kevin O'Callaghan

Page 232
"Wine Glasses"
Art Director: Boworndej Wangkeo
Photographer: Myko Photography
School: School of Visual Arts
Instructor: Kevin O'Callaghan

Page 232
Art Director: Adria Ingegneri
Designer: Adria Ingegneri
Photographers: Donna Aristo, Aristo Studios
School: School of Visual Arts
Instructor: Kevin O'Callaghan

Page 232
"Tulip Lights"
Designer: Dorothy DiComo
School: School of Visual Arts
Instructor: Kevin O'Callaghan

Page 233
"Mona Lisa Puzzle Chairs"
Art Director: Boworndej Wangkeo
Designer: Boworndej Wangkeo
Photographer: Myko Photography
School: School of Visual Arts
Instructor: Kevin O'Callaghan

Page 234
"Wine Bottle"
Art Director: Natsumi Nishizumi
School: School of Visual Arts
Instructor: Carin Goldberg

Page 235
"Vespa Annual Report"
Art Director: Indrawn Boediman
School: Academy of Art College
Department Chair: Mary Scott

Page 236
"Amarige"
Designer: Danielle Broussard
Photographer: Danielle Broussard
School: Louisiana University at Lafayette
Instructor: Ferris Crane

Page 237
"Je suis une panseuse"
Designer: Anne Donnard
Other: Lora O'Neil
School: Penn State University
Instructor: Kristin Sommese

Page 238
"Stripped Fragrance"
Designer: Alex Karras
Photographer: Blaine Faul
School: University of Louisiana at Lafayette
Instructor: Ferris Crane

Page 239
Art Director: Mototsugu Komatsu
Designer: Mototsugu Komatsu
School: School of Visual Arts
Department: Advertising and Graphic Design
Instructor: James Victore

Page 240
"FG Reduced Typeface"
Art Director: Mine Suda
Designer: Mine Suda
Illustrator: Mine Suda
Copywriter: Mine Suda
School: School of Visual Arts
Instructor: Christopher Austopchuk
Client: LyneType

Page 240
"Anatomy"
Art Director: Mine Suda
Designer: Mine Suda
Illustrator: Mine Suda
Copywriter: Mine Suda
School: School of Visual Arts
Instructor: Christopher Austopchuk
Client: LyneType

Page 241
"Body of Work 2003-2003:
Adventures in Typography assorted Posters"
Art Director: Adam Vohlidka
School: School of Visual Arts
Instructor: J. Diresta

Page 242
"Type Dogs"
Art Director: Renetta Welty
School: Miami Ad School
Instructor: Steven Timana

CreativeDirectorsArtDirectorsDesigners

Directory of Schools

Academy of Art College
79 New Montgomery Street
San Francisco, CA 94105
Tel: 415.274.2200

Art Center College of Design
1700 Lida Street
Pasadena, CA 91103-1999
Tel: 626.396.2200
Fax: 626.405.9104

Art Institute of Atlanta
6600 Peachtree Dunwoody Road
100 Embassy Row
Atlanta, GA 30328-1649
Toll Free: 1.800.274.4242
Tel: 770.394.8300
Fax: 770.394.0008

Austin Community College
11928 Stonehollow Drive
Austin, TX 78758
Tel: 512.223.4000

California College of Arts & Crafts
1111 Eight St.
San Francisco, CA 94107-2247
Tel: 415.703.9500
Fax: 415.703.9539

Emerson College
120 Boylston Street
Boston, MA 02116-4624
Tel: 617-824-8500

Kunstschule Alsteldamm
Lange Reihe 29
Hamburg, Germany D-20099
Tel: +49.40.327180

Louisiana University at Lafayette
104 University Circle, P.O. Box 42651
Lafayette, LA 70504
Tel: 337.482.1000

Miami Ad School
955 Alton Road
Miami Beach, FL 33139
Tel: 305.538.3193
Fax: 305.538.3724

Miami Ad School-San Francisco
415 Jackson Street, Suite B
San Francisco, CA 94111
Tel: 415.837.0966
Fax: 415.837.0967

Parsons School of Design
66 Fifth Avenue
New York, NY 10011
Toll Free: 1.800.252.0852
Tel: 212.229.8910
Fax: 212.229.8975

Penn State University
210 Patterson Building
University Park, PA 16802
Tel: 814.865.1203
Fax: 814.865.1158

Portfolio Center
125 Bennett St.
Atlanta, GA 30309
Toll Free: 1.800.255.3169
Tel: 404.351.5055
Fax: 404.355.8838

Pratt Institute
200 Willoughby Avenue
Brooklyn, NY 11205
Tel: 718.636.3600

School of Visual Arts
209 East 23 Street
New York, NY 10010-3994
Tel: 212.592.2000
Fax: 212.725.3587

Southwest Texas State University
601 University Drive
San Marcos, TX 78666
Tel: 512.245.2111

Tyler School of Arts–Temple University
7725 Penrose Avenue
Elkins Park, PA 19027
Tel: 215.782.2828

University of Delaware
104 Recitation
Newark, DE 19716
Tel: 302.831.1198
Fax: 302.831.0505

University of Illinois at Chicago
School of Art and Design
College of Architecture and the Arts
106 Jefferson Hall
929 West Harrison Street
Chicago, Illinois 60607-7038
Tel: 312.996.3337
Fax: 312.413.2333

University of North Carolina, Chapel Hill
Campus Box #3365 Carroll Hall
Chapel Hill, NC 27599-3365
Phone: 919.962.1204
Fax: 919.962.0620

University of Washington
PO Box 353440
Seatle, WA 98195
Tel: 206.543.0515
Fax: 206.685.1657

Western Washington University
516 High Street
Bellingham, WA 98225
Tel: 360.650.3923

Directory of New Firms

Apparatis Co.
4027 Marcasel Ave.
Los Angeles, CA 90066
Tel: 310.439.1442
Fax: 310.439.1442

Rick English Pictures
1162 El Camino Real
Menlo Park, CA 94025
Tel: 650.322.1984
Fax: 650.322.1986

Studio 1312
1312 Ponce de Leon Avenue
Santurce, Puerto Rico 00909
Tel: 787.977.0133

PhotographersIllustrators

Copywriters

DesignFirms

Universities

Chairs

Instructors

Graphis New Titles

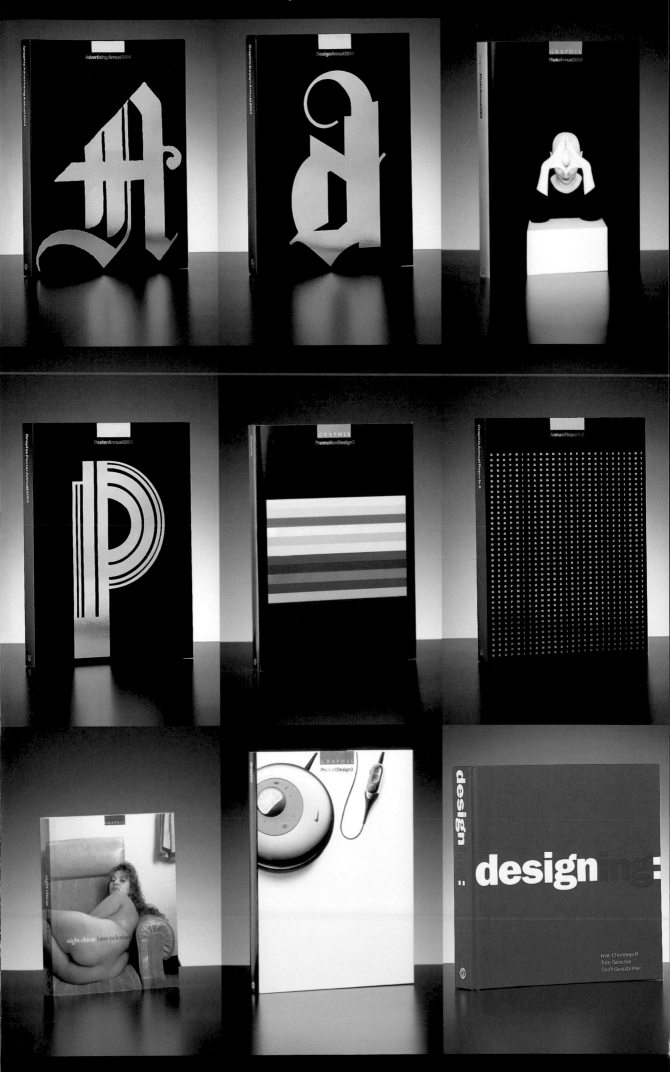

At your local Bookstore or 1-800-209-4234

www.graphis.com

{ ORDER FROM ANYWHERE IN THE WORLD.
Yes, even from Christmas Island.

DESIGN›› JON CANNELL DESIGN & BALANCE PROGRAMMING›› SYSTEMS CATALYST FLASH DESIGN›› GARN CREATIVE